THE BRANCH LINES OF
BUCKINGHAMSHIRE

THE BRANCH LINES OF BUCKINGHAMSHIRE

COLIN G. MAGGS

AMBERLEY

Acknowledgements

Grateful thanks for assistance are due to Kevin Boak; A. D. M. Baker (Buckinghamshire Railway Centre); Andrew Bunyard (Chinnor & Princes Risborough Railway); Richard Forse; Ben Roberts (Waste Recycling Group) and Colin Roberts.

This edition first published 2010

Amberley Publishing Plc
Cirencester Road, Chalford,
Stroud, Gloucestershire, GL6 8PE

www.amberley-books.com

British Library Cataloguing in Publication Data.
A catalogue record for this book is available from the British Library.

ISBN 978 1 84868 342 6

Typesetting and Origination by FONTHILLDESIGN.
Printed in Great Britain.

Contents

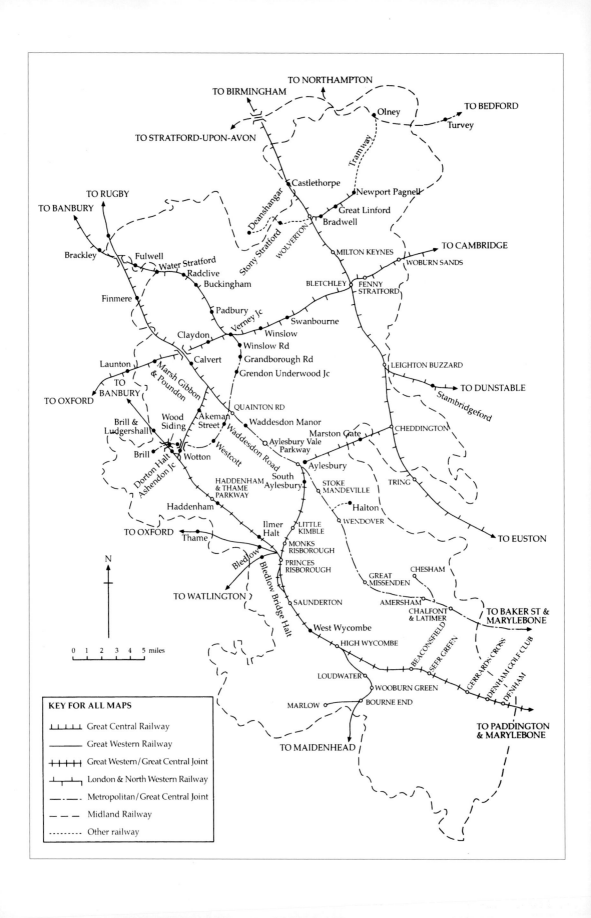

Introduction

The pre-Grouping railway map of Buckinghamshire was quite simple. Three parallel main lines ran north-westwards from London: the Great Western & Great Central Joint line from Paddington and Marylebone to Princes Risborough and beyond; the Metropolitan & Great Central Joint line from Baker Street and Marylebone to Aylesbury and Quainton Road; and the London & North Western Railway's Euston to Birmingham line. Running south-west to north-east through the county was an important secondary route, the LNWR's Oxford to Cambridge line.

Although Euston to Birmingham remains an important trunk route, the other two main lines are shadows of their former selves and today can be considered as branches, rather than main lines. GWR branches in the county included: Oxford to Princes Risborough; Watlington to Princes Risborough; Princes Risborough to Aylesbury; Maidenhead to Princes Risborough and Bourne End to Marlow. Metropolitan Railway branches were from Quainton Road to Brill; Quainton Road to Verney Junction and the now electrified Chalfont & Latimer to Chesham branch.

The section of the Oxford to Cambridge line within the county now consists of just the Bicester Town to Calvert line used only by 'bin-liner' trains and the Bletchley to Bedford section still open to passenger traffic. It is highly likely that the Bicester to Bletchley line will be re-opened to passenger traffic in the not too distant future. LNWR branches in Buckinghamshire were Verney Junction to Banbury; Wolverton to Newport Pagnell and the Wolverton & Stony Stratford Tramway which could be classified as a branch. The Leighton Buzzard to Dunstable line ran for less than a mile within the county. The Midland Railway's Bedford to Northampton line passed through the northern tip of Buckinghamshire.

The pattern of this book is that the GWR lines are described first, followed by those of the GCR, Metropolitan Railway, the LNWR and the MR, the general trend being in a clockwise direction.

Grateful thanks are due to Kevin Boak, Richard Forse, Colin Roberts and the late John Hayward for assistance.

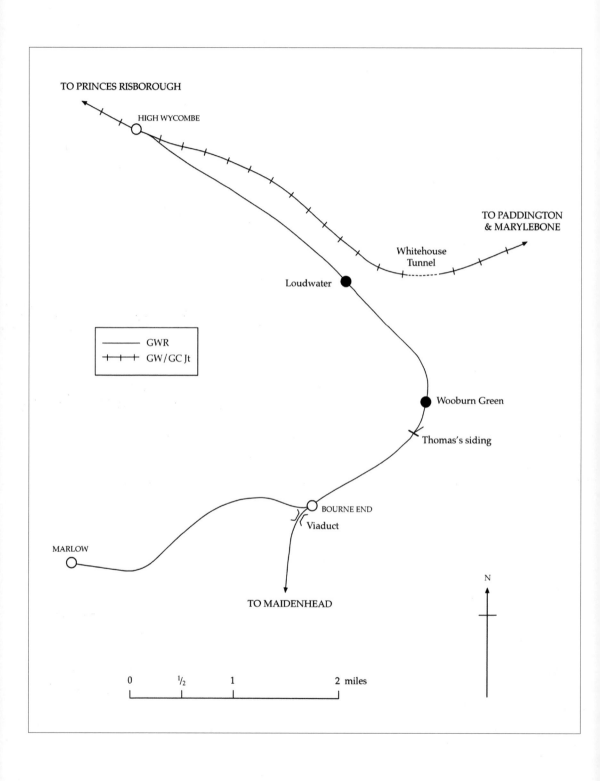

Bourne End to High Wycombe

The line from Bourne End to High Wycombe was built as part of the Wycombe Railway which received its Act on 27 July 1846, sanctioning a line from Maidenhead (on the main GWR Paddington to Bristol line) to Aylesbury via High Wycombe. Its authorized capital was £102,600 in shares and £33,600 in loans. This broad gauge single line was laid with 90½ lb per yard Barlow rails. In section these looked like an inverted 'V' with ends a foot apart. They were not laid on sleepers like conventional rail, but the 'V' was packed with ballast to prevent movement. In use these rails proved unsuccessful because the gauge had a tendency to spread. They had been patented in 1849 by William Henry Barlow, engineer to the Midland Railway and later responsible for building St Pancras station which, at 240 ft, had the widest roof span in Britain.

After overcoming financial difficulties, the line from Maidenhead through Bourne End to High Wycombe opened on 1 August 1854 and was leased to the GWR for an annual rental of £3,600. In due course the line was extended from High Wycombe to Oxford and from Princes Risborough to Aylesbury. The Wycombe Railway was amalgamated with the GWR from 1 February 1867. Between 23 and 31 August 1870 the branch was converted to standard gauge, passenger traffic recommencing on 1 September and goods a few days later. On 1 August 1899 the GCR commenced running goods trains from Aylesbury to London via Princes Risborough, High Wycombe and Maidenhead, taking traffic to GWR stations in the Metropolis and to railways south of London.

The first four miles from Maidenhead run through Berkshire before crossing the Thames over the 162-yard long Bourne End Viaduct into Buckinghamshire. This viaduct was originally built of timber.

The first station in Buckinghamshire, Bourne End (named Marlow Road until 1 January 1874), was the junction of the branch to Marlow. It is double-tracked and the outer face of the Down platform formed a bay for the Marlow shuttle. Pointwork permitted running to Marlow from both through platforms. The Down loop was signalled for two-way working so that if two trains were not crossing, passengers of an Up train could be landed adjacent to the Marlow shuttle service.

The building of Bourne End station is a typical Wycombe Railway design in brick and knapped flint. The line north of the station was closed when passenger services beyond were withdrawn on 4 May 1970; thus Bourne End became a two-road terminus. Today, Platform 1, the former Down platform, is used by through trains to Marlow and, due to the layout, they have to reverse here. Platform 2 is longer, but has no direct access to Marlow. The tablet machine is conveniently placed in a hut adjacent to the ground frame. A GWR water surface-box cover can be seen set into Platform 2.

Bourne End had eight goods sidings but rationalization began on 30 January 1956 when the South signal-box closed and was replaced by a ground frame. The North signal-box succumbed on 13 June 1971. The station closed to goods on 11 September 1967. The goods shed, a typical Wycombe Railway structure in red brick and knapped flint, is now used as an auction room. A section of Barlow rail protects one corner from damage by road vehicles.

North of the station Cores End level crossing was operated by a gate-keeper. About one- and- three-quarter miles beyond Bourne End was Thomas's siding which served a paper mill; the private siding agreement terminated on 31 August 1967. Wooburn Green, spelt Woburn Green until October 1872, was a block post but had no crossing facilities.

Its two sidings closed to goods on 11 September 1967. Loudwater station originally had one passenger platform and later a goods loop, but on 15 May 1942 a new Down platform was opened. There were four goods sidings and Ford's Blotting Paper formed an important source of traffic with raw materials in and the finished product out.

From Loudwater the branch rose as the approaching Great Western & Great Central Joint line fell. Although a junction at the High Wycombe South signal-box was opened in 1905, branch passenger trains had an independent line running into the bay platform on the Down side at High Wycombe. The original station, simply called Wycombe, closed 1 October 1864 and was replaced by a new station 'High Wycombe' opened on the same date. Then on 2 April 1906 a second replacement catered for the increased traffic with the introduction of main line trains to the Ashendon Junction to Northolt Junction and Greenford section. The former two-track plan changed to two platform roads plus a bay and two through roads. Due to the unavailability of extra land for quadrupling, the new Up platform was staggered to the south. The massive retaining wall facing the Down platform required 1,250,000 Staffordshire blue engineering bricks. The Up and Down platforms are linked by subway. Reverse curves require a speed limit of 35 mph to be imposed on through trains. The layout was remodelled between the end of July 1989 and May 1990, the through non-platform roads being lifted. The 200-ft long goods shed contained three 30 cwt hand cranes.

Local trains were generally worked by tank engines, while those travelling a longer distance could be headed by tender engines. In 1960 Maidenhead to High Wycombe locals were in charge of 0-6-0PTs, while '61XX' class 2-6-2Ts hauled through trains. In 1961 diesel multiple-units took over.

Right from the line's opening, through services ran from Paddington to High Wycombe, though some trains started from Maidenhead. In December 1872 the branch enjoyed a service of eleven trains to London: nine to Paddington and two to Victoria. By 1893 a coach was slipped at Taplow from the 5.15 p.m. ex-Paddington and then taken on to Maidenhead, Bourne End and Marlow. In 1933 the branch enjoyed thirteen Down and twelve Up trains, of which eleven Down and eight Up were to or from Paddington. Trains were restricted to a limit of 50 mph over the branch. Since 4 May 1970 trains have run from Maidenhead to Bourne End or Marlow only. The 2010 branch shuttle service offers twenty-four trains each way daily and thirteen on Sundays.

At one time some Oxford-Princes Risborough-Paddington trains ran via Bourne End rather than direct through Beaconsfield.

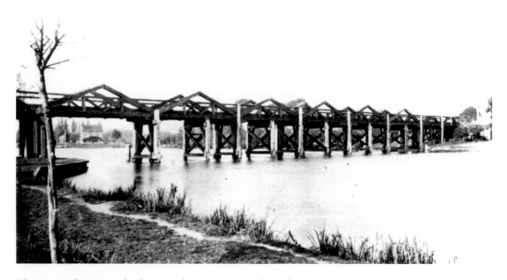

The original 162-yards- long timber Bourne End Viaduct across the Thames south of Bourne End. *Author's collection*

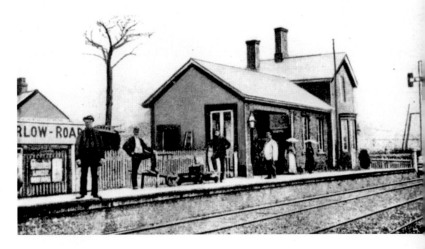

Marlow Road station, view Down *c.* 1872, before being re-named Bourne End on 1 January 1874, *c.* 1872. Notice the crossbar signal at 'Danger'. *Author's collection*

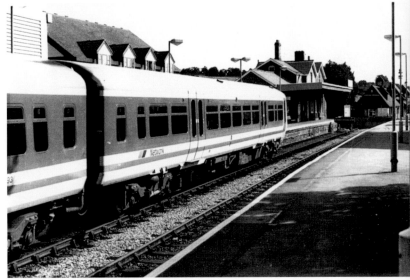

Bourne End, view Down. Network Southeast DMU No 165132 has arrived with the 09.33 Maidenhead to Marlow and will reverse. Since the previous photograph was taken, the station building has been extended. 2 August 1998. *Author*

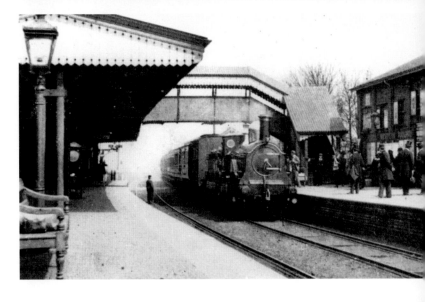

A 2-2-2 enters Bourne End with a High Wycombe to Maidenhead train *c.* 1900. The track is composed of bridge rails. Notice the advertisements covering the goods shed walls. *Author's collection*

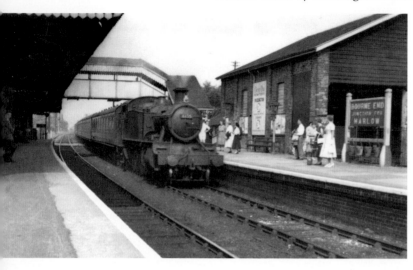

61XX class 2-6-2T
No. 6135 arrives at
Bourne End with a
High Wycombe to
Maidenhead train. The
goods shed stands behind
the passengers. Notice
the fire buckets hanging
below the station name
board. 16 July 1955.
E. Wilmshurst

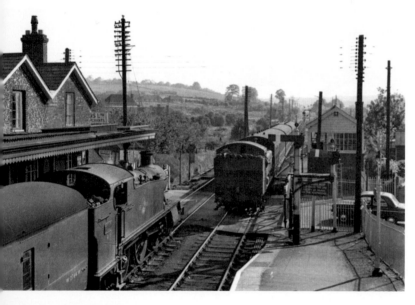

At Bourne End 61XX
class 2-6-2T No. 6113 on
a Maidenhead to High
Wycombe train crosses
a High Wycombe to
Maidenhead train headed
by 94XX class 0-6-0PT.
An engineman is about
to hand the staff to the
signalman. Notice that
the station building,
originally of flint, has
been extended in brick.
May 1957. *R. A. Lumber*

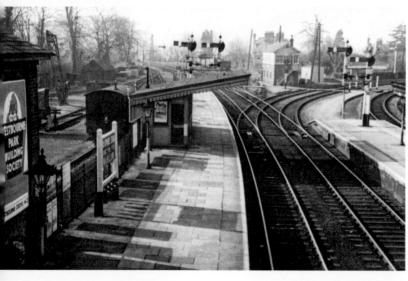

Bourne End view Up
c. 1935. The line to
Maidenhead curves left
and that to Marlow,
right. A crane stands
in the goods yard, left.
Author's collection

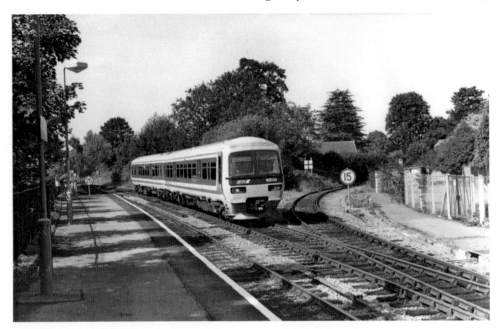

The junction at Bourne End as Class 165/1 165132 arrives with the 09.33 Maidenhead to Marlow. After calling at the platform, it will reverse to the Marlow branch, right, where the speed restriction round the tight check-railed curve to Marlow is 15 mph. A 25 mph restriction is in force across the Bourne End Viaduct. 2 August 1998. *Author*

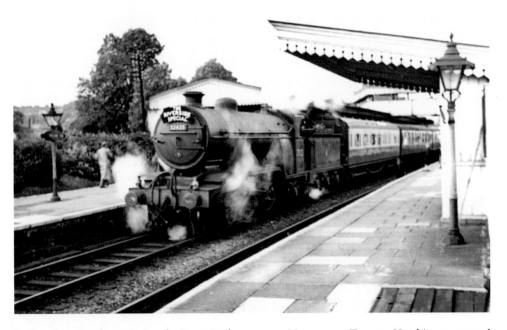

Ex-London, Brighton & South Coast Railway 4-4-2 No. 32425 *Trevose Head* is an unusual visitor as it arrives at Bourne End with 'The Riverside Special'. No. 32425 worked from East Croydon to High Wycombe. It then ran light to Slough shed for servicing before returning to Bourne End to pick up the nine-coach special. 29 July 1956. *J. H. Bamsey*

"The Riverside Special"

DIRECT EXCURSION
to
MAIDENHEAD, COOKHAM, BOURNE END,
& MARLOW (Bucks)

SUNDAY, 3rd AUGUST, 1958

For the beautiful Chiltern scenery overlooking the Thames Valley and superb river views from Maidenhead to Henley.

TRAIN TIMES AND FARES AS UNDER :

OUTWARD		RETURN FARE 2nd CLASS		RETURN SAME DAY		
New Cross Gate ..	9.34 a.m. dep.		Marlow	7.34 p.m. dep.		
Aldgate East	9.47 ,, ,,	} 8/6	Bourne End ..	7.41 ,, ,,		
Moorgate (Met.)	9.51 ,, ,,		Wooburn Green	7.45 ,, ,,		
King's Cross (Met.)	9.58 ,, ,,	} 7/9	Loudwater	7.50 ,, ,,		
Paddington (Suburban) ..	10.07 ,, arr.					
Paddington (Suburban) ..	10.13 ,, dep.	} 7/-	Greenford ..	8.45 p.m. arr.		
Ealing Broadway	10.26 ,, ,,		West Ealing	8.56 ,, ,,		
West Ealing	10.30 ,, ,,	} 6/-	Ealing Broadway ..	9.00 ,, ,,		
Greenford (See Note A)	9.58 ,, ,,		Paddington ..	9.12 ,, ,,		
			Paddington ..	9.17 ,, dep.		
Maidenhead	10.57 ,, arr.		King's Cross	9.26 ,, arr.		
Cookham	11.05 ,, ,,		Moorgate	9.33 ,, ,,		
Bourne End	11.09 ,, ,,		Aldgate East	9.37 ,, ,,		
Marlow	11.25 ,, ,,		New Cross Gate	9.50 ,, ,,		

Note A.—Change at West Ealing in outwards direction.

Children 3 and under 14 years, half fare.

Please note that the special train will NOT call at Cookham or Maidenhead on the return journey. Passengers who have spent the day there should proceed to Bourne End to join the return excursion.

CONDUCTED RAMBLES (optional) will be arranged with the usual catering facilities. It is hoped to include a river trip for some of the parties at extra fare.

This excursion is also suitable for NON-WALKERS. Boats may be hired at a number of points and suitable connections will be made with Salter Bros. vessels of which details will be distributed on the train so that passengers may enjoy some of the finest river scenery, including the famous CLIVEDEN REACH.

TICKETS may be obtained from Station booking offices at New Cross Gate, Aldgate East, Moorgate (Met.) and King's Cross (Met.). They will be available at Paddington (Suburban), Ealing Broadway, West Ealing and Greenford Stations, from the Organisers' Stewards from twenty minutes till five minutes prior to the advertised departure times. They may also be obtained IN ADVANCE from G. R. Lockie if remittance and addressed envelope are received by him not later than July 31st, 1958.

Organisers :
G. R. Lockie,
36 Harold Road, S.E.19 (LIV 3171).

R. Mulholland,
84 Stondon Park, S.E.23.

FUTURE PROGRAMME. On Sunday, September 28th, it is hoped to arrange a special excursion, entitled the "Essex Wealdman," from Clapham Junction (depart about 9.30 a.m.), to Epping, North Weald, Blake Hall and Ongar, calling intermediately at Streatham Hill, West Norwood, Crystal Palace, Forest Hill, New Cross Gate, Liverpool Street and Leyton. Further details may be obtained from the Organisers early in September.

PRINTED BY CROWN PRINTING WORKS, UPPER NORWOOD, S.E.19

Above right: The signal box having long since closed, Conductor Verma operates the ground frame at Bourne End. 2 August 1998. *Author*

Below: 61XX class 2-6-2T No. 6124 approaches Woodburn Green with a Maidenhead to High Wycombe train *c.* 1960. *Lens of Sutton*

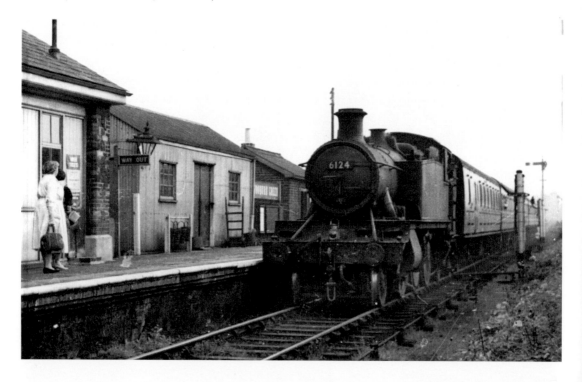

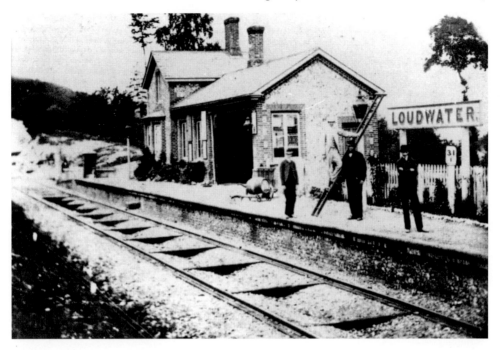

Loudwater, view towards High Wycombe *c.* 1870 soon after gauge conversion and before the goods loop was laid. Notice the 31¼ mile post. *Author's collection*

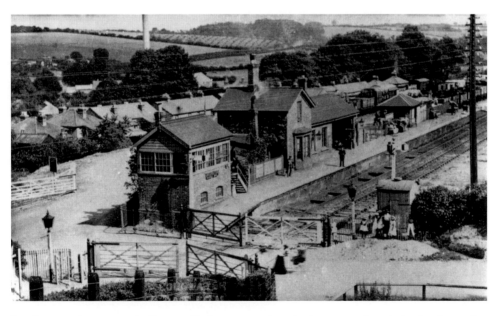

Loudwater, view towards Bourne End *c.* 1910. A train is expected and the level crossing gates are closing. The signal box name plate seems unusually large. An oil store is in the right background. *Author's collection*

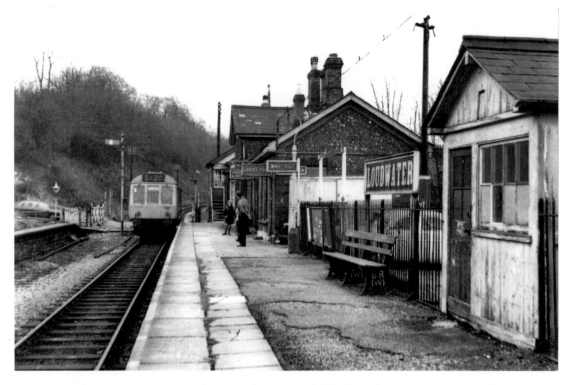

A single car DMU on a High Wycombe to Maidenhead working approaches Loudwater. 18 January 1969. *E. Wilmshurst*

Bourne End to Marlow

The Great Marlow Railway obtained an Act on 13 July 1868 to build a branch two-and-three-quarter miles in length from Bourne End on the Maidenhead to High Wycombe line. It was authorized to raise a capital of £18,000 in shares and £6,000 by loans. Worked by the GWR from its opening on 1 July 1873, it amalgamated with that company on 1 July 1897.

In 1898 the GWR proposed constructing a line linking Marlow with Henley and, although supported locally, the scheme was abandoned following fierce objections from a rowing club which disliked the idea of a railway ravaging the river's north bank. In January 1914 the Marlow branch used the single line electric train token and was the first Great Western line to employ this apparatus.

The branch shuttle-trains used the sharply curved outer face of the Down platform at Bourne End, and the line beyond curves acutely from that to Maidenhead. It then follows the north bank of the Thames, crossing the 50-yard long Marlow Viaduct before curving north-westwards to terminate at Marlow. The station here originally had two passenger platforms – a longer one with run-round loop, and a shorter bay. Until it was ruthlessly destroyed in 1967, passengers could enjoy using a splendid Italianate-style building. Today, the slightly resited platform opened on 10 July 1967 has just a simple shelter at ground level beyond the buffer stops. The station was originally named 'Great Marlow' until curtailed to Marlow on 14 February 1899. Until closure to freight on 18 July 1966 there were four goods sidings and a private line to a timber yard. Two ground frames replaced the signal-box closed from 26 September 1954.

Branch locomotives were stabled in the single track, brick-built, slated-roofed engine shed at Marlow which measured 22 ft by 50 ft. In 1947 the shed had an allocation of two engines: a '54XX' class 0-6-0PT and a '14XX' class 0-4-2T The water tank formed part of the shed roof, but by 1914 it was in poor condition and so was replaced by a 2,000 gallon tank set on sleepers. This replacement proved of inadequate size and about 1919 a 13,000 gallon tank was erected on iron columns. In 1921 the branch was worked by a 'Metro' class 2-4-0T hauling a train comprised of six-wheelers: one van, one third-class coach, two compos and one brake third. By the 1930s push-pull working with bogie stock had been introduced and in July 1962 the usual ex-GWR auto-trailer was changed to a BR brake third converted for auto-train use. Mixed trains were run and even in the 1960s it was not unusual to observe about a dozen trucks rattling behind the auto-trailer between Marlow and Bourne End.

The 0-4-2T and its auto-coach travelled 97 miles each morning and 115 miles in the afternoon. On Sunday afternoon the engine ran to Slough for a boiler washout and Marlow received a replacement engine. Overnight work at Marlow shed was carried out by a Slough fireman. He coaled the engine direct from a coal wagon and then shovelled coal from the wagon to the coal stage so that the fireman could top up the bunker during the day. The night fireman removed the locomotive's whistle, attached a flexible hose and for two to three hours steam pumped water to the storage tank. While this was happening, he cleaned the engine's fire and emptied the smokebox of ashes. Steam working of the 'Marlow Donkey' ended on Sunday 7 July 1962, but remained on goods trains until 31 December 1965. The branch had an overall limited of 40 mph and 'Red' engines were not to exceed 20 mph with a lower limit of 5 mph (10 mph for 0-4-2Ts), leaving Bourne End. 'Castle' class engines were permitted to haul 455 tons.

The branch hit the national press on 1 December 1961. A short while previously a '14XX' class 0-4-2T was propelling its auto-trailer working the 8.12 p.m. from Bourne End when it exploded three detonators at a level-crossing half a mile short of Marlow. The crew correctly stopped the train and were amazed to see three cowboys armed with six-shooters. On observing this apparent act of pillage, the solitary passenger, having leaned out of the window to see what was amiss, took cover under a seat. The men then explained that the guns were merely toys and that the hold-up was a stunt to celebrate the change of name from the 'Railway Hotel' to the 'Marlow Donkey'.

As they had set a bad example to young people, the British Transport Commission prosecuted. All the defendants pleaded guilty to entering a carriage 'otherwise than on the side of a platform' contrary to railway by-laws; unlawfully and wilfully stopping 'a vehicle on the railway' and wilfully obstructing the driver in the execution of his duty. They were fined ten shillings on each of the three charges and ordered to share the costs of £7 13s od. At the end of the court proceedings they returned to the 'Marlow Donkey' for a celebration drink.

In 1887 the train service on the branch offered nine Down and seven Up trains daily and five Down and three Up on Sundays. By 1902 this had improved to fourteen Down and fifteen Up and a through coach leaving Marlow at 8.50 a.m. and arriving Paddington at 9.55 a.m. Eight trains ran each way on Sundays. By 1938 the timetable had improved even further to twenty-one trains each way and fourteen on Sundays. The 2010 timetable was just as good, showing twenty-three trains each way and thirteen on Sundays.

The Marlow branch auto train leaves Bourne End. The 5 mph speed restriction sign has a cast iron plate below reading: '10 mph is permitted to engines of the 48XX class'. In fact the '48XX' class had been renumbered 14XX in 1946. Mile post 0¼ is on the far left. 16 July 1955. *E. Wilmshurst*

14XX class 0-4-2T No. 1474 near Marlow, propelling a train from Bourne End. No. 1474 was the final engine of its class to be built. 5 June 1960. *J. H. Bamsey*

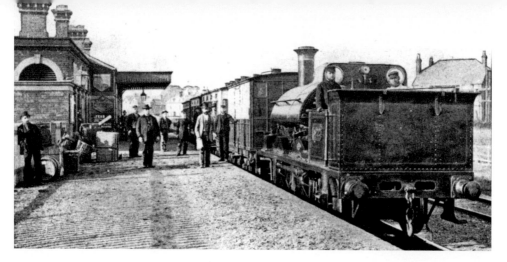

Open cab 517 class 0-4-2ST No. 522 with four coaches at Marlow *c.* 1882. No. 522 carries no headlights and is without vacuum brake. The footplate crew would have an unpleasant time in wet or frosty weather. The low sun casts fence shadows across the platform. *Author's collection*

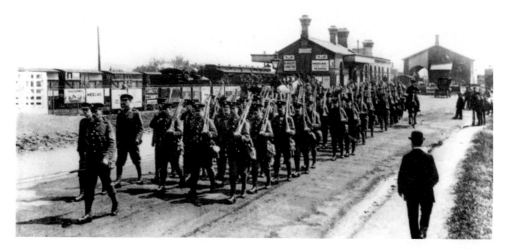

The 3rd Battalion Grenadier Guards marching from Marlow station to Bovington Green Camp. Notice the whitewashed cattle pen on the far left and cattle wagons beyond. 4 June 1915. *Lens of Sutton*

A train of five four-wheeled coaches at Marlow *c.* 1910. Cattle pens are on the extreme right and cattle wagons on the left standing in front of a spare coach. A quantity of milk churns stands on the platform. An oil store and 2¾ mile post are in the foreground. The end of the station building is plenteously endowed with advertisements. *Author's collection*

Since the previous photograph was taken, a structure has been added to the end of the station building. On the far left is a gas tank wagon for recharging coach lighting. The engine shed and water tower are beyond. This photograph *c.* 1935. *Author's collection*

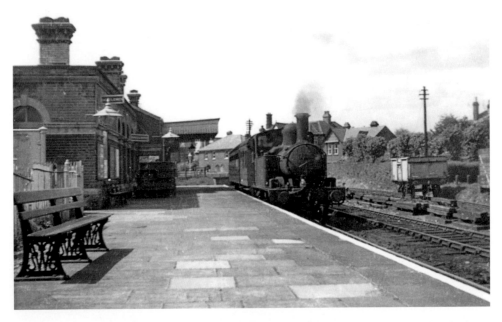

Marlow, view towards the stop blocks. The auto train for Bourne End stands at the platform. A GWR seat is on the spacious platform. 7 May 1964. *Lens of Sutton*

Denham to Ludgershall & Brill

The present line between Denham and Ludgershall & Brill was once part of one of the last main lines to be opened in this country. It was built to shorten the GWR's route from Paddington to Birmingham, which at the turn of the century was via Reading, Didcot and Oxford. Apart from the need for a shorter route to rival LNWR competition to and from Birmingham, American liner traffic using Birkenhead had developed and a more direct route to London was essential for this. The new line was a definite improvement: it was 19 miles shorter than via Oxford and 2 miles less than the LNWR's route into Euston.

The Great Central Railway also needed a new route to London, as that which it shared with the Metropolitan Railway was far from ideal. Gradients were fairly steep and the necessity of having to share tracks with the Metropolitan stopping trains impeded fast through traffic, while in addition, John Bell, the Metropolitan's general manager, introduced irritating obstruction and expense for the GCR. Sharing the GWR's new line was thought to be a much better alternative, with easier gradients and quadruple track at most stations enabling fast traffic to overtake stopping trains. So although it was 5 miles longer than the Metropolitan route, there was less chance of delays. South of Quainton Road GCR trains were restricted to 45 mph on the Metropolitan, but were allowed to reach 70 mph over the GW & GC Joint line.

The Buckinghamshire section of the railway comprised a new line between Denham and High Wycombe; doubling the existing High Wycombe to Princes Risborough branch and, rather later, building a direct railway between Princes Risborough and a junction with the Oxford to Birmingham line at Aynho. The section from Old Oak Common Junction to High Wycombe Junction was built by the Acton & Wycombe Railway under the GWR (Additional Powers) Act of 6 August 1897. From the date of the GW & GC Joint Railways Act of 1 August 1899, the portion of this line from Northolt Junction to High Wycombe Junction became GW & GC Joint Committee property as did the existing High Wycombe to Princes Risborough section which was sold to the Joint Committee for £225,000 before the second track was added. The Joint Committee Act also authorized 15 miles of line from Princes Risborough to the GCR at Grendon Underwood Junction, north of the GCR's Quainton Road station. Before the line was completed the GWR and GCR decided to make Ashendon, rather than Grendon Underwood, the end of the Joint Committee metals, so the 5¾ miles of line was transferred entirely to the GCR and confirmed in that company's Act of 1907. The Joint Committee comprised an equal number of GWR and GCR directors.

The Northolt to High Wycombe contract was let at £580,000 to Messrs R. W. Pauling & Co., Westminster. Its plant consisted of:

34	locomotives (5 of these were ex-LBSCR 'Terrier' 0-6-0Ts Nos 36; 39; 49; 52; 57)
12	steam navvies
765	tip wagons
120	permanent way trucks
9	mortar mills
14	portable engines
4	steam cranes.

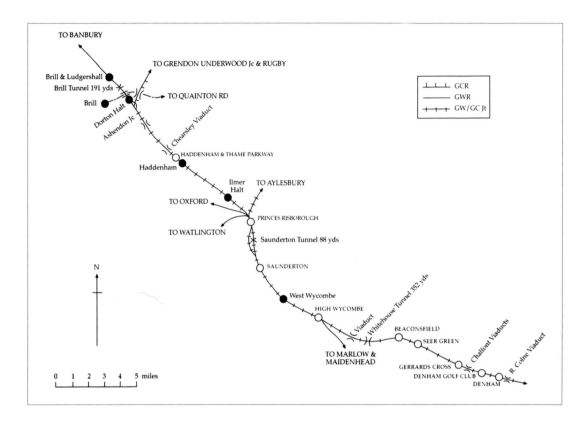

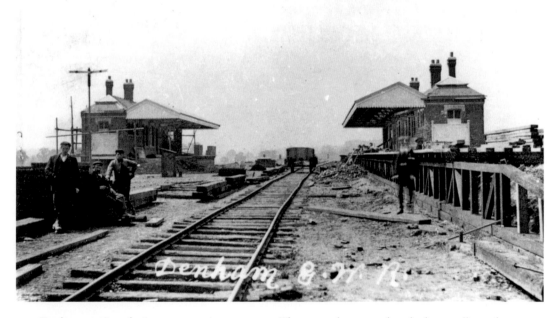

Denham station during construction, *c.* 1905. The space between the platforms allows four tracks. Notice the contractor's impermanent way. The platform on the right is of timber. *Author's collection*

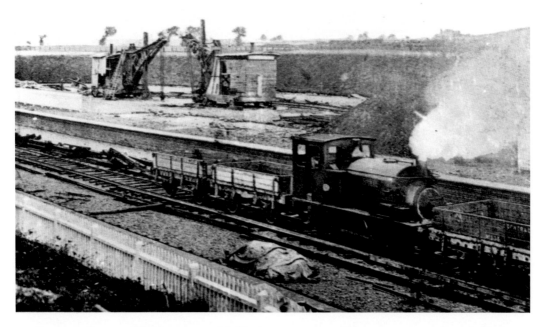

Contractor's 0-6-0ST *Norman* at Haddenham, *c.* 1905. The wagon at each end of the locomotive is dumb-buffered. 'L&P Nott' is inscribed on his wagons. Notice the two steam cranes on low-slung chassis. *Author's collection*

About 1,500 men were employed on the contract and work began early in 1901. The GWR resident engineer was R. C. Sikes who made his headquarters at Gerrards Cross, as did the contractor. In addition to the latter's offices, there were workshops, saw mills and store sheds. The engine shed held twenty-two locomotives. One of Messrs Pauling's engines became derailed at Denham, killing its driver, Richard Pilkington. On 6 September 1902 a fall in White House Farm Tunnel killed six men, and a memorial was subsequently erected in High Wycombe cemetery. The minimum radius of curves between Denham and High Wycombe was one mile, and half mile radius at junctions.

The High Wycombe to Princes Risborough contract at £116,797 was won by Mackay & Davies of Cardiff, work starting in June 1902. The Haddenham to Grendon Underwood Junction section linking with the GCR was built by Messrs Nott & Sons for £170,276, work for this also beginning in June 1902. The resident engineer was G.H. Mackillop of the GWR. Subsequently it was decided to build stations at Wotton and Akeman Street and in the latter half of 1904 these were constructed by Webster & Cannon for £1,514.

Doubling the single line from High Wycombe to Princes Risborough entailed building a new viaduct through the centre of High Wycombe alongside the old single line viaduct; making a new goods yard at High Wycombe and completely rebuilding Princes Risborough station. The other major work was constructing a new and independent Up line about two miles in length between Saunderton and Princes Risborough in order to ease the gradient to 1 in 167 and thus greatly assist loaded coal trains. The original line, which became the Down road, had a ruling gradient of 1 in 88. West Wycombe station was rebuilt to allow quadruple tracks, but the centre roads were never laid. The double tracked Saunderton station was left largely unaltered.

Although this Joint Committee line provided a route to Oxford eight miles shorter than via Didcot, it was of no use for expresses due to the single track, curvaceous line beyond Princes Risborough. The answer was the Aynho & Ashendon Railway, authorized under

the GWR (New Railways) Act of 11 July 1905. Designed for fast running, it was laid out by Walter Armstrong, the GWR's new works engineer. It had a ruling gradient of 1 in 193 and gentle curves not less than two miles' radius, except at junctions where the minimum curve was a half mile radius. To avoid conflicting movements at Ashendon Junction, GWR Up trains were carried over the GCR. The approach to this flyover was at 1 in 150 – the steepest on the line. Straight stretches of track were a feature, there being five miles between Princes Risborough and Haddenham and almost three miles between Ashendon Junction and Brill & Ludgershall.

The line from Northolt Junction to Grendon Underwood Junction opened to goods traffic on 20 November 1905, the timetable for the following month showing five trains daily. Having allowed earthworks time to settle, it was opened to passenger trains on 2 April 1906. To celebrate the opening, instead of the railway entertaining local people as was often the case, matters were reversed and the High Wycombe & District Chamber of Commerce gave a public luncheon in the Town Hall to the directors and leading officers of the GWR and GCR. Two special trains from Paddington and Marylebone carried them to High Wycombe and, after the meal, ran to the extremity of the line before returning to London. To allow the embankments more time to settle, no fast expresses used the line for three months, but from 2 July 1906 the GCR diverted three Marylebone to Manchester and one Marylebone to Bradford express in each direction, while additionally four Down and five Up local GCR trains called at Princes Risborough. Most local trains on the High Wycombe line were worked with Paddington and Marylebone portions coupled or uncoupled at Northolt Junction, and return or season tickets could be used to either London terminus. Opening the GW & GC Joint line immediately doubled the number of passengers using Marylebone station. In addition to advertising the new line by poster and press, the GCR issued circular-shaped pocket timetables of the suburban services.

Messrs Scott & Middleton did not start work on the line to Aynho until the Joint Committee's line had been fully opened on 2 April 1906. Almost three million cubic yards of clay and rock needed to be excavated and deposited to form embankments, while fifty bridges were required. Stations were built in brick to the GWR standard pattern. As goods trains of eighty wagons plus engine and brake van demanded a passing loop with points further from a signal-box than could be worked manually by rodding, to avoid the expense

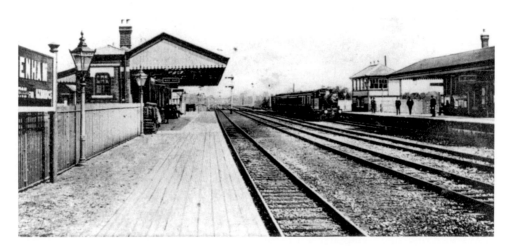

A Down four-coach stopping train arrives at 'Denham for Uxbridge' *c.* 1906. The engine is probably a 36XX class 2-4-2T. *Author's collection*

of building and staffing an additional signal-box, the problem was solved at Haddenham by providing a siding at the ends of each loop. A long train could then run through the platform loop into the facing siding to clear the brake van from the main line. It would then set back into the trailing siding until the engine was clear of the points leading back to the main line ready to resume its journey when the train behind had overtaken it.

The line between Ashendon Junction and Aynho Junction was opened to goods on 4 April 1910 and to passengers on 1 July that same year. The route could not compete with the Euston to Birmingham line electrified in 1966 and really ceased to be a main line when expresses were withdrawn from the route in 1968, and Princes Risborough to Aynho Junction was singled on 4 November 1968.

About fourteen-and-a-half miles from Paddington the line crosses the five-arch 121-yd long River Colne Viaduct of concrete faced with brick and enters Buckinghamshire, Denham being the first station in the county. The station buildings, like most others on the line, are in red brick. As it is sited on an embankment, the buildings are carried on cast-iron girders supported on concrete and brick piers resting on the original ground level. Due to the station being on this embankment the pedestrian subway was actually above ground level, approximately midway between the track and the natural ground level, the subway being situated in the arch of an underline bridge. The platforms were extended in 1960 and in December 1965 the layout was modified to remove the centre roads and bring the main Up and Down lines to the platform faces. The goods yard closed on 6 January 1964 and had a lock-up rather than a goods shed. As from 1 January 1917 the rail shuttle-service between Denham and Uxbridge High Street was withdrawn and instead a Milnes-Daimler bus connected the stations. The branch re-opened on 1 May 1919, a move much welcomed by passengers as the bus frequently broke down and made the service unreliable. The rail service was withdrawn again on 25 September 1939.

North of Denham station the line climbs at 1 in 175 to Denham Golf Club Platform, opened on 22 July 1912. Still set today in a rural location, unlike other stations on the line it has no car park. One of the increasingly rare corrugated-iron pagodas is on each platform. The 1938 wage bill was £271, with receipts of £1,433. The small pagoda booking-hut was on the Down side. About three-quarters-of-a-mile beyond, the line crosses the 114-yd long River Misbourne Viaduct (or Chalfont No. 1 Viaduct), comprising

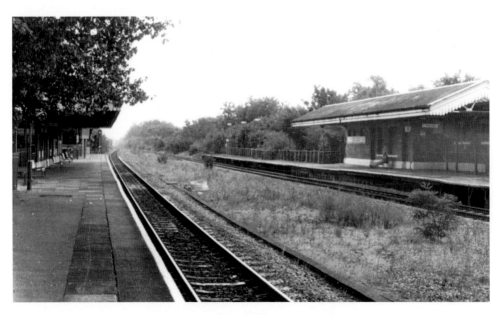

Denham from approximately the same position as the previous view. Colour light signals have replaced the semaphores. 30 August 1998. *Author*

Denham Golf Club station view Down. The GWR corrugated iron pagodas must be two of the very few still extant at the date. 30 August 1998. *Author*

Class 165/0 165018 at Denham Golf Club station, working the 09.15 Marylebone to Aylesbury. 30 August 1998. *Author*

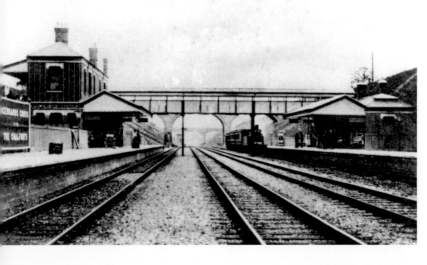

A Great Central Railway three-coach Down stopping train enters 'Gerrards Cross for the Chilterns' c. 1907. *Author's collection*

five arches 60-ft high and 51-ft span. It is followed by the 165-yd Chalfonts Viaduct (or Chalfont No. 2 Viaduct), with five 77-ft spans.

Gerrards Cross station is set in a cutting almost one-and-a-half miles in length and which entailed the removal of 1,300,000 cubic yards of spoil. As it was impracticable to provide road access at ground level, the station building is of two storeys, the booking office being on the Up side, level with the road. The footbridge is so lengthy that intermediate supporting pillars are provided. In October 1989 the Up line was slewed towards the Down, allowing the Up platform to be widened and thus allowing more car-parking space. The railway was placed in a tunnel to create land for building a Tesco store. Unfortunately the tunnel collapsed in 2005 causing line closure from 30 June until 20 August. In the station garden on the Up side stands a modern statue of a navvy. The goods yard closed on 6 January 1964. Beyond the station the line rises at 1 in 254.

Seer Green, still in a country location, opened on 2 April 1906 as the private Beaconsfield Golf Platform, a gate opening directly on to golf-course property. On 1 January 1915 the station opened to the public as Beaconsfield Golf Links Halt. Subsequent name changes were: Seer Green, 16 December 1918; Seer Green & Jordans, 25 September 1950 and Seer Green, 6 May 1974. The summit of the line is just beyond the platforms and the track then falls towards High Wycombe.

Beaconsfield had a goods shed rather than lock-up but otherwise was similar to Denham. It, too, had its passenger platforms extended in 1960 and the through non-platform lines were removed in December 1973. One of the first GWR bus services ran from Slough station to the White Hart, Beaconsfield, via Farnham Common. The service commenced on 1 March 1904 and on 31 March that year some journeys ran via Stoke Poges. The route was eventually transferred to the London General Country Services Ltd on 10 April 1932. Beaconsfield goods yard closed 10 August 1964.

A further two-and-a-quarter miles north of the station is the 352-yd long White House Farm Tunnel; brick-lined, the arch varies from 18 to 27 inches thickness. The chalk cutting beyond was formed by driving a heading as for tunnelling and then loading the chalk through shoot holes into wagons. Sir Philip Roses Viaduct, 66 yards in length and of concrete faced with blue bricks, is a mile beyond. Three 40-ft spans carry the railway over the valley through which his carriage drive ran.

High Wycombe station has already been described on page 8. To the north the line crosses the Hughendon Road Viaduct, 77 yards in length comprising four 46-ft spans, with the goods depot beyond, which opened 17 October 1904. This goods and mileage yard was capable of holding almost 200 wagons of timber and coal required for furniture manufacture. As furniture is easily damaged, from the beginning of the twentieth century the finished product tended to be distributed by road. Opposite the goods yard, private sidings served Broom & Wade Ltd's works and Wycombe Corporation.

The line rises at 1 in 179 to West Wycombe station which originally had just a single passenger platform on the south side of the line, but an Up platform was added when the line was doubled 22 October 1905 and the offices on the Down side rebuilt. The station closed to passengers on 3 November 1958 and to goods 4 January 1963. The LNER maintained the line from mile-post 17¼ (just south of West Wycombe station) to Ashendon Junction, and so GWR-style stations were painted in LNER livery. Some signal-boxes had their cast nameplates replaced with end nameboards in accordance with LNER practice.

Beyond West Wycombe the line rises at 1 in 164 to Saunderton. From its opening on 1 July 1901, which was in single line days, a passing loop was provided so that when the line was doubled the station did not require alteration. It was considered unnecessary to make it a four-road station. The station buildings were destroyed by fire on 10 March 1913 and evidence suggested that the arsonists were suffragettes. Today there is a small GWR brick building out of use, on the Up platform, and a waiting shelter on the Down side. It closed to goods 1 March 1965.

A mile north of Saunderton the Up and Down lines separate. When doubled, it was decided to make a new Up line to ease the climb to Saunderton, though the deep cuttings

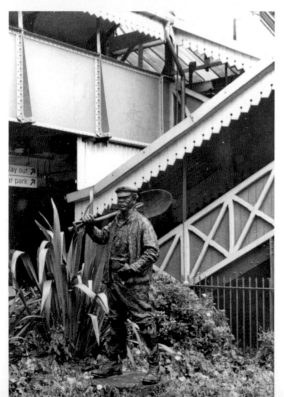

Top: Gerrards Cross, view Down. The removal of two tracks has enabled a large station garden to be laid. 30 August 1998. *Author*

Middle: Class 165/0 165036 arrives at Gerrards Cross with the 09.45 Marylebone to Birmingham Snow Hill. 30 August 1998. *Author*

Left: Statue of a navvy in the garden on the Up platform, Gerrards Cross 30 August 1998. *Author*

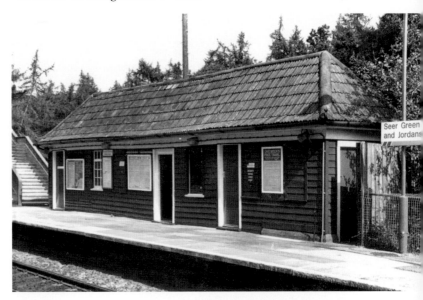

The sagging timber building on the Up platform at Seer Green & Jordans. 30 August 1998. *Author*

A Down stopping train calls at Beaconsfield *c.* 1907. The 36XX class 2-4-2T No. 11 built in 1907, has burnished buffers. No. 11 was re-numbered 2600 in December 1912. *Author's collection*

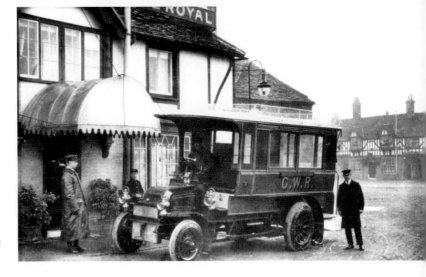

GWR bus No. 5, Cornwall registration AF 64, outside the Royal Inn, Beaconsfield, working the service to Slough, April 1904. It is painted in a non-standard livery. *Author's collection*

GCR 9K class 4-4-2T No. 359 built in April 1905, at High Wycombe, 2 April 1906. *Author's collection*

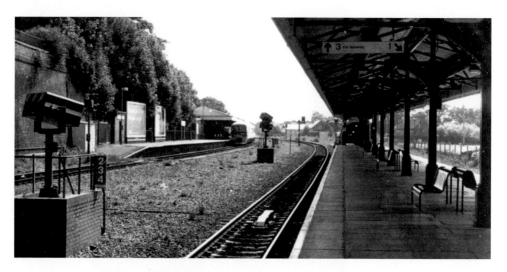

The staggered platforms at High Wycombe: right the Down, left the Up; CCTV cameras left and centre. The '2, 3, 4' signs on the left indicate the correct stopping point for a train with that number of cars. 30 August 1998. *Author*

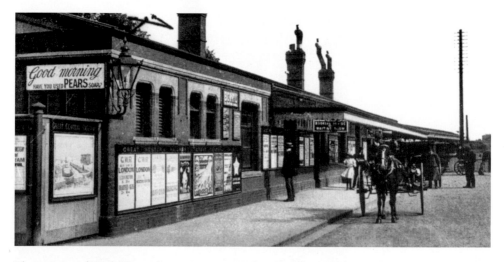

The exterior of High Wycombe station *c.* 1910. Posters advertise the GWR's new route London to Leamington and Stratford-on-Avon. *Author's collection*

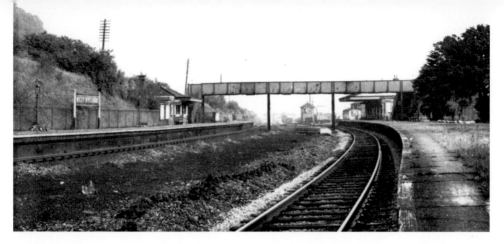

West Wycombe view Up *c.* 1960. The station was laid out for centre tracks which were never laid. *Lens of Sutton*

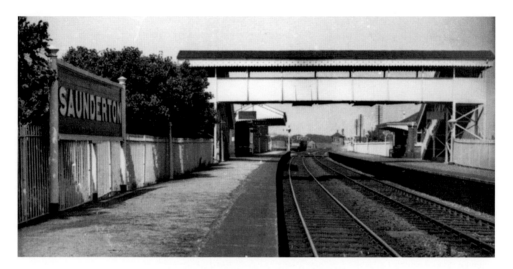

Saunderton view Down, *c.* 1960. *Lens of Sutton*

The north portal of the 88-yards-long Saunderton Tunnel on the Up line. 30 August 1998. *Author*

required had the disadvantage of being prone to blockage by snow or landslips, in fact a slip in 1947 cost the Joint Committee £13,000. The Up line passes through the 88-yd long Saunderton Tunnel. The Up and Down lines become parallel again just prior to reaching Princes Risborough.

In its early days Princes Risborough station had a main island platform, the west side used by trains to and from Watlington and the east face by those to and from Oxford and Aylesbury. The latter line was also served by an island platform to the east which had a bay for Aylesbury trains. Both platforms were short and narrow. The main building was constructed of brick, unlike the nearby Station Hotel which was of timber. Following the doubling of the line to High Wycombe on 22 October 1905, the station was completely rebuilt 100 yds south of the original and opened in March 1906. Two through platform roads were provided with two through roads between. At the west end of the Up platform was the Aylesbury bay and at the west end of the Down, the Watlington bay. Unusually, the platform awning was carried over the flat roofed office block. On 23 September 1968 the Down platform was taken out of use, all stopping passenger trains using the former Up platform. On 6 March 1991 the Up through non-platform road was removed, but on 1 March 1999 the Down platform was brought back into use. Although most signals were of the GWR pattern, some LNER upper quadrants could be seen. Until 1907 the water supply was pumped by the branch engine, but that year, with main-line status, the Joint Committee spent £3,100 sinking a 100-ft deep well, erecting a pump house and installing a steam pump, 23,500 gallon water tank and connecting pipework. In 1928 electric pumps replaced those of the steam variety. Apart from general goods traffic, the station dealt with furniture, finished items leaving by rail and timber and springs arriving. Today, engineer's sidings are south of the station.

North of Princes Risborough the line falls at 1 in 200, steepening to 1 in 176 to reach the 70-ft long Ilmer Halt with short, shelterless timber platforms opened 1 April 1929 and closed 7 January 1963. Haddenham station opened 2 April 1906 and had a quadruple track; in the 1920s a private siding served clay wharves. The station closed to passengers 7 January 1963, and on 18 April 1966 both platform loops were taken out of use. Goods closure was on 2 January 1963. On 3 October 1987 Haddenham & Thame Parkway station opened about one quarter-of-a-mile mile north of the site of the old station. The track was doubled 6 July 1998 and a new Up platform built with a footbridge to give access; at the same time the car park was also extended.

Chearsley Viaduct, five brick arches each of 40-ft span, carries the line over the River Thames. As far as Ashendon junction all overbridges and most underbridges were built to accommodate quadruple track. Ashendon Junction signal-box caught fire in July 1938. The Down line to Grendon Underwood Junction was taken out of use on 18 November 1965 following a derailment at the junction and henceforth trains in both directions used the former Up line. The last train ran on 4 September 1966 and the spur was taken out of use the following day, being officially closed 21 July 1967. When the Aynho line was singled in November 1968 the Up line, with its climb over the former GCR line, was taken out of use and all trains used what had been the Down track. The GWR and Down lines converged from the flyover at Ashendon North signal-box which from its opening on 4 April 1910, controlled two loops with reversing sidings. These loops were removed in 1917 and the box closed in 1924.

The 70-ft long Dorton Halt was opened on 21 June 1937 at a cost of £374 and each platform had a timber waiting shelter. It closed on 7 January 1963. The line rises at 1 in 200 and just south of Brill Tunnel, 191 yards in length, a steel bridge carried the Metropolitan Railway's Brill branch over the GWR just by the former's Wood Siding station. At the tunnel's south portal, the gradient descends at 1 in 200. Brill & Ludgershall station was another example of the four-road design. Unstaffed as early as 2 April 1956, it closed to passengers on 1 July 1963 and to goods 7 September 1964. Beyond, the line passes into Oxfordshire.

In its days as a main line, all GWR Standard classes could be seen. The GCR used '11B' class 4-4-0s, and Atlantics of the '8B' and '8D' classes. The four, or five-coach local trains

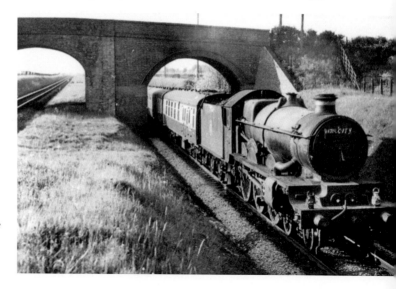

4-6-0 No. 5008 *Raglan Castle* bearing a chalked headboard, works the Up Inter City. 21 May 1956. *C. R. L. Coles*

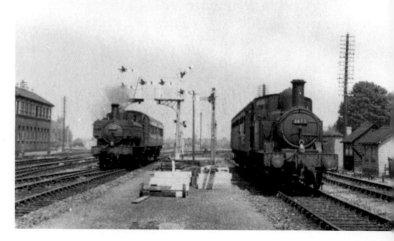

Auto trains arriving simultaneously at Princes Risborough, 23 July 1955: 54XX class 0-6-0PT No. 5409 from Banbury and 14XX class 0-4-2T from Aylesbury. *H. C. Casserley*

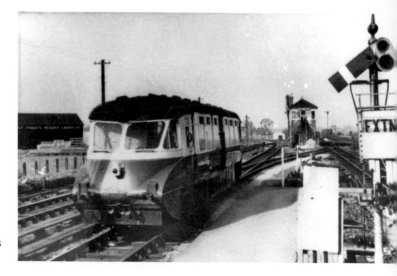

A GWR diesel railcar leaves the Princes Risborough Down bay platform for Banbury, June 1957. The name board on the end of the signal box is in LNER style. *P. Q. Treloar*

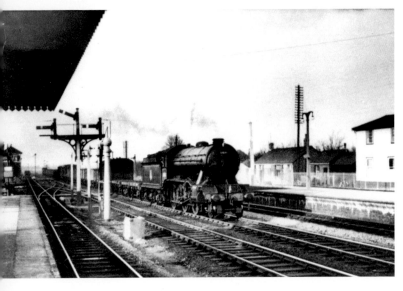

K3 class 2-6-0 No. 61841 passes Princes Risborough with an Up freight, June 1957. Notice the mix of ex-LNER upper quadrant signals and ex-GWR lower quadrant signals.
P. Q. Treloar

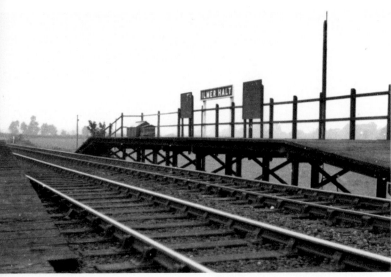

The simple Ilmer Halt for railmotors, *c.* 1960. No shelter is provided. *Lens of Sutton*

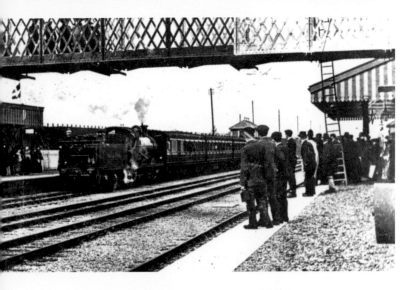

A GCR 0-6-0 at Haddenham carrying express headlights *c.* 1906. It is probably working the first train. Flags are in evidence, right. A ladder rests against the footbridge, the centre half of which is painted black. *Author's collection*

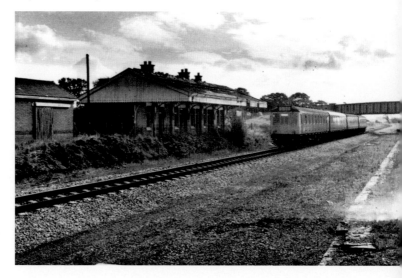

The 09.52 Marylebone to Banbury passes Haddenham station which was closed 18 April 1966. September 1973. *R. A. Lumber*

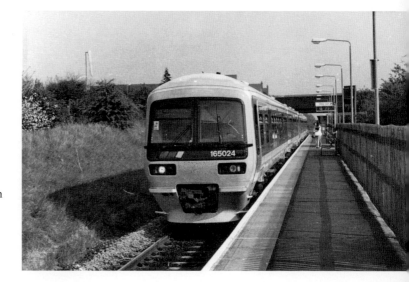

Class 165/0 165024 working the 15.40 Marylebone to Birmingham Snow Hill, at the single track Haddenham station which opened 3 October 1987, ⅓ mile north of the old. 6 May 1995. *Author*

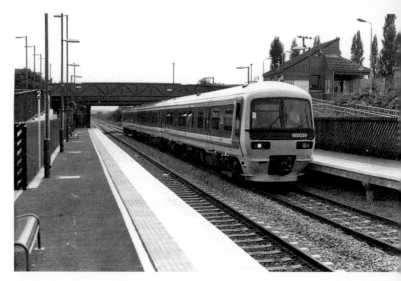

Class 165/0 165039 working the 12.45 Marylebone to Birmingham Snow Hill, seen here at the double track Haddenham & Thame Parkway station. 30 August 1998. *Author*

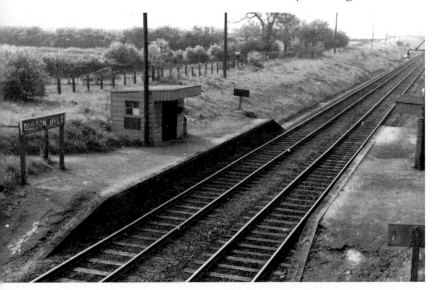

Dorton Halt view Down *c.* 1960. The platform ramps are in poor condition. *Lens of Sutton*

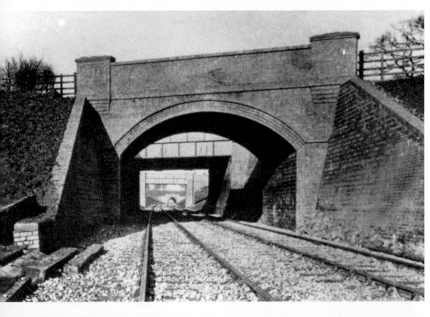

View north to the 191-yards-long Brill Tunnel, *c.* 1910: the first bridge carries the Wotton Underwood to Brill Road; the second the Brill branch with Wood Siding station above; while the third is an accommodation bridge. *Author's collection*

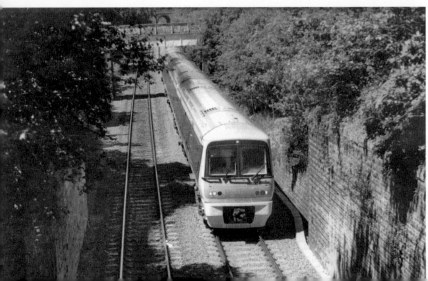

Class 168 four-car 'Chiltern Clubman' No. 168004 working the 12.30 Birmingham Snow Hill to Marylebone, passes the abutments of the bridge which carried the Brill Tramway across the line at Wood Siding. 25 June 1999. *Author*

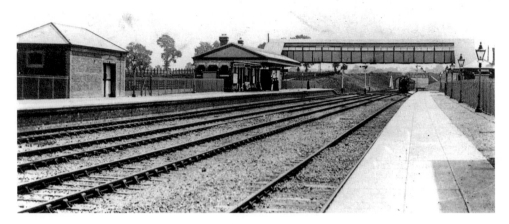

A Down stopping train enters the platform road at Brill & Ludgershall, *c.* 1908. *Author's collection*

were headed by 4-4-2Ts of the '9K' class and later by Class '9L'. Goods trains were mostly worked by '9H' and '9J' class 0-6-0s. Later, these engines were superseded by larger and more modern locomotives. At High Wycombe the GWR provided a pilot engine for five years, the GCR supplying one for the next five. In 1952 the line between Marylebone and Princes Risborough was used during off-peak periods for trials of a three-car light-weight diesel train built by ACV Sales Ltd. It consisted of two power cars and an intermediate trailer, giving a total seating capacity of 129. All the vehicles measured 40 ft 3 in overall and were carried on four wheels. Its rectangular design led to the sobriquet 'flying brick'. The unladen weight of the set was 39 tons 14 cwt. The unit was designed to be split, the motor cars capable of being operated singly, or in pairs, and with, or without, a trailer, the latter having a driving compartment. Power was provided by an AEC six-cylinder diesel engine identical with those used on London Transport Green Line buses and developing 125 bhp at a maximum of 1800 rpm. Top speed was only 45 mph. The design was not sufficiently successful to be purchased by BR but five railbuses of a similar, but much improved, design were bought in 1958. In more recent times passenger traffic has been handled by Class 165/0 Network Turbos.

For much of its life as a main line, in addition to expresses, four Down and five Up stopping trains were run on weekdays only. When DMUs were introduced in 1962, services were offered to both Paddington and Marylebone. Today only one runs to Paddington. Until 1939 a train of GWR close-coupled compartment coaches ran through from High Wycombe to Liverpool Street, being hauled onwards from Paddington by Metropolitan Railway electric locomotives.

Today Chiltern Railways offers ninety-five Down trains to High Wycombe including two trains an hour from Marylebone to Birmingham, Snow Hill. Two trains a day run through to Kidderminster. In an effort to ease road congestion, in 1999 Chiltern Railways offered free local bus travel with certain bus operators in High Wycombe to holders of monthly and longer season tickets, and free car-parking at High Wycombe when three or more customers arrived in the same car.

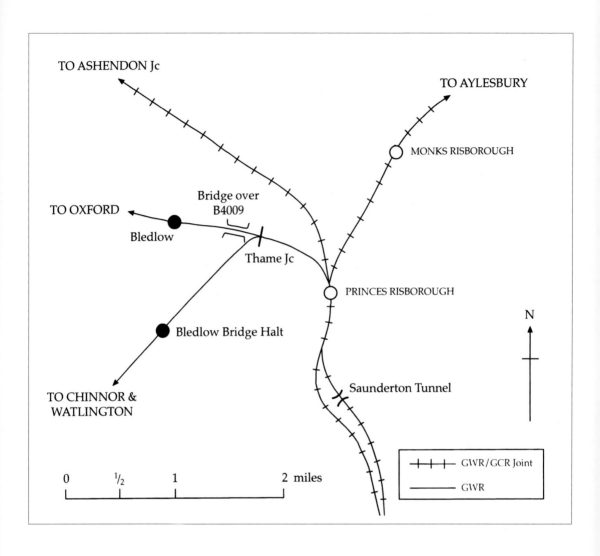

Princes Risborough to Bledlow Bridge Halt

Although the Wallingford & Watlington Railway Act was passed on 27 July 1864, only the section from Cholsey & Moulsford to Wallingford was actually constructed. The Watlington & Princes Risborough Railway Act of 26 July 1869 was promoted largely by the Earl of Macclesfield of Shirburn Castle, near Watlington. The Act authorized a capital of £36,000 and borrowing powers of £12,000. To minimize earthworks the line followed the lie of the land and so had a switchback nature; a further economy was using chalk ballast. The company's first manager was J. G. Rowe, also secretary of the Aylesbury & Buckingham Railway.

The line opened on 15 August 1872 but owing to a dispute with the GWR, at Princes Risborough through passengers had to alight at a small wooden platform and walk to the GWR station, though a through connection was provided for the interchange of goods traffic. Single fares were: first class 2s 3d, second class 1s 6d, third class 1s 1d and Parliamentary class 9d; they altered little through the years. Traffic was light and as receipts rarely exceeded working costs, the directors kept services running at their own expense. At first locomotives were hired from the GWR but in 1875 a special undertaking, the Watlington Rolling Stock Company, was formed to supply the line with locomotives and coaches. By October 1876 the W&PRR owed the GWR £2,000, and that same year an agreement was signed which allowed the W&PRR to use the junction and GWR station at Princes Risborough for five years ending 31 December 1881, for £250 annually.

Finances improved in 1877 and the company was able to pay 3 per cent interest on the cash advanced by the directors. That year the GWR refused to work the line, claiming that its light construction would require special locomotives, so those of the Watlington Rolling Stock Company continued in use. The line was not run too efficiently. On 2 January 1878 the engine of the 6.30 p.m. train to Watlington left Princes Risborough, but on arrival at Chinnor they found the train missing. Reversing, they met the guard who explained that the coaches had not been coupled!

A special meeting was held on 16 June 1883 to consider the GWR's offer of £23,000 for a line that had cost £46,522. At a further meeting held the following month, these terms were accepted, the company being vested in the GWR as from 1 July 1883 by the GWR Act of 29 August 1883. The value of the rolling stock from the Watlington Rolling Stock Company was estimated to be £1,714.

Thomas Taylor, chairman of the W&PRR and rather an odd character, failed to transfer plans and sections of the line to Paddington, and attempts to obtain them were met with evasive replies. No proper conveyances of land had been drawn up when the company was first constituted. The GWR witheld payment of minor sums until the documents and plans were produced. One day, Taylor arrived at Watlington station with workmen to remove various stores and scrap metal, which he claimed were his. Resolving the problem proved to be the subject of considerable correspondence between Taylor and Sir Daniel Gooch chairman of the GWR.

On 18 August 1883 the GWR directors authorized the expenditure of £3,750 to improve the branch. One rectification was to the fencing, though this failed to satisfy the wishes of a farmer at Lewknor who desired the company to build a fence sufficiently high to prevent his turkeys from flying over it.

On 1 May 1890 the GWR obtained Board of Trade sanction to cancel the undertaking given by the W&PRR to work the line on the staff and ticket system – the GWR thus avoided

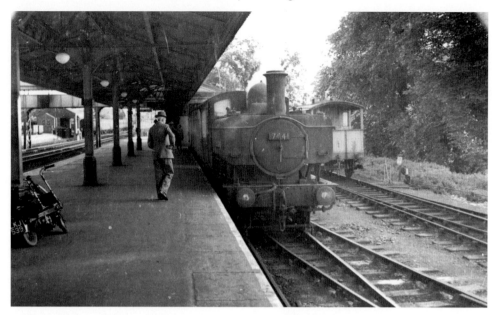

74XX class 0-6-0PT No. 7441 (81B Slough) stands in the Watlington bay platform at Princes Risborough, 1957. *Lens of Sutton*

the expense of installing the block telegraph. On 1 September 1906 steam railmotors were introduced and rail level halts opened at Bledlow Bridge and two on the Oxfordshire section of the branch. When the railmotors ceased, an auto-coach was used because it, like the railmotors, had retractable steps to enable passengers to entrain at low-level platforms. It also enabled the guard to issue tickets to passengers boarding at such halts.

The branch closed to passengers on 1 July 1957, the last train running on 29 June. Chinnor to Watlington closed to freight on 2 January 1961, the final train running on 30 December 1960 and hauled by London Midland Region Class 2 2-6-2T No. 41272. Following the closure of Chinnor to general goods traffic on 10 October 1966, the branch was operated as a 'long siding', the guard obtaining from the Princes Risborough signalman the key to unlock the ground frames at Chinnor. The key was that formerly used on the Denham East to Uxbridge High Street branch and was so stamped.

In 1989 the hopper wagons used for carrying coal to Chinnor cement works were declared obsolete and as their replacement was uneconomic, BR announced the line's closure. Class 47 No. 47258 and thirty-five hopper wagons made the final journey on 20 December 1989.

Branch trains usually left Princes Risborough (described on page 30), from the bay platform at the Down end. This bay made a trailing connection with the Down Main and Thame line, but otherwise there was no link. Branch trains curved westwards on what appeared to be double track, but was in fact parallel single lines to Watlington and Thame. From Princes Risborough Junction the line falls for over half a mile at 1 in 106 and then rises at 1 in 132 for about the same distance before arriving at Bledlow Bridge Halt. As the Watlington and Thame lines left the line to Banbury, on the inside of the curve was a private siding serving Forest Products Research Laboratory. Established in 1926, this government department investigated timber preservation, wood bending and adhesives. Timber and coal for this work arrived by road. The private siding agreement terminated in 1971. About a mile from Princes Risborough the Watlington branch curves south and falls, mostly at 1 in 107, to the 70-ft long Bledlow Bridge Halt with its timber shelter. As the platform was at rail level, the guard warned passengers, 'Mind the steps please, they are a bit steep'. It was all too easy for a guard to close the door and forget to pull the lever to retract the steps. If the footplatemen noticed that they were still out, they would repeatedly

Thame Junction, view Up: the branch from Chinnor, right and from Thame, left. 6 May 1995. *Author*

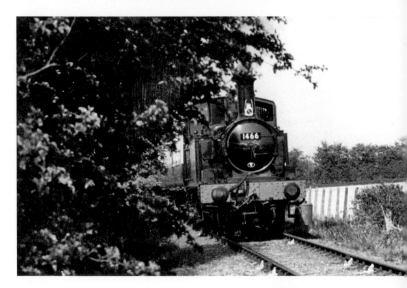

14XX class 0-4-2T No. 1466 near Bledlow Bridge Halt. 6 May 1995. *Author*

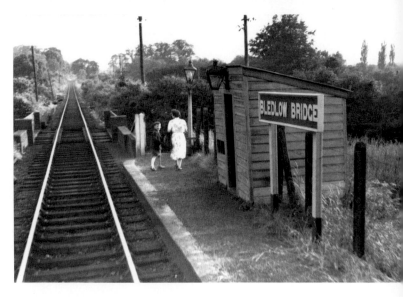

Bledlow Bridge Halt view towards Watlington, showing the rail level platform. Old rails support the station name board. 29 June 1957. *E. Wilmshurst*

sound the engine whistle to attract his attention and point to the steps. When the steps were broken, a chair was borrowed from a station until a spare trailer could be obtained. In 1951 branch guards still carried out the tradition of wearing a rose or carnation in their buttonhole. The line enters Oxfordshire just prior to reaching Wainhill Crossing Halt.

The engine used for hauling the first trains was probably hired from the GWR. By the summer of 1874 the W&PRR was very behind hand in settling the account with the GWR. The W&PRR believed it could work the line more cheaply itself and so purchased for £900 No. 1, a Sharp Stewart 2-2-2WT built in 1857 and run as Furness Railway No. 11 until 1873. In February 1875 the W&PRR purchased new for £1,475 a 2-4-0T from the same builder. No. 1 was scrapped in 1883 when the GWR took over, but No. 2 was rebuilt as GWR No. 1384. From 1886 it worked on several GWR branches before being withdrawn in 1911 and sold to the Weston, Clevedon & Portishead Light Railway where it became No. 4 *Hesperus*. It was eventually cut up in June 1937.

Around 1900 the branch was worked by 2-4-0T and 0-4-2T locomotives, while '2021' class 0-6-0ST/PTs were used for goods trains from the early 1900s until 1951. No. 2112 was on the branch from 1930 until 1951 when the '57XX' and '74XX' classes took over, with '850' class 0-6-0PTs making rare appearances. Occasionally a '14XX' class 0-4-2T was used, but this was less successful hauling goods trains.

Following the arrival of the 8.40 a.m. at Princes Risborough each Monday morning, the branch locomotive was changed for a fresh engine which carried a week's supply of firelighters and cotton waste. It usually faced Watlington to ensure that when tackling Chinnor bank the firebox crown was not uncovered thereby causing the fusible plug to melt.

5-17 March 1951 branch services were temporarily suspended because Fireman A. V.Benham of Chinnor was granted 12 days leave to get married. His relief had been called up for National Service, so the passenger services were temporarily replaced by buses. In the event, bus substitution ended quicker than expected as on 8 March Driver Tom Nicholson volunteered to fire for ten days.The branch engine ceased to be stabled at Watlington from about 1954 when the regular fireman was called up for National Service and no replacement could be found. Slough shed supplied the engine which departed from there at 5.38 a.m. arriving at Watlington, 33 miles distant, at 7.00 a.m. It returned after the last service, departing from Watlington at 9.00 p.m. and arriving at Slough by 10.50 p.m. In February 1955 an ex-GER 'J68' class 0-6-0T from Aylesbury shed was tried over the line, but lacked sufficient water capacity. In 1957 engines working the branch came from Aylesbury rather than Slough which led to the use of ex-GER 'J15'class 0-6-0 tender engines on goods trains and ex-LMS Ivatt Class 2 2-6-2Ts.

When the W&PRR began working its own trains in 1874, the Watlington Rolling Stock Company purchased three coaches for branch use. That their condition was poor is indicated by the fact that four years later, three new coaches had to be purchased from the Lancaster Wagon Company. In 1922, rail motor working by then having ceased, the branch was worked by a 60-ft auto-trailer and six-wheeled van-third, but latterly just an auto-trailer was used. An auto-trailer was required rather than an ordinary coach because the latter had no steps to allow passengers to gain access from the ground level halts.

The initial passenger service of three each way on weekdays-only had by 1875 become five each way and two on Sundays, the time taken for the nine miles being 30 minutes. By 1887 there were only three trains on weekdays, taking 35 minutes. By 1910 this number had risen to six and in 1922 the five trains were allowed 25 minutes for the journey. Good connections at Princes Risborough gave a time of just over an hour from Watlington to Paddington. A considerable milk traffic and a fair quantity of freight were handled, two goods trains running daily plus one from Princes Risborough to Chinnor and back. In the 1930s an occasional excursion train consisting of three or four coaches of ramblers bound for the Roman Ridgeway ran on a Sunday. In 1956, five Up and four Down passenger trains were run and an extra round trip made at midday on Saturdays. The timetable was unbalanced as the first train from Watlington returned empty stock. The last Down passenger train made a connection with the slip-coach off the 7.10 p.m. Paddington to Birmingham.

The last BR train to Chinnor on 20 December 1989 did not signal the end of trains on the branch. The Chinnor & Princes Risborough Railway Association, which was formed in August 1989, took over the line's maintenance from 20 December 1989. In Berkshire the Association has rebuilt a replica of Chinnor station which was opened by the Hon Sir William McAlpine on 20 April 2002. Wainhill Crossing Halt has been restored but cannot be opened to traffic because of a lack of parking facilities for passengers – even turning a vehicle is almost impossible.

In August 1994 the CPPR Association purchased the freehold of the branch and on the 20th of that month operated round trips from Chinnor to Wainhill Crossing Halt and back. The following April, passenger services were extended to Thame Junction where a run-round loop was constructed. A connection to the Chiltern Railways at Princes Risborough has been maintained and it is hoped that access agreements will eventually permit the branch train to use the Watlington bay platform once more.

The CPPR Association has restored Bledlow Bridge Halt, though this too has not been opened to the public due to access problems. The Association looks after Princes Risborough signal box, a Grade II listed building. It has 124 levers, only seven fewer than Exeter West, Britain's largest preserved signal box which has been restored and rests at Crewe Heritage Centre. The CPPR has plans to erect a maintenance shed at Chinnor, reopen the line to Princes Risborough and in the long term between Chinnor and Aston Rowant.

CPPR Stock List

Class 08 0-6-0 diesel-electric *Haversham* was originally BR No 13018 and delivered new in 1953 to Willesden shed. In July it became D3018, then in June 1974 No 08011. The oldest working diesel on BR, it was painted in its original green livery and named *Haversham* by the staff at Bletchley. As it had no air brakes, BR withdrew it from traffic on 16 December 1991 and it was purchased by the Association. D8568 Bo-Bo diesel-electric built by the Clayton Equipment Company inJanuary 1964, is the only member of the 117-strong class still extant. First allocated to Haymarket shed, Edinburgh, it was sold for industrial use in 1972, eventually arriving at Chinnor in 1992. Ruston & Hornsby Limited 0-6-0 diesel-hydraulic works No. 459515 was sent on 13 April 1961 new to the Central Ordnance Depot, Bicester. On 3 June 1961 it was transferred to the Central Ordnance Depot, Donnington where it remained until December 1989. Purchased privately, it was moved to Chinnor in 1991 and named *Iris*. Class 31 diesel-electric No. 31163, formerly D5581,and built by Brush, was donated to the railway in 2006. The line is also home for two Class 37s – No. 37116 *Sister Dora* and No. 37219 *Shirley Ann Smith*. When it is not desireable to run a locomotive-hauled train, Class 121 single railcar W55023 is available.

The association has six ex-BR coaches, one LNWR brake-third, two GWR brake vans, a 'Shoc' van, box van, flat truck, low-loading wagon and a BP petrol tanker. Mobile plant includes a 1960 rail-mounted Coles crane and a Wickham petrol trolley.

Passenger services operate at weekends from Easter to Hallowe'en and also for Santa and mince pie specials.

Princes Risborough to Bledlow

The Princes Risborough to Oxford branch ran through Buckinghamshire for about three miles. The broad gauge single line branch was authorized by the Wycombe Railway (Extension to Oxford & Aylesbury) Act of 28 June 1861 and empowered the company to raise £260,000 by shares and £86,000 in loans. Built by contractor Thomas Tredwell and leased by the GWR, it opened to Thame on 1 August 1862. The first train, carrying directors and shareholders, arrived at 3.00 p.m. drawn by *Sunbeam,* a 'Sun' class 2-2-2. The line was opened to the public the following day. Work on the remainder of the line to Kennington Junction south of Oxford had begun by December 1862. Once this work was completed, the branch opened on 24 October 1864 and the company amalgamated with the GWR as from 1 February 1867. The line was given over to the engineers on Tuesday 23 August 1870 and reopened for standard gauge passengers on Thursday 1 October 1870. Standard gauge goods trains commenced a few days later.

Following the granting of an Act for constructing a new line from Old Oak Common Junction to High Wycombe in 1897, in 1900 powers were obtained to make substantial improvements to the Thame branch. Track levels were to be improved and the line doubled in order to upgrade it to a main line so that it could be used by expresses to Oxford and Birmingham, thus creating a shorter route than that existing via Didcot. In the event these improvements were never carried out as the directors considered a direct line from High Wycombe to Aynho Junction to be a better proposition.

The Thame branch closed to passengers from 7 January 1963, remaining open for parcels and goods, but the state of Horspath Tunnel east of Oxford caused the section from Morris Cowley to Thame to be closed as the repair cost of approximately £60,000 was quite uneconomic. It was intended that through freight and parcels traffic would cease on 6 February 1967, but due to main-line heavy engineering work on Sundays, Paddington to Birkenhead trains were diverted to Banbury via Thame and Oxford. Morris Cowley to Thame was closed completely on 1 May 1967.

Oil traffic continued to run to Thame via Princes Risborough. At peak times it received block oil trains from Llandarcy, the Isle of Grain and Ripple Lane, two to three trains running to the terminal daily. Eventually a pipeline was laid to Thame so that oil could be pumped there instead of travelling by rail. On 21 March 1991, Class 37/7 No. 37709 worked the 13.20 Ripple Lane to Thame light engine and returned with eight loaded 100 tonne TEA tanks. This 16.50 ex-Thame was the last booked train to use the branch. The tanks were loaded as they carried surplus oil back to North Thameside. Two more trains visited the line on 10 and 12 April, hauled by No. 47369 and No. 47223, each forming a 16.50 Thame to Ripple Lane returning surplus oil stock. The track was not lifted until 1998.

Trains for Bledlow left Princes Risborough (for a description of this station see page 30) and curved west away from the Aynho line, and the single line to Bledlow ran parallel with the Watlington branch for a mile before the latter line diverged. Bledlow had a single platform and brick buildings on the south side of the line. By 1938 its signal-box had been reduced to a ground frame. The station closed to both goods and passengers on 7 January 1963.

In the nineteenth century the line was worked by 0-4-2Ts and 2-4-0Ts on passenger trains while Armstrong 'Standard' and 'Dean Goods' 0-6-0s handled freight. In the pre-First World War era steam railmotors worked some services. In the 1920s 'Bulldog' and 'County' class 4-4-0s appeared on passenger trains as did '61XX' class 2-6-2Ts. '48XX'

class 0-4-2Ts and '54XX' class 0-6-0PTs operated Princes Risborough to Thame services and GWR diesel railcars, especially No. 9, No. 10 and No. 11, worked between Princes Risborough and Oxford from 1935 until 1957. Paddington to Oxford trains were generally worked by a 4-6-0 or 2-6-0. The line was able to carry all locomotives except those of the 'King' class or '47XX' class 2-8-0s. Steam finished when Oxford shed closed on 3 January 1966.

In 1887, between Princes Risborough and Oxford six Down and four Up trains ran on weekdays and two each way on Sundays. By 1910 the service offered seven each way, two trains still running on Sundays. By 1922 five passenger trains ran each way plus three railmotors from Princes Risborough to Thame and back. This frequency varied very little apart from during the Second World War when the number of through passenger services were cut from four to three and local trains also reduced by one. Goods traffic during the war years increased tremendously. By late 1946 the passenger timetable was back to its pre-war level.

By 1937 Princes Risborough to Oxford trains generally consisted of four-coach 'A' sets comprising a brake third, first, third and brake third. In the post-war period through trains were formed of five-coach 'Q' sets. Engines carried a 'B' class head code from Oxford, trains calling at all stations to Princes Risborough, and then 'A' lamps for the faster run to Paddington only calling at such stations at High Wycombe, West Ruislip and Greenford.

A new overbridge spans the B4009 just west of Thame Junction. 6 May 1995. *Author*

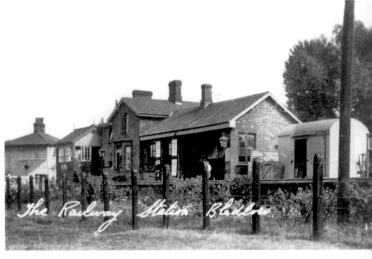

Station buildings at Bledlow, view Up, *c.* 1910. *Author's collection*

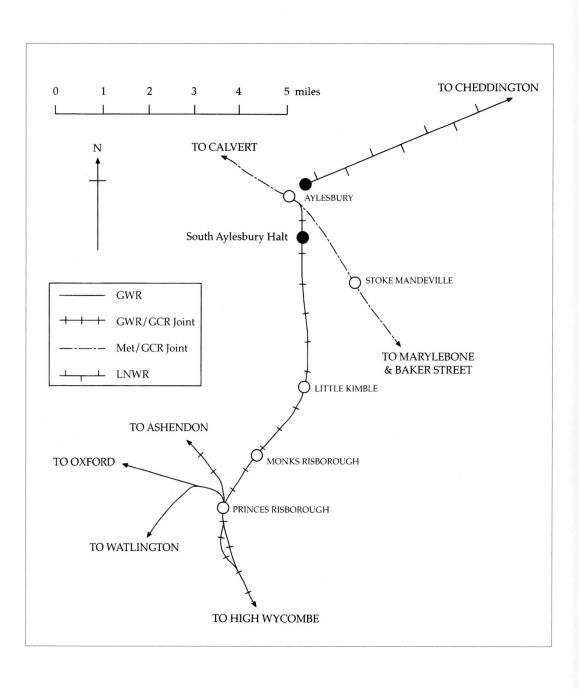

Princes Risborough to Aylesbury

Princes Risborough to Aylesbury was built under the Wycombe Railway (Extension to Oxford & Aylesbury) Act of 28 June 1861 which empowered the company to raise £260,000 in shares and £86,000 by loans to build these extensions. The seven-and-a-quarter-mile long, single track, broad gauge line, with Walter M. Drydone as engineer and built by the contractor Francis Rummens, opened without ceremony on 1 October 1863. It was decided not to use the Down platform at Aylesbury until the Aylesbury & Buckingham Railway was about to open, though when this event took place on 23 September 1868, the Aylesbury & Buckingham used the Up platform as did the GWR, (the GWR had taken over the Wycombe Railway on 1 February 1867), which facilitated the exchange of passengers. A Down GWR train arriving at Aylesbury ran through the Down platform and then reversed to the Up platform for passengers to detrain.

As the GWR worked the standard gauge Aylesbury & Buckingham Railway, to enable it to transfer standard gauge stock to and from this line, the Princes Risborough & Aylesbury branch was converted to standard gauge. This made it one of the last and the shortest-lived broad gauge lines. On Wednesday 14 October 1868 the Princes Risborough to Aylesbury service was suspended until 21 October to allow the work of narrowing to be carried out. A temporary omnibus was provided for passengers, and carts for goods. This was the first gauge conversion the GWR had carried out and, unlike later conversions, the work was not rushed. The result was that the estimated time was exceeded and the standard gauge could not be used until Friday 23 October. The Aylesbury & Buckingham Railway defrayed a fifth of the £2,500 cost for narrowing the gauge. The work enabled the Down track at Aylesbury to be slewed nearer the Up line so that the hitherto little-used Down platform could be widened. From 1 August 1899 GCR goods trains ran from Aylesbury to London via Princes Risborough, High Wycombe and Maidenhead, taking traffic to GWR London stations and for railways south of the Thames. Logically, the branch was transferred to the Great Western & Great Central Joint Committee from 1 July 1907 by order of the GCR Act of 26 July 1907. This gave the Joint Committee a final length of 41 miles.

Princes Risborough station is described on page 30. North of the station the Aylesbury branch curves away from the main line to Banbury and the Oxford and Watlington branches. Monks Risborough & Whiteleaf Halt opened on 11 November 1929. Re-named Monks Risborough on 6 May 1974, on 13 January 1986 a new replacement platform was opened 132 yards to the north. From street level a ramp is provided for disabled people at the Princes Risborough end and stairs for the able-bodied at the other. No waiting shelter is provided. All platforms on the branch are on the Up side of the line and there are no sidings or passing loops.

Little Kimble opened on 1 June 1872 and although the platform is still in use, the station building is now a private house. Unusually for a station, as opposed to a halt, it never had any goods sidings. Beyond, the line falls at 1 in 50 to South Aylesbury Halt, opened on 13 February 1933 to serve nearby factories and the Southcourt housing estate. It closed on 5 June 1967. A description of Aylesbury station appears on page 65. Very unusually, Aylesbury Vale Parkway consists of just a bay platform, with no platform on the single track main line which is no longer used by passenger trains. Space has been left to allow a platform to be built should this prove necessary.

For many years the branch was worked by 'Metro' class 2-4-0Ts, but later by '2221'class 'County Tanks', '36XX' 2-4-2Ts and '3150' class 2-6-2Ts. Around 1937 the early morning auto from Aylesbury to High Wycombe and back was worked by an 'E8' class 2-4-0T, or 'F1' or 'F2' class 2-4-2T. About this date, Paddington to Aylesbury trains consisted of four-coach 'A' sets comprising a brake third, first, third and brake third. By the mid-1950s through trains were generally hauled by '61XX' class 2-6-2Ts and the remainder either by a '14XX' class 0-4-2T, or '54XX' class 0-6-0PT, and auto-trailer. The local goods train originated from Neasden and was usually worked by an ex-LNER 'N5' class 0-6-2T or 'J11' 0-6-0. The branch was used as a diversionary route for main-line trains when the Harrow line was temporarily closed and when this happened, heavy trains leaving Aylesbury found the rising gradient a problem.

The first passenger service between Princes Risborough and Aylesbury offered four trains each way on weekdays and two on Sundays. The fares to London were the same as for the London & North Western Railway's route via Cheddington. The distance was 49¾ miles by GWR and 43 by LNWR. By 1933 fourteen trains ran each way daily, five Down and six Up from/to Paddington and one through Up train ran to Marylebone. Nearly all the branch trains offered good connections to Marylebone. On Sundays six trains ran each way over the branch with two from/to Paddington. As there were no goods yards on the branch no local goods trains were operated, but two through goods trains worked over the line.

The 1955 passenger service showed eight trains to/from Marylebone via Beaconsfield and four to/from Paddington some travelling via Maidenhead rather than taking the direct route. In 2010 the branch was served by twenty three Down and twenty Up trains. Aylesbury to Marylebone is 43½ miles via Princes Risborough and 37¾ miles via Amersham.

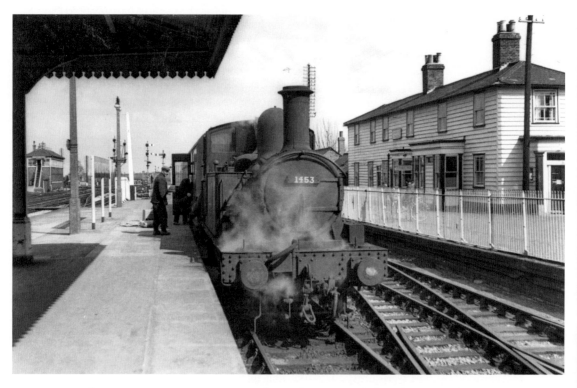

14XX class 0-4-2T No. 1453 at Princes Risborough with an Aylesbury branch train. Notice that it has a painted, and not cast, smokebox number plate. 14 April 1962. *E. Wilmshurst*

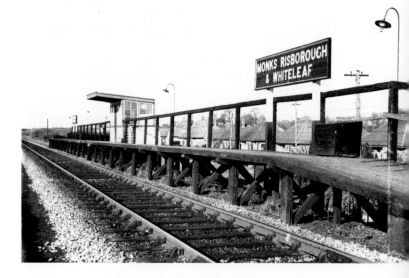

Monks Risborough & Whiteleaf Halt view north *c.* 1965. Opened 11 November 1929, it was moved northwards on 13 January 1986. *Lens of Sutton*

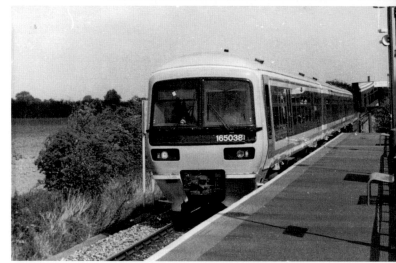

Class 165/0 165038 passes Monks Risborough with the 12.30 Aylesbury to Marylebone via Princes Risborough. 30 August 1998. *Author*

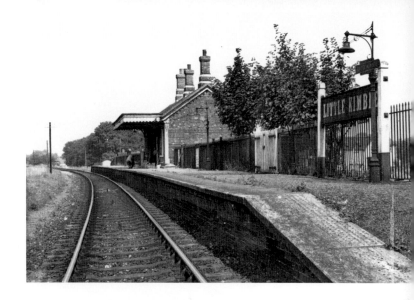

Little Kimble view Down, *c.* 1960. *Lens of Sutton*

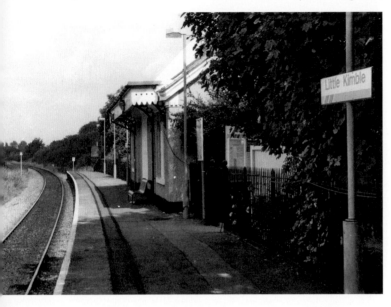

Little Kimble view Down. The canopy has been cut back since the previous photograph was taken. 30 August 1998. *Author*

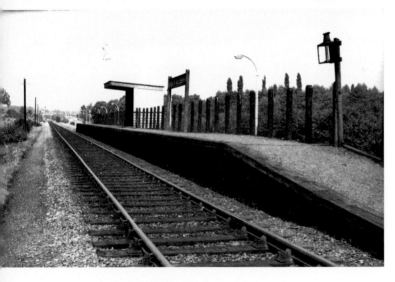

The timber and gravel platform at South Aylesbury, view North, *c.* 1962. Although electric lighting has been installed, oil lighting is still in place. *Lens of Sutton*

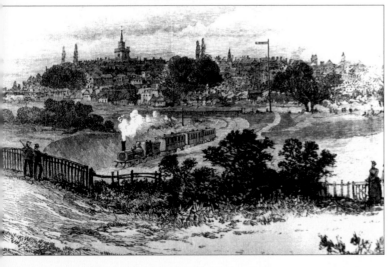

A GWR train leaves Aylesbury for Princes Risborough, May 1880. *Author's collection*

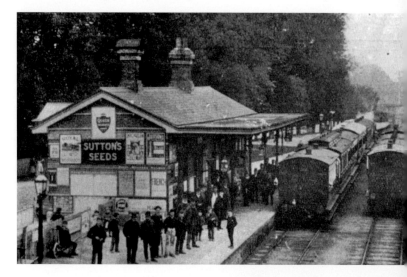

The original GWR station at Aylesbury, *c.* 1900
Author's collection

64XX class o-6-oPT No. 6429 (84C Banbury shed) at Aylesbury with the 12.30 p.m. to Princes Risborough. Notice 'Aylesbury' on the seat's backrest. 30 April 1961. *D. Holmes*

View north *c.* 1910 to Aylesbury Joint goods shed, originally broad gauge. Notice the cattle pen, right. The two loading gauges probably have different dimensions and belong to different companies. *Author's collection*

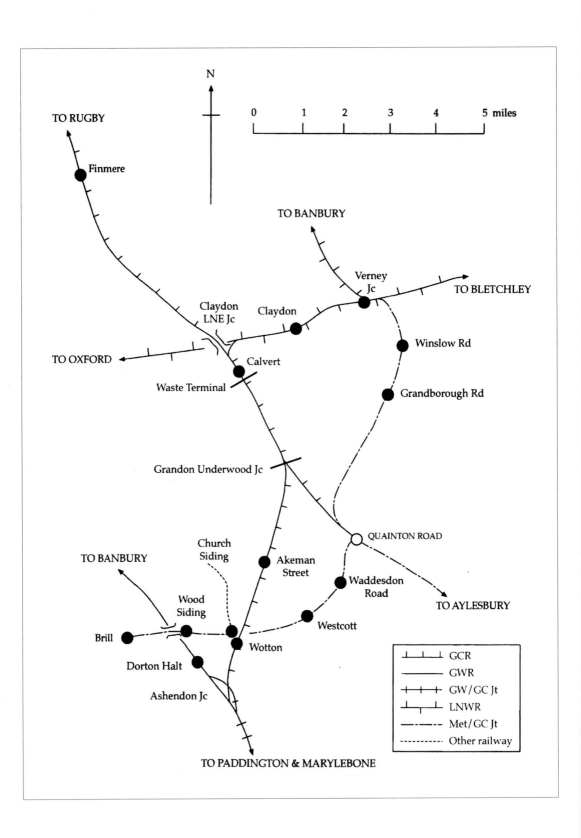

Ashendon Junction to Grendon Underwood Junction

The line was built under the Great Western & Great Central Joint Committee Act of 1 August 1899 and enabled the GCR to have an alternative route to and from Marylebone. Grendon Underwood Junction to Northolt Junction, constructed by Messrs Nott & Sons, was opened to goods traffic on 20 November 1905 and to passengers on 2 April 1906. As the GWR had no direct interest in the line, it was transferred to and vested in the GCR from 20 November 1905 by an agreement of 12 November 1906 confirmed by the GCR Act of 26 July 1907, the GWR being reimbursed for the costs it had incurred towards construction.

The junction at Ashendon was repositioned 110 yards west of its previous position and a new signal-box opened 25 October 1959, though it was not to last long. The Down line to Grendon Underwood Junction was taken out of use on 18 November 1965 following a derailment at Ashendon Junction and from that date, Down trains used the former Up line. The last train ran over the section on 4 September 1966, the line taken out of use the following day and officially closed on 21 July 1967, Ashendon Junction signal-box closing on 3 September 1967. The line was retained from Grendon Underwood Junction to Akeman Street station in order to serve Firman Coates' private siding.

North of Ashendon Junction signalling was of GCR pattern and initially was GCR permanent way of 96 lb/yd rails in 30-ft lengths. Doubtless due to the GWR's influence, Wotton and Akeman Street stations had quadruple tracks with platforms only on the outer roads. This was an uncommon feature on the GCR which generally preferred island platforms on its London Extension. Both stations had platforms and waiting shelters built from timber. Immediately north of Wotton station the GCR passed over the Metropolitan Railway's Brill branch. Wotton closed to both passengers and goods on 7 December 1953, while Akeman Street closed to passengers on 7 July 1930 and to goods, except for private siding traffic, on 6 January 1964. Fertilizer trains ran to Akeman Street until about 1989 and today (2010) the track between there and Grendon Underwood Junction is still in situ but overgrown. Grendon Underwood is a flat junction.

The Metropolitan & Great Central Joint Committee's seal. *Author's collection*

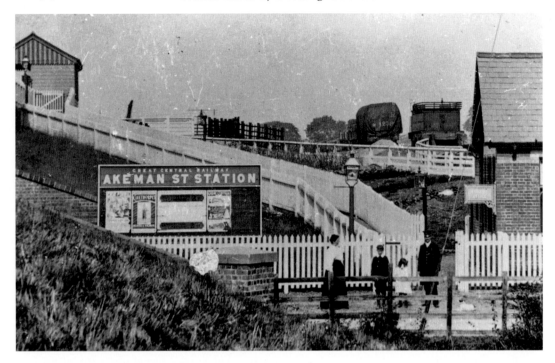

Akeman Street station *c.* 1910: the office building at road level, with the waiting shelter and platform high on left. A locomotive tender is in the goods yard sidings. *Author's collection*

View of the overgrown line near North Farm, north of Akeman Street station. 25 June 1999. *Author*

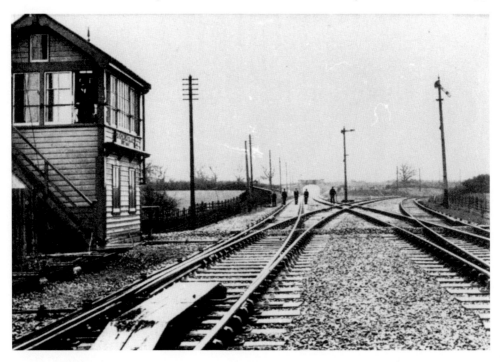

Grendon Underwood Junction, *c.* 1910: the line to Harrow left, and High Wycombe, right. *Author's collection*

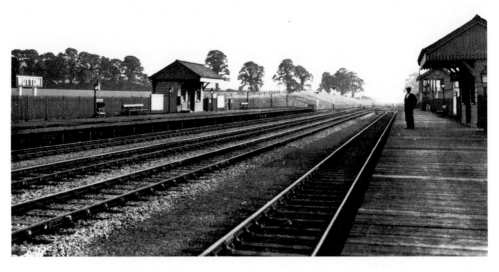

The timber-built platforms at Wotton, *c.* 1960. The planks are lateral, rather than longitudinal as at many stations. *Lens of Sutton*

Quainton Road to Finmere

Sir Edward Watkin, one-time secretary of the Buckinghamshire Railway and chairman of the Metropolitan Railway, the Manchester, Sheffield & Lincolnshire Railway (MSLR), and also the South Eastern Railway, planned to link all three companies of which he was chairman and even told Gladstone that he hoped to have the privilege of running him in a through train from his constituency at Hawarden to Dover. The Aylesbury & Buckingham Railway offered itself a connecting link for a small part of the way and this was taken into the Metropolitan Railway system in July 1891. The first bill for a rail link between the MSLR and the Metropolitan Railway was rejected by Parliament in 1891, but passed on 28 March 1893. Walter Scott & Co., Newcastle-upon-Tyne, won the Brackley to Quainton Road contract at £470,000 and cut the first sod in November 1894. Island platforms were used to save on building and land costs. The better to express its coverage, the MSLR was renamed the Great Central Railway on 1 August 1898.

On 3 May 1898 C. A. Rowlandson, resident engineer of the London Extension, R. Haig-Brown, superintendent of the line, and C. T. Smith, goods manager, travelled up the new line from Annesley, Nottinghamshire, to Quainton Road where the Metropolitan Railway had almost finished making the junction. A month later another officers' inspection train ran prior to commencing coal traffic on 1 July 1898.

John Bell, the Metropolitan's managing director, proved highly obstructive. He would not allow timetable clerks to plan paths for the GCR mineral trains, would not permit a large GCR locomotive to run over his line for test purposes and refused to open the junction at Quainton Road until the GCR was open to passenger as well as mineral and goods traffic. Eventually he was persuaded to allow mineral traffic to begin on 25 July 1898. Rather unwisely, William Pollitt, the GCR's general manager, sent the inaugural train off early and it approached Quainton Road Junction around 3.00 a.m. It whistled for the home signal to be cleared but, despite numerous blasts, the signal failed to come off. A fireman and inspector walked to the signal-box to discover the problem.

The problem was there in the box, John Bell himself who in no uncertain terms stated that the GCR train would not run over Metropolitan metals until certain matters had been settled. This caused an impasse: the train could not return 'wrong road' to Woodford, so the locomotive inspector asked if the engine could proceed to the crossover in order to gain the Down road. Bell half-heartedly agreed until the smart Metropolitan signalman opined that if this was done, it would create a precedent for the junction to be opened. Agreeing, Bell withdrew permission. Eventually another GCR engine arrived to draw the train back to Woodford where it remained until matters were settled and mineral traffic commenced on the following day, 26 July 1898. Coal tonnage proved to be light due to Bell refusing to allow traffic to be exchanged with the GWR at Aylesbury, or worked either to Metropolitan stations or to destinations south of the Thames. This highly uncooperative attitude of the Metropolitan was a main reason for the GCR seeking an alternative route and so an alliance with the GWR was sealed in September 1898. The GCR carried general goods to London from 1 October 1898.

The ceremonial opening of the GCR to Marylebone took place on 9 March 1899 when three special trains carried guests to Marylebone station which had been gaily decorated with flags. Following the banquet, the President of the Board of Trade, the Rt Hon. C. T. Ritchie MP, ceremonially started '11A' class 4-4-0 No. 861 heading the first passenger train

out of the station – though after proceeding a short distance it returned to become the 4.28 p.m. special to Rugby and Manchester. Public passenger services commenced on 15 March, the first train leaving Manchester, London Road, at 2.15 a.m., while the inaugural train from Marylebone departed at 5.15 a.m. with but four passengers.

By the late 1950s, major towns served by the ex-GCR received a faster and better service by other routes. Down-grading of the line began in January 1960 when Marylebone to Manchester expresses were replaced with three semi-fasts. During the electrification of the Euston line some West coast expresses were diverted via Bletchley to Marylebone and the wartime spur laid at Calvert. Local passenger trains ceased on 4 March 1963 and the line to Rugby north of Calvert closed completely on 5 September 1966.

The original passenger station at Quainton Road closed in 1896 when a new one opened 100 yards to the south with two through platforms and a bay at the south end of the Down platform for Brill branch trains. A brick office building was sited on the Up platform and a wooden shelter on the Down. At one time Quainton Road enjoyed handling an extensive transfer of goods traffic between the Metropolitan Railway and the GCR. BR closed Quainton Road to passenger traffic on 4 March 1963 and to goods on 4 July 1966, since when it has been developed as a railway preservation centre.

The Buckinghamshire Railway Centre first opened on August Bank Holiday 1969 and the 25-acre site now houses one of the largest collections of Victorian and Edwardian coaches outside of York. It is unique in having so many varied and interesting features not found elsewhere. The former LNWR Rewley Road station, Oxford, dating from 1851 and Grade II* listed, has been rebuilt at Quainton Road and serves as the main building. It houses the restaurant, gift shop, toilets, meeting room and offices. Restoration was in two stages, with the initial rebuild of the dismantled items from Oxford followed by a Heritage Lottery funded project to extend the canopy over the platforms to two coach lengths. This work also saw the reconstruction of the *porte-cochère*. Railway exhibits in the building comprise a LNWR dining car, a LNWR sleeping car (now used as a railway cinema coach), GWR Castle class 4-6-0 *Defiant* (on loan from Tyesley) and GWR Special Saloon W9001 adapted by the GWR as a mobile conference room and reputedly used in 1944 for 'D-Day' planning meetings.The Visitor Centre is extensively used for commercial functions such as conferences and product launches and is a popular choice for civil wedding ceremonies.

A Second World War buffer depot, originally rail-served for keeping emergency supplies of basic foods, now has two uses: part is used to house long-term restoration projects, while the remainder of the space is the main museum. Open every weekend its principal exhibits are:

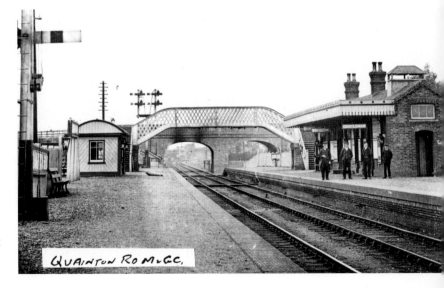

Quainton Road view north, *c.* 1910. The junction signals are for the Verney Junction line which bears off to the right north of the station. *Lens of Sutton*

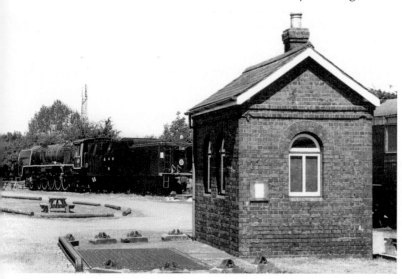

Weighbridge and hut at Quainton Road. Most stations of any size had this equipment. It now forms an exhibit at the Buckinghamshire Railway Centre. The locomotive in the background is South African Railways 3 foot 6 inch gauge Class 25 NC 4-8-4 No. 3405. 25 June 1999. *Author*

1. A complete freight train with loaded wagons and vans.
2. A London Underground 1938 stock tube display.
3. A London Underground Passimeter ticket office.
4. A small relics display.
5. A research library.
6. An education coach.

The Centre suffers from being divided by the operational Network Rail freight line, but this problem has been obviated by the construction of a bridge including a wheelchair lift and ramps. A recent acquisition is two Travelling Post Office vehicles which are open to the public monthly with a hands-on demonstration of letter sorting.

Today the station has four platforms:

Platform 1, originally the Up platform, is the Network Rail platform and only used by occasional visiting trains. There is no rail connection to the Centre.

Platform 2, the original Down platform, at present has no track.

Platform 3 was for the former Brill branch and is adjacent to the Down platform.

Platform 4 is on the north side and is used by internal Railway Centre trains.

The Centre has a variety of steam locomotives including ex-GWR 0-6-0PT No. 7715, later London Transport No. L99; GWR 2-8-2T No. 7200; and Metropolitan Railway 'W' class 0-4-4T No. 1 which is of local interest as it originally worked through Quainton Road on Baker Street to Verney Junction trains. Railways south of the Thames are represented by LSWR '0298' class 2-4-0WT No. 0314. A wide variety of industrial steam locomotives from various makers are on view and the collection includes a very low engine and a fireless locomotive. The Centre is also the base for the Sentinel Trust and there are several examples including a Sentinel-Cammell steam railcar built in 1951 for the Egyptian National Railway. Another unusual exhibit is a grounded New York subway car built circa 1935.

The station's original weighbridge and office can still be seen. The Vale of Aylesbury Model Engineering Society has half-mile of mixed gauge track at the Centre, a beautifully and neatly kept station and picnic area.

Table 1.
Stock list of standard gauge main-line steam locomotives at the Buckinghamshire Railway Centre

Number	Name	Wheel Arrangement	Original company	Date built	Current owner
01314 (BR 30585)		2-4-0WT	LSWR	1874	QRS*
1 (LT L44)		0-4-4T	Met. Railway	1898	QRS*
6989	*Wightwick Hall*	4-6-0	BR(W)	1948	QRS*
7200		2-8-2T	GWR	1934	QRS*
7715 (LT L99)		0-6-0PT	GWR	1930	QRS*
9466		0-6-0PT	BR(W)	1952	D. Howells

* QRS = Quainton Railway Society

Calvert station was not named after a place, but after Sir Harry Verney's original surname before he changed it on succeeding to the Verney estates. The station closed to passengers on 4 March 1963 and to goods, except the brick works' private siding opened about 1900, on 4 May 1964. Well before closure of the brick works in 1994 (latterly bricks were dispatched by road), tipping to fill the 100-ft deep clay pits started in 1980. Today (2010) on Mondays to Fridays the waste disposal company Waste Recycling Group may receive up to five trains of waste, but normally see one from Bristol with fifty-one Waste Management bins weighing a total of 650 tonnes; one from the West London Waste Terminal at Brentford with sixty-six bins (850 tonnes); one from North London with sixty bins (800 tonnes); and one from East London with 60 bins (450 tonnes). In total about 11,500 tonnes of waste arrive each week by rail.

One crane lifts off a full container bin and places it on a Volvo truck which carries it to the tipping site. The Volvo returns with the empty bin and another crane lifts it off and places it further up the train. Each railway wagon holds three bins. The drivers of all train locomotives are in radio contact with a crane driver so they can move the train forward as required and all are unloaded the same day. No trains are unloaded during the weekend.

The site is extremely well run: methane from decaying refuse is extracted from the ground before it can escape and cause pollution; most of the methane is used for generating electricity and all water is purified before discharge into Claydon Brook. The site is filled to the level prescribed by planning and then fully engineered to control emissions.

A mile north of the Waste Recycling Group's siding the line curves to Claydon L&NE Junction where it joins the Oxford to Bletchley line. Pre-September 1966 the GCR main line also headed north from Calvert and crossed the LNWR's Oxford to Bletchley line. Finmere station was approached by an embankment containing 200,000 cubic yards of spoil and was the chief engineering feature on this section of line. Finmere closed to passengers on 4 March 1963 and to goods 5 October 1964. Immediately before the station, the line entered Oxfordshire and passed through that county for four miles before crossing the Great Ouse and re-entering Buckinghamshire for a mile before passing into Northamptonshire almost a mile south of Brackley station.

At first, fast trains were generally worked by Harry Pollitt's 4-4-0s, then in 1913 J. G. Robinson's 'Directors' appeared and the 'Improved Directors' in 1920 with side window cabs. 'Atlantics' and 4-4-0s were also used. In 1938 some 'A1' Pacifics were cascaded to GCR expresses. Robinson designed Great Britain's first 4-6-2Ts, the 'A5' class, for the line's local services. Gas-turbine 4-6-0 GT3 appeared on trials in 1961. From 1962 the Marylebone to Manchester semi-fasts were worked by 'Britannia' class Pacifics. Two years later the semi-fasts were generally headed by a 'Black Five' 4-6-0, but occasionally were in the hands of a diesel-electric.

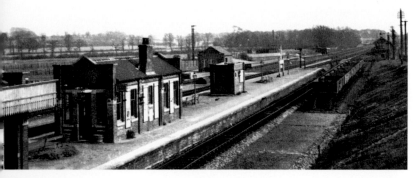

Calvert, view Up,
c. 1960. *Lens of Sutton*

The waste terminal at
Calvert: two Aabacas
28 tonne cranes transfer
containers between
rail wagons and Volvo
trucks. 5 May 1999.
Author

A 'Train Haul' trolley for
moving wagons without
a locomotive, seen below
the buffers after being
dragged back to the
start, still has its small
wheels retracted. 5 May
1999. *Author*

Chalfont & Latimer to Chesham

The Metropolitan Railway opened from Baker Street to Harrow-on-the-Hill on 2 August 1880, extended to Pinner on 23 May 1885 and to Rickmansworth on 1 September 1887. It offered thirty-three trains daily and a contemporary writer questioned whether the line should be carried through a district consisting only of farms and fields. Subsequent development proved that critic wrong and the far-sighted Metropolitan Railway directors correct. Chesham trebled its population during the nineteenth century as light industry supplemented the watercress bed economy. The Metropolitan Railway Act of 16 July 1885 authorized a line from Chalfont Road to Chesham. On 8 July 1889 this railway, built by Messrs J. T Firbank, opened without any of the usual ceremony. The Metropolitan Railway's intention was to erect a station in the Mill Field a half-mile outside Chesham, but residents raised £2,000 and presented this sum to the railway in order that it could purchase a central site. Yet despite this practical display of enthusiasm, no decorations were in evidence for the opening except an illuminated device bearing the phrase: 'Forward be our Watchword'. Above the signal-box, which still stands today, though no longer used for its original purpose, flew a red flag inscribed 'Metropolitan Railway'. A total of 1,500 passengers travelled on the opening day, and the following day 300 booked to the Crystal Palace.

The Metropolitan Railway opened Chalfont Road to Aylesbury on 1 September 1892, an action which turned the line from Chalfont Road to Chesham into a branch. Initially passengers were not required to change at Chalfont Road as through coaches continued to be run to and from Chesham to Baker Street, being added to Aylesbury to Baker Street trains. Eventually this practice ceased to the great displeasure of Chesham folk who then had the fuss and bother of changing at Chalfont.

Until the Metropolitan opened to Chesham, the London & North Western Railway operated a horse bus service between the town and Berkhamsted, but following the extension of the Metropolitan to Chesham, the LNWR allowed the bus service to fall into private hands. From 30 January 1899 the LNWR operated a Daimler van lettered: 'L&NWR Co. Express Parcels Service' from Berkhamsted to Chesham, but the experiment ended the following month as it proved more expensive than using horses.

Branch trains start from Chalfont Road, renamed Chalfont & Latimer 20 November 1915. This station has two through platforms and a bay. Until the London Passenger Transport Board introduced push-and-pull working to Chesham, a train was required to be shunted out of the bay platform before an engine could run round it. From Chalfont & Latimer the branch runs parallel with the main line to Aylesbury for three-quarters-of-a-mile before diverging and then traverses a series of reverse curves to Chesham. The terminus has a brick-built station with attractive ironwork to the platform canopy. A most delightful garden stands on the site of the former bay platform. The former signal-box of timber, is now beautified with hanging baskets.

The branch was worked by various Metropolitan tank engines, but then in the summer of 1936 the LPTB placed an order for two AEC diesel railcars for service on the Chesham branch. Similar in design to those of the GWR, each car was to be powered by a 130 hp six-cylinder engine giving a maximum speed of 65 mph. A car was to be 62 ft in length, seat seventy passengers and have air-operated doors. Electro-magnetic controls would have permitted two or more cars to be driven together as a multiple unit. The order was cancelled due to the LNER taking over working in 1937.

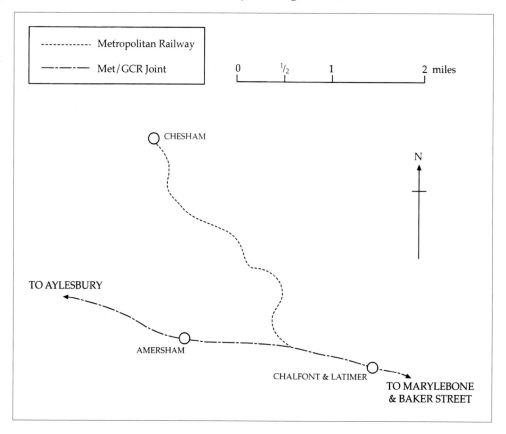

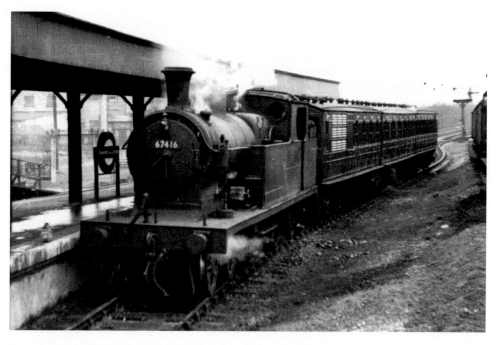

C13 class 4-4-2T No. 67416 at Chalfont & Latimer with the 10.23 a.m. from Chesham. The train set is of coaches built by Messrs Ashbury *c.* 1900. 14 April 1958. *D. Holmes*

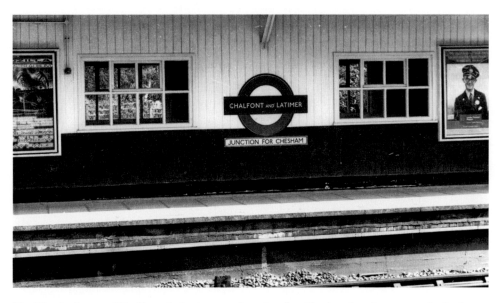

The Up platform at 'Chalfont & Latimer — Junction for Chesham'. 2 August 1998. *Author*

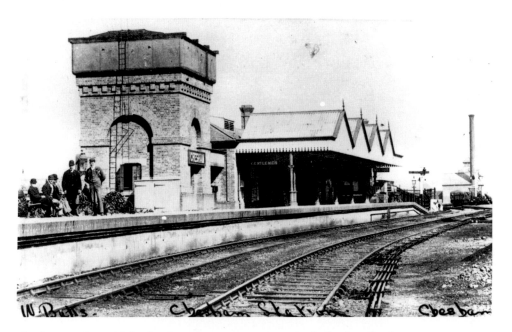

Chesham station with its dominant water tower, *c.* 1905. *Author's collection*

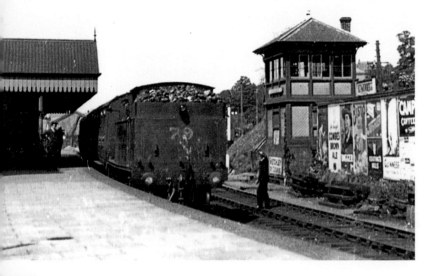

Metropolitan Railway E class 0-4-4T No. 79 built in 1900 and withdrawn 1935, at Chesham, *c.* 1930. Coal is stacked high in its bunker. *Author's collection*

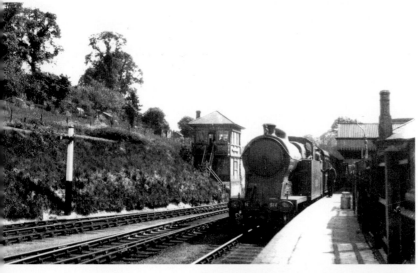

LNER A5 class 4-6-2T (probably No. 5168) arriving at Chesham, *c.* 1937. *Author's collection*

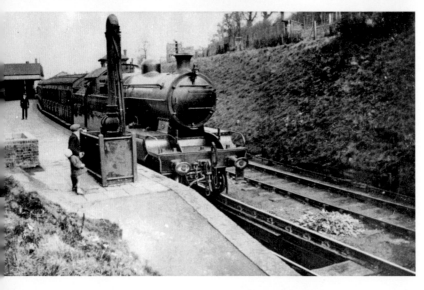

A Metropolitan Railway 4-4-4T at Chesham, *c.* 1933. A water column guard is provided to avoid passengers being splashed. The metal loop on each end of the buffer beam, aids crews mounting the front footplate. Notice the safety chains each side of the central coupling. An inspection pit is in front of the locomotive. *Author's collection*

The 11.18 ex-Chalfont & Latimer arrives at Chesham. No. 5092 is the leading car. Notice the flowers left and right. The Metropolitan Railway signal box has been preserved. 2 August 1998. *Author*

London Transport's Chesham station has a rural appearance and setting. The Metropolitan Railway signal box can be seen on the left. 2 August 1998. *Author*

From 1953 Neasden depot supplied auto-fitted engines such as ex-GER 'N7' class and ex-GCR 'N5' class 0-6-2Ts and in the late 1950s ex-GCR 'C13' class 4-4-2Ts. In the latter days of steam working and following the transfer of the branch from the Eastern Region to London Midland Region, an auto-fitted Ivatt Class 2 2-6-2T, often No. 41294, was used. The branch was steam-worked until Monday 12 September 1960 when it was electrified, the last steam train being the 12.03 a.m. Empty electric trains had actually begun running over the branch from 15 August 1960 to enable drivers to learn the road. The first passenger-carrying electric train left Chalfont & Chesham at 6.12 a.m. on 12 September. Most comprised 'T' stock compartment motor cars with an intermediate trailer. In the morning two trains ran through from Chesham to the City with corresponding return services in the evening. These were hauled throughout by an ex-Metropolitan electric locomotive. The 7.21 p.m. Chesham to Harrow-on-the-Hill had an electric engine at each end. This was because one locomotive had worked the 5.14 p.m. Liverpool Street to Chesham and its coaches were to remain at Chesham overnight. When the 5.41 p.m. from Liverpool Street reached Chesham at 6.57 p.m., its engine was not uncoupled, but the locomotive from the 5.14 p.m. was attached to the other end. The 7.21 p.m. carried passengers to Harrow-on-the-Hill and then ran empty to Neasden depot. This interesting working ceased in September 1961.

After 12 September 1960, one steam-hauled train was still operated by British Railways to deliver newspapers to Chesham and returned as a passenger train leaving at 5.38 a.m. One freight train ran each weekday. At Chesham a new 230-ft long bay road and platform were built to accommodate a four-car train and thus allow the station to deal with two trains at a time – either the branch shuttle, or a through train to or from London. Hitherto a second train could only enter Chesham after the first had been shunted from the platform road into a siding.

In the latter days of steam working, the engine pushed the coaches to Chesham and pulled them to Chalfont. The vehicles themselves were quite historic and the oldest

working on London Transport, having outlived the rest of the class by twenty years. They had been built by Messrs Ashbury at the turn of the century as part of a numerous order of steam stock for the Metropolitan Railway's extension to Aylesbury. They were the Metropolitan's first bogie vehicles, as previous eight-wheelers had been of rigid design with radial outer axles. These Ashbury coaches measured 42 ft 4 in in length, 8 ft 8 in wide and 11 ft 6 in high, 12 ft 2 in to the top of the ventilators. The coaches weighed almost 20 tons. Each body contained six first-class, or seven third-class compartments.

In 1906 twenty-four of these coaches were converted to electric multiple unit sets and in 1940/1 six were re-converted for use as two three-car steam push-pull sets. Each of the two auto-sets comprised a former motor coach, a former first- and second-class class composite trailer and a former third-class driving trailer, the latter arranged for push-pull operation. The braking reverted to vacuum, as when running as EMUs they used the Westinghouse system. Of the six coaches, three were built in 1898, one in 1899 and two in 1900. Each three-coach set worked for a week. Every Sunday morning one left Neasden depot behind an ex-Metropolitan electric locomotive and called at stations to Rickmansworth where the electric engine was removed. Meanwhile the first Sunday trip from Chesham worked the previous week's carriage set to Rickmansworth and then, after locomotive changing, the electric locomotive proceeded to Neasden with the old set, while the steam engine propelled the fresh set to Chesham. The set was used very intensively during the week. The first trip was at 6.30 a.m.and the last arrived at Chesham at 1.10 a.m. where the engine and train were stabled overnight. A set covered something in excess of 1,600 miles weekly. One other interesting feature was than until 1939, a Pullman car worked over the branch.

In 1910 about twenty-nine trains ran each way daily to and from London taking about an hour from Chesham to Baker Street and fifty minutes to or from Marylebone. The Sunday service offered nineteen trains each way. The four miles Chalfont Road to Chesham was scheduled as nine minutes. The 1938 timetable showed thirty-one trains on weekdays and twenty-one on Sundays.

Table 2.
Logs of trips on the Chalfont to Chesham branch,5 July 1958
Load: Three London Transpsort compartment coaches. Distance 4 miles

Locomotive: C13 class 4-4-2T No 67418

Station	Scheduled arrival hr min	Actual arrival hr min sec	Scheduled departure hr min sec	Actual departure hr min sec
CHALFONT	–	–	1.42	1.45.10
CHESHAM	1.51	1.53.50	–	-
	(Running time: 8 min 40 sec. Average speed: 27.7 mph)			
CHESHAM	–	–	1.57	1.57.15
CHALFONT	2.6	2.6.50	–	–
	(Running time: 9 min 35 sec. Average speed: 25 mph)			

Locomotive: N5 class 0-6-2T No 69257

Station	Scheduled arrival	Actual arrival	Scheduled departure	Actual departure
CHALFONT	–	–	2.10	2.16.10
CHESHAM	2.19	2.24.50	–	-

Lateness of connecting train dealyed the start from Chalfont.

	(Running time: 8 min 40 secs. Average speed: 27.7 mph)			
CHESHAM	–	–	4.1	4.1.23
CHALFONT	4.10	4.10.59	–	-
	(Running time: 9 min 36 sec. Average speed: 25 mph)			

Chalfont Road to Aylesbury

Although on 18 July 1881 Parliament authorized an extension to Aylesbury from a junction with the Chesham line midway between Chalfont Road and Amersham, it was not until 5 May 1890 that the ceremony of cutting the first sod took place at Aylesbury. Construction by J. T. Firbank took two years and provision was made for quadrupling the line should this be found necessary. Extra land was acquired at Stoke Mandeville where it was proposed to transfer the works from Neasden.

On 1 September 1892 the Metropolitan Railway opened to Aylesbury, the special train leaving Baker Street at 10.45 a.m., its passengers including Sir Edward Watkin, chairman; John Bell, general manager and G. H. Whissell, secretary. On arrival at Aylesbury they attended a public luncheon in the Town Hall. As arrangements for through passenger working were incomplete, there could be no through running to the company's Verney Junction outpost and trains terminated at a single temporary platform at Brook Street, Aylesbury, to the south of the planned Joint station and near the site of the later East signal-box.

Then on 1 January 1894 the Metropolitan was extended a short distance to join the Great Western Railway just outside Aylesbury Joint station. Only two platforms were provided to cater for Metropolitan, GWR and Great Central Railway trains. The 44-lever Joint signal-box erected by the GWR on the Up platform controlled GWR-pattern signals except those on the London side of the junction applying to Metropolitan and GCR traffic. The Metropolitan signalman at the East box controlled by slots the Up starting signal for Metropolitan/GCR trains. In the early 1900s the signalman at the Joint box averted an accident. A Down Metropolitan passenger train and a GWR goods from Princes Risborough were both approaching Aylesbury The alert signalman foresaw that the GWR train would be unable to stop at the adverse home signal and that this would cause the two trains to collide at the junction. Thinking quickly how to avoid disaster, he switched the runaway goods train into the outer face of the Down platform and the only damage was to the coaching stock stabled there.

Unfortunately the events of 23 December 1904 did not echo this satisfactory ending. The speed restriction through the reverse curve immediately south of Aylesbury station was 15 mph, but the 2.45 a.m. newspaper and mail train from Marylebone approached at such speed that Ganger Boughton in Aylesbury East signal-box remarked: 'My God, isn't this fellow travelling!' '11B' class 4-4-0 No. 1040 and four coaches were hurled on the Down platform and two ran to the Up, the remaining four vehicles being spread over both tracks. Among the wreckage were Christmas puddings. Both footplatemen were killed, together with two enginemen travelling 'on the cushions' in the second coach. The inquest jury returned a verdict of accidental death and, although caused by excessive speed, it is believed that Driver Joseph Bradshaw was unaware he was so near the curve and thus was not 'culpably negligent'. The jury admired the presence of mind displayed by Signalman John Keedle at Aylesbury Joint signal-box who, seeing the train start to derail, threw his Up signals to danger as the 10.20 p.m. express from Manchester had been given the road. Its driver was able to apply his brakes so that it struck No. 1040's tender relatively lightly, resulting in only the two front wheels of the Up engine being derailed.

In 1907 track slewing at a cost of almost £9,000 removed the reverse curve, while the Down platform was widened and made into an island. At the same time the original Joint signal-box and the Metropolitan box were removed, the latter to an unidentified

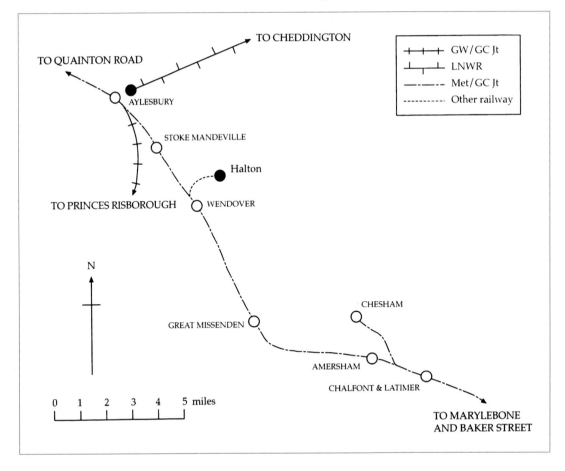

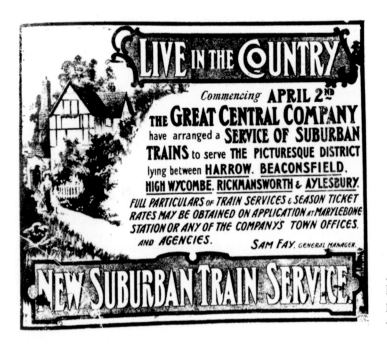

A GCR Aylesbury
line publicity
poster, 1906.
Author's collection

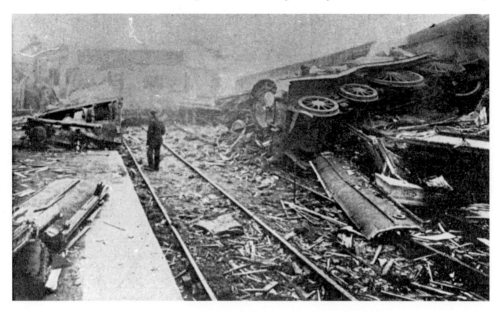

GCR 11B class 4-4-0 No. 1040 overturned after having taken the reverse curve south of Aylesbury station at too high a speed, 23 December 1904. *Author's collection*

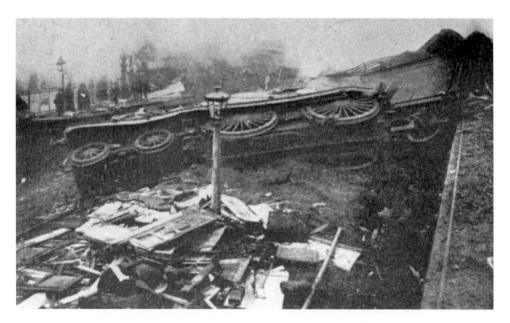

Another view of GCR 11B class 4-4-0 No. 1040 overturned in Aylesbury station after having taken the reverse curve too quickly, 23 December 1904. *Author's collection*

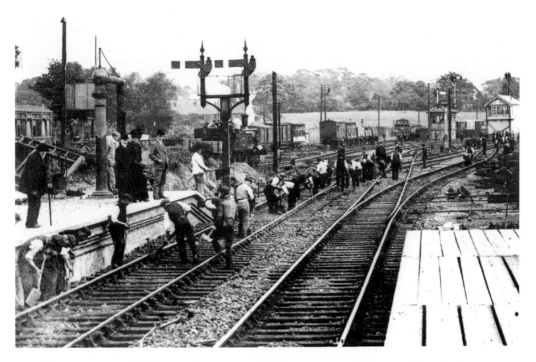

Aylesbury, view south during work to remove the reverse curve which caused the derailment on 23 December 1904. The new Aylesbury South signal box can be seen on the extreme right. Open cab Metropolitan Railway 4-4-0T No. 7 stands beyond the junction signal. 1908. *Author's collection*

north Lincolnshire station. The new junction signal-box with fifty-five levers was called Aylesbury South and located almost opposite the former Metropolitan box. Signalling maintenance was carried out by the GCR.

Under an Act of 1905 the Metropolitan Railway from Harrow to Aylesbury and Verney Junction was leased for 999 years to the Metropolitan & Great Central Joint Committee as from 2 April 1906 at £44,000 per annum. The 51 miles 41 chains of Joint Committee line was maintained by each company alternately every five years until April 1916 when the Metropolitan took it over permanently. Rather more recently Marylebone-Aylesbury has been used for a pilot scheme testing ATP – Automatic Train Protection – whereby an onboard computer picks up information from the track regarding the position of signals, or speed restrictions. Should a driver fail to slow the train to the required speed, a horn would sound and, if this warning were ignored, the brakes would be automatically applied. Trains on the line are now operated by Chiltern Railways.

Chalfont & Latimer and all stations northwards to Aylesbury are similar in style with buildings in yellow brick and ridge and valley type platform awnings. Chalfont & Latimer has two through platforms with a bay at the north end of the Up platform. Beyond, the line rises at 1 in 105 to Amersham, the end of London Underground track and the termination of electric trains. Originally a two-road station, the 1960 electrification added a platform face when the Down was converted into an island, the inner face used for terminating electric trains. From 12 September 1960 during off-peak times some electric trains had been extended to Amersham, but all other Metropolitan trains still continued to change from electric to steam propulsion at Rickmansworth. On Sunday 10 September 1961 Amersham became the terminus of London Transport trains and from then onwards stations to the north were only served by the LMR Amersham to Aylesbury shuttle service, which from 18 September 1960 had been in existence on Sundays. From 10 September

1961 when the Sunday through service was curtailed at Amersham, except for peak hour trains to Chesham, new trains of 'A60' stock were introduced to replace the Metropolitan compartment vehicles.

Just north of Amersham the line now enters Network Rail territory, reaches the summit of the line 500 ft above sea level, falls at 1 in 160 and rises just before Great Missenden. Beyond, the line climbs to a second summit of 500 ft at Dutchlands and drops to Wendover at 1 in 117. The Down platform has a bus-type shelter and the yellow brick building on the Up platform has hanging baskets of flowers to beautify its rather plain appearance. On one occasion early in his reign, King Edward VII used the station when visiting his friend Leopold Rothschild. The return journey to Marylebone arrived at the terminus ten minutes late and after remonstrating with William Thomas Monckton, the station superintendent, His Majesty strode off the platform ignoring the GCR directors lined up to receive him. The cause of the delay? A Metropolitan Railway pick-up goods train from Aylesbury, which by accident, or design, had been allowed to precede the royal train. Another notable visitor to the station was Winston Churchill who, with three chiefs of staff, joined a train at Wendover to travel to Thurso to board HMS *Prince of Wales* to meet President Roosevelt at Placenta Bay, Newfoundland.

In 1917 a railway about one-and-three-quarter-miles in length was opened between Wendover station goods yard and the Royal Flying Corps workshops at Chestnut Avenue, Halton. Although principally for goods traffic, unofficially some passengers were carried, such as men going to or from leave. Delivery of 500 tons of coal weekly for the camp boilers was additional to other traffic. In 1917 timber from Halton Woods was carried by the line and eventually was used as trench props on the Western Front. The line's importance grew during the Second World War, but traffic decreased in the ensuing years and it closed on 31 March 1963.

At Wendover the line made an end-on junction with the siding which ran alongside the Metropolitan & Great Central goods shed – a gate dividing RAF from GCR property. Beyond this gate the double-track curved sharply and climbed at 1 in 148. Beyond a gated cattle crossing it descended at 1 in 60 to a gated crossing over Dobbins Lane, by which

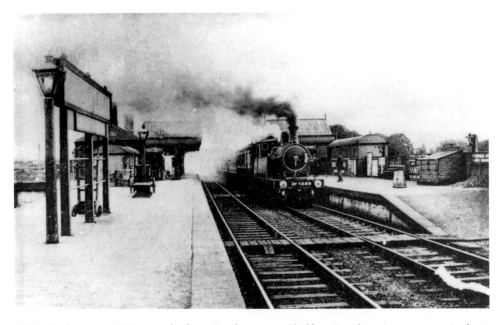

GCR 9K class 4-4-2T No. 359 built 20 April 1905, at Chalfont Road station, *c.* 1907. *Author's collection*

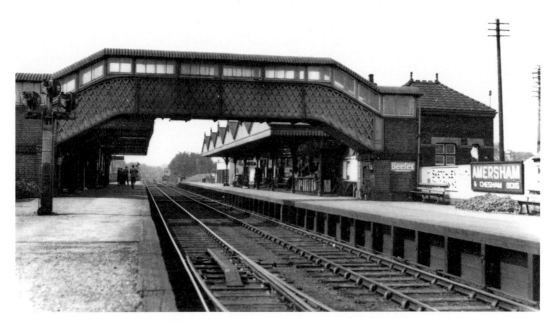

Amersham station: a bookstall can be seen on the right just beyond the footbridge, *c.* 1935. *Lens of Sutton*

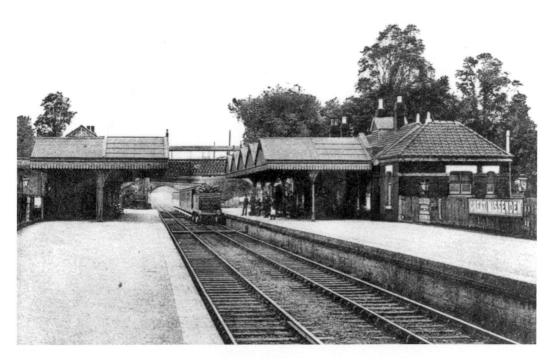

A tank engine enters Great Missenden with an Up train, *c.* 1910. *Author's collection*

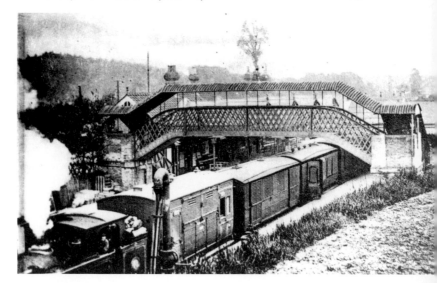

A Down train at Great Missenden; the first vehicle is a horse box and the second a ventilated van, *c.* 1905. *Author's collection*

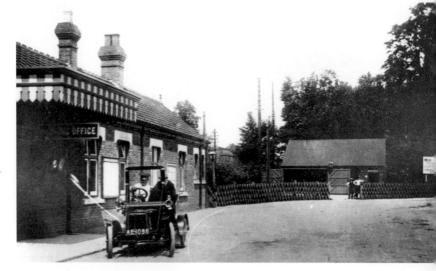

The carriage approach to Great Missenden, *c.* 1905. On the far right is an advertisement for the White Lion Livery Stables. The chauffeur-driven Napier 16.7hp AE 1096 car is registered at Bristol and deregistered at Dorset, 1 March 1933. *Lens of Sutton*

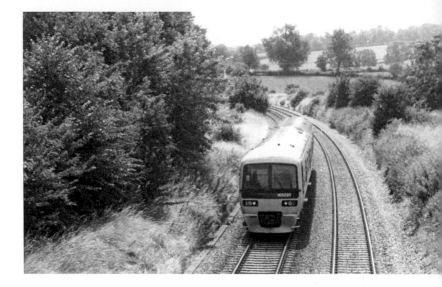

Rear view of Class 165/0 165020 north of Great Missenden working the 11.40 Aylesbury to Amersham. 2 August 1998. *Author*

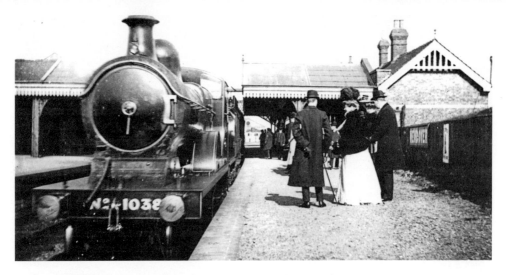

GCR 11B class 4-4-0 No. 1038 built in 1903, at Wendover with an Up stopping train, *c.* 1908.
Author's collection

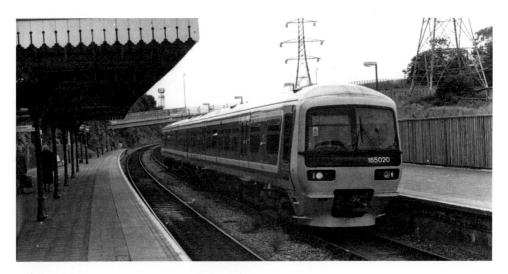

Class 165/0 165020 at Wendover with the 12.23 Amersham to Aylesbury. 2 August 1998.
Author

The Wendover
station cash bag
exhibited in the
Buckinghamshire
Railway Centre.
To the right is
a dating press.
21 June 1999.
Author

time the track had become single. The gradient steepened to 1 in 39 down to the Aylesbury Road (A413) level crossing which had no fewer than six gates: two for a fairly wide footpath on one side, two for the carriageway and two for the further footpath. South-west of the road was a loop line. Further on, the Wendover branch of the Grand Junction Canal was crossed by an iron bridge.

A triangular junction gave access to sidings terminating at right-angles to Tring Road or Upper Icknield Way (A4011) where the exchange siding with the 1 ft 11½ in gauge timber railway was situated. The standard gauge line continued parallel with Tring Road to terminate at right-angles to Chestnut Avenue alongside workshops built in 1917.

The line was worked by a variety of motive power which included: *Benton* a Black, Hawthorn 0-4-0T; *Southport,* a Hunslet 0-6-0ST; *Birkenhead* a Manning, Wardle 0-6-0T and various John Fowler 0-4-0 and 0-6-0 diesel-mechanical locomotives.

Stoke Mandeville has some interesting concrete statues on the station lawn: a porter with a barrow and rake, and a BR lion emblem. The east end of the station building houses a café.

Aylesbury Joint station has red brick buildings surmounted by a classical cupola. At one time there were three through roads and a bay on the Up side for Metropolitan trains, while the outer face of the Down platform was used by GWR trains to Princes Risborough. Today Aylesbury has two through platforms and a bay.

The engine shed at Aylesbury was situated to the west of the passenger station. Opened by the Aylesbury & Buckingham Railway in 1863, it was a single road, mixed gauge depot converted to standard gauge and an extra road laid in a lean-to building in 1868. About

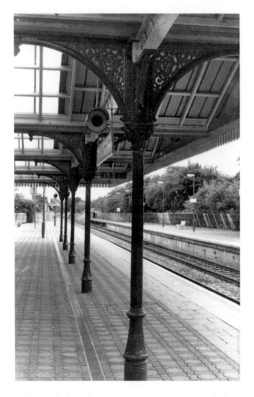

Above left: The attractive 'ridge and furrow' canopy sheltering the Up platform, Stoke Mandeville. Notice the skylights illuminating what would have been the dark rear of the platform. 2 August 1998. *Author*

Above right: A concrete statue on the station lawn adjacent to the Up platform, Stoke Mandeville: the BR lion emblem. 2 August 1998. *Author*

More concrete statues on the station lawn adjacent to the Up platform, Stoke Mandeville: porter, rake and sack truck. 2 August 1998. *Author*

Metropolitan Railway bridge plate No. 152 at Stoke Mandeville. 2 August 1998. *Author*

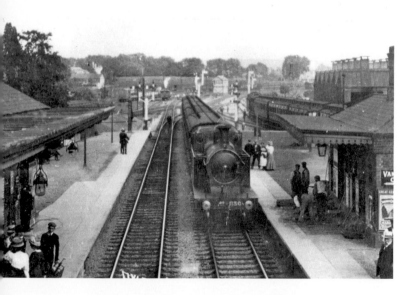

A GCR 9L class 4-4-2T enters Aylesbury Joint station with a five coach stopping train from Marylebone following the removal of the reverse curves, *c.* 1918. On the right is the GWR's branch to Princes Risborough and the engine shed. *Author's collection*

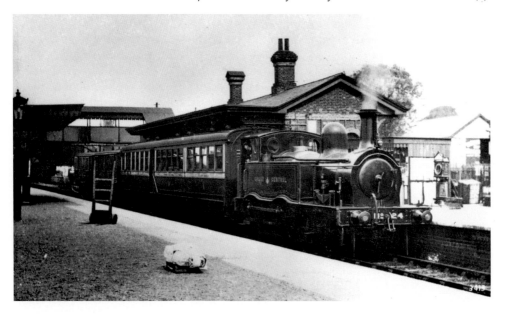

GCR 12AM class 2-4-0T No. 24 fitted for motor working in 1906, stands at Aylesbury Up platform, *c.* 1909. This engine was built by Charles Sacré for the Manchester South Junction & Altrincham Railway. The electrically lit 60-foot- long auto coach is carried on two six-wheeled bogies. Apart from the driver's and luggage compartments, it contained a 16-seat first class compartment and two 24-seat third class saloons. Notice the weighing machine and pigeon basket to the right of the smokebox. *Lens of Sutton*

1893 the shed was rebuilt and given a slated north-light pattern roof. The shed road nearest the running line was known as the 'Met Road', though in fact it was later also used by the GCR. Aylesbury shed was used by engines of all three companies (GCR, GWR, Metropolitan), who shared expenses. In 1912 a gas engine was provided 'for pumping water from a brook-fed well for locomotive purposes', but in 1931 it was replaced by an electrically driven centrifugal pump. This pleased the cleaners who took turns using the gas engine. GWR men looked after it from 9.00 a.m. until 9.00 p.m. and LNER men from 9.00 p.m. till 9.00 a.m. Occasionally fish slipped through the grid and spent their lives quite happily in the water tank.

Circa 1920 the combined Great Central and Metropolitan staff at the shed outnumbered those of the GWR. Great Central staff comprised four sets of men for the 'A5' class 4-6-2Ts working to London; three sets of men working more locally including services to Verney Junction; a night foreman and four cleaners. The GWR employed four crews for working the principal turns and two sets for the 'Banbury Car' – the auto-train from Princes Risborough to Banbury. Additionally there were two GWR cleaners and a fire dropper. In 1938 an improvement was made to working conditions when the coal stage was covered at a cost of £90.

The Metropolitan Railway's first locomotives were 'A' and 'B' class 4-4-0Ts, but with the extension into the surrounding countryside came 'C' and 'E' class 0-4-4Ts and 'D' class 2-4-0Ts. In 1901 'F' class 0-6-2Ts were built for freight working. In 1915 the 'G' class 0-6-4Ts appeared, No. 97 named *Brill*. In 1921 'H' class 4-4-4Ts were supplied by Kerr, Stuart for working fast passenger trains north of Rickmansworth and in 1925 these were joined by 'K' class 2-6-4Ts built by Armstrong, Whitworth & Co., mainly from parts supplied by Woolwich Arsenal for 2-6-0 tender engines to Richard Maunsell's South Eastern & Chatham Railway design based on GWR practice. The 'K' class were mainly used on heavy freight traffic between Verney Junction and Finchley Road. On 1 November 1937

the London Passenger Transport Board, as the Metropolitan had become, ceased working trains north of Rickmansworth and handed eighteen locomotives of classes 'G', 'H' and 'K' to the LNER, From 1938 onwards the ex-Metropolitan tank engines were superseded on Rickmansworth to Aylesbury trains by ex-GCR Robinson 'A5' class 4-6-2Ts, these in turn being replaced by 'L1' class 2-6-4Ts in the early post-war period. The transference of the line to the London Midland Region in 1950 brought Fairburn 2-6-4Ts, and in later years BR Standard Class 4 2-6-4Ts, to replace the ex-LNER engines.

In 1931 the LNER out-stabled three Neasden engines: two engaged on local working between Aylesbury and Marylebone, the third working a shuttle service between Aylesbury and Verney Junction. In GWR days, the depot, although a sub-shed of Slough, had engines supplied by two other sheds. For example, in 1937 Old Oak Common and Slough both supplied a '61XX' class 2-6-2T, while the auto '48XX' class 0-4-2T came from Banbury. The friendly nature of the shed was obvious when on Christmas Eve 1939 J. Baverstock, who had been a GWR chargeman at Aylesbury, retired and was presented with gifts by GWR, LNER and LPTB officials. The cosmopolitan style of Aylesbury shed is illustrated by its 1955 allocation of a '14XX' class 0-4-2T; a '64XX' class 0-6-0PT, an ex-LMS Class 4 2-6-4T; an ex-LNER 'L1' class 2-6-4T; two ex-LNER 'N5' class 0-6-2Ts and two BR Standard Class 4 2-6-0s. In March 1958 Aylesbury became solely a Neasden sub-shed, but the engine for the 'Banbury Car' was still supplied by Banbury. In 1961 some Derby-built DMUs appeared, the full DMU timetable starting in June 1962 which led to the closure of Aylesbury shed on 18 June 1962. Subsequent events have proved that this was not really the end of Aylesbury's importance as in more recent years Chiltern Railways has established a maintenance depot there.

Until the end of steam, Baker Street to Aylesbury trains were interesting in that they contained some of the features of Metropolitan days – 1909 'Dreadnought' compartment coaches painted in the old Metropolitan livery of varnished teak rather than comprising red saloon cars with guard-operated sliding doors. In peak periods trains from Aylesbury worked through to terminate in the City. In 1955 the service to Aylesbury required four trains in off-peak hours but demanded nine in peak periods. Until 1 February 1940 first-class accommodation was available, but due to war-time conditions requiring the utmost use of space, third class was abolished on the LPTB, and the former first-class compartments, retaining their Lincrusta-papered ceilings, were relegated to third class. Knowledgeable passengers preferred using them as they offered more leg room. With the advent of electrification to Amersham, after making their last journey on 9 September 1961, the nine trains of 'Dreadnought' stock were withdrawn.

Another interesting coaching feature of the line was that from 1 June 1910 until 7 October 1939 two Pullman cars, *Mayflower* and *Galatea,* worked over the line. The Pullman Car Company charged a supplementary fee of sixpence from London to Rickmansworth, or a shilling north of Rickmansworth, The Metropolitan route from Aylesbury to London was 38 miles – twelve miles less than the GWR via Princes Risborough and Maidenhead, and five miles less than the GWR's later route via Denham. From its opening, the Metropolitan started a service offering two trains an hour for most of the day and covering the 38 miles in about one-and-a-half hours. Its fares undercut those of the GCR and GWR by a shilling for a single to London with the result that it soon captured all the traffic. In 1910 about twenty-three trains ran each way between Baker Street/ Marylebone and Aylesbury and twelve on Sundays. In 2010 forty one trains run on weekdays and sixteen on Sundays from Marylebone to Aylesbury via Amersham. Most call at all stations and take approximately sixty minutes, but at the evening rush hour a few run non-stop Marylebone to Amersham or Great Missenden and reach Aylesbury a few minutes faster. One train an hour is extended to Aylesbury Vale Parkway. At first using temporary buildings, Aylesbury Vale Parkway opened two-and-three-quarter miles north of Aylesbury on 12 December 2008, permanent structures being officially opened by Transport Secretary, Lord Adonis on 13 July 2009. This station enjoys an hourly off-peak service to Marylebone via Amersham, with a slightly more frequent service during rush hours. On Sundays eighteen Down and Fourteen Up trains run.

DMU No. 960010 and No. 165026 at the Chiltern Line Maintenance Depot, Aylesbury. 29 August 1998. *Author*

In the past, a special train could be hired by an individual. One evening a man missed the last train from Marylebone to Aylesbury. Demanding a special, he paid the first-class return fare plus £5. An engine and first-class brake was brought to a platform and the gentleman boarded. The last Down scheduled passenger train was at Chorley Wood when the signalman there received the bell code offering the special. Giving it priority, he shunted the timetabled train into a siding to allow the special to pass. Thus the man who missed his train arrived home before it reached its destination!

In 1999, to help ease road congestion, the Chiltern Railway Company offered free local bus travel with certain bus operators in Aylesbury, to holders of monthly, or longer, season tickets, or free car-parking at Aylesbury station when three or more customers arrived in the same car.

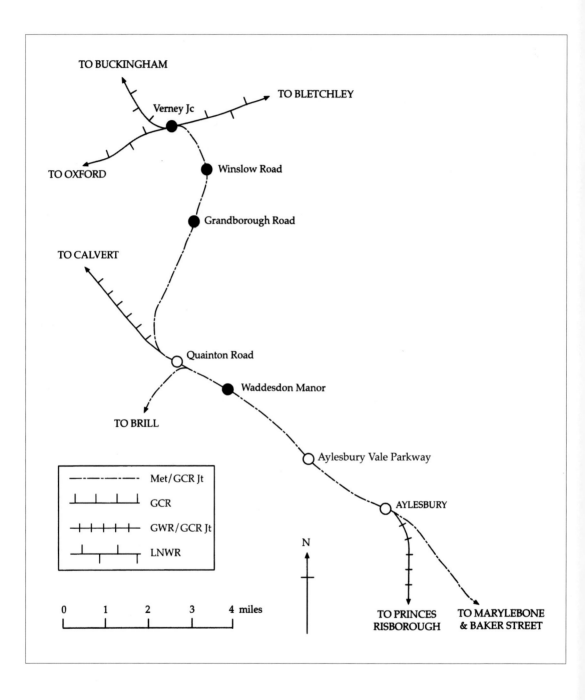

Aylesbury to Verney Junction

The first scheme to link Aylesbury with Verney Junction on the Oxford to Bletchley line, was a direct railway from the LNWR's Aylesbury terminus of its branch from Cheddington. This scheme was submitted to the principal landowner, the Marquis of Chandos, Wotton House, Wotton Underwood. He offered his financial support to the tune of £5,000 and agreed to join the board of directors as chairman (the Marquis was already chairman of the LNWR), on condition the route was modified to run west, instead of east, of Quainton Hill thus taking the line to within about three-and-a-half miles of his home.

An Act of 6 August 1860 authorized this railway between Aylesbury and Verney Junction. Its capital was £98,000, plus loans of £32,500 and the LNWR given powers to work the line. As the original capital proved inadequate, an Act of 25 July 1864 allowed the raising of a further £12,000 in shares and £4,000 on loans, while another Act of 19 June 1865 authorized £110,000 in shares and £35,000 on loans. The line's promoters were Francis Rummens, contractor; Walter M. Brydone, engineer; and Thomas D. Calthrop, solicitor. Its first directors were: the Marquis of Chandos, chairman; Sir Harry Verney, deputy chairman; and Joseph Grindley Rowe, secretary.

In February 1861 Francis Rummens began work at the Verney Junction end of the line. As the junction was two miles from both Winslow and Claydon, there was no obvious geographical choice of name. Sir Harry Verney of Claydon House, Winslow, deputy chairman of the company and MP for Buckingham, said that as the junction was on his land, he should name the station. The station was made by the LNWR, but its cost defrayed by the Aylesbury & Buckingham Railway (ABR).

In 1861 the Marquis of Chandos resigned the LNWR chairmanship and under the direction of Richard Moon, the new chairman, that company's policy changed. When the ABR was almost complete, the company applied to the LNWR to work the line, but the LNWR directors considered it a poor proposition financially and repudiated the agreement. The ABR had partly laid the link at Aylesbury with the LNWR's branch from Cheddington and, with this announcement, work on this connection ceased abruptly. The LNWR continued its antagonism and, when the ABR opened, encouraged passengers to Aylesbury from stations on the Oxford to Verney Junction line to travel the circuitous route via Bletchley and Cheddington, thus adding fourteen-and-three-quarter miles to their journey, rather than travelling directly by the ABR.

The ABR sought a new ally and found one in the GWR as its broad gauge Wycombe Railway had reached Aylesbury on 1 October 1863. Both railways had the same contractor, Francis Rummens, in common. For working the line to Verney Junction the GWR supplied two standard gauge '517' class 0-4-2Ts and three ex-Oxford, Worcester & Wolverhampton Railway coaches, first, second and third class respectively. As the single track ABR opened without ceremony on 23 September 1868, a month before the Princes Risborough to Aylesbury line was narrowed, the GWR standard gauge stock for working the ABR was run over the LNWR from Oxford to Verney Junction. The GWR charged the ABR 1s 1½d per mile as working expenses. As the GWR station at Aylesbury was broad gauge, the platform problem was overcome by erecting a temporary stage built from sleepers and situated outside the broad gauge limits. Three trains were run each way daily, but as the LNWR had anticipated, ABR traffic proved light and, except on market days, one coach sufficed. Receipts for the half-year ending 30 June 1870 were only £700. The

company never paid a dividend and eventually fell into the Receiver's hands as it owed no less than £21,000 to the GWR.

Except for the enginemen and guard, who were Great Western servants under ABR control, the ABR provided the staff. To facilitate working, the GWR converted its Princes Risborough to Aylesbury branch to standard gauge between 13 and 23 October 1868 and this allowed ABR trains to work into Aylesbury Joint station and also to run through to Princes Risborough when the occasion arose. The ABR opened a ten-lever signal-box at Aylesbury, the GWR installing Thomas Blackhall's locking gear made at the Great Western's signal works, Reading. The signal-box adjoined the level-crossing and this, and a portion of Station Road, was closed on Good Fridays to protect the company's rights as it was not a public way.

In 1874 the Great Western obtained powers to absorb the ABR, a policy which commended itself to James Grierson, the GWR's general manager, but immediate action was not taken and before the terms of transfer had been arranged, Grierson died in 1887. His successor Henry Lambert was not alive to the potentialities of the route and declined to proceed with the matter. The ABR directors then treated with the Metropolitan Railway whose chairman, Sir Edward Watkin, was interested in the ABR as it would assist his company to expand northwards. In due course the ABR was vested in the Metropolitan by an Act of 25 July 1890 as part of a projected link from the Manchester, Sheffield & Lincolnshire Railway via the Metropolitan to the South Eastern Railway, all companies with which he was associated, the plan being to link with a Channel Tunnel. From the 1870s Sir Edward Watkin was concerned in the Submarine Continental Company, but in 1882 the Board of Trade ordered the Submarine Company to cease boring. The Metropolitan took over the ABR as from 1 July 1891 paying £100,000 in three per cent guaranteed stock which compared unfavourably with the construction price of £167,000.

At first nothing changed and the GWR continued to provide locomotives and rolling stock. J. G. Rowe, former secretary and general manager of the ABR was appointed traffic superintendent for this section of the Metropolitan Railway. The line was isolated from the rest of the Metropolitan system until 1 September 1892 when a temporary terminus was opened at Brook Street, Aylesbury, pending a settlement of a dispute with the GWR over the use of the junction station. The latter was used by the Metropolitan from 1 January 1894. Although in theory the Metropolitan could work its trains to Verney Junction, in practice this was impossible as the light track and weak underline bridges precluded the use of existing Metropolitan locomotives. Due to the Metropolitan's 'unfriendliness', the GWR agreed to continue working to Verney Junction only until 31 March 1894. The Metropolitan believed that the line could take 38-ton tank engines, though not of the saddle tank variety 'as they roll'. For the interim period until the Metropolitan's engines began work on 31 January 1895, the LNWR loaned two 38½-ton 2-4-2Ts.

The Metropolitan improved the line by rebuilding stations and relaying the track to main-line standard with heavier rail, purchasing additional land and adding a second track, this doubling being completed on 1 January 1897. An economy was effected by closing twelve level crossings between Aylesbury and Quainton Road. The ABR had used a wooden train staff on the two single line sections from Aylesbury to Quainton Road and Quainton Road to Verney Junction, but the Metropolitan Railway installed 'lock and block' signalling. For a long time a double-armed signal at Verney Junction controlled ABR traffic, but latterly was not used. The Metropolitan installed Verney Station Cabin at the west end of the exchange sidings, a 'yard box' for occasional use being sited at their east end. In ABR days there was no telegraph between Quainton Road and Verney Junction, the wires from Aylesbury only running to Quainton Road and then on to Brill. They were GPO lines, so the GPO linemen enjoyed free travel over the ABR. Verney Junction was staffed by the LNWR except for the Metropolitan signalman and the goods yard shunter.

The section from Aylesbury to Quainton Road took on a new importance when it became part of the Great Central Railway's London extension, the Rt Hon. C. T. Ritchie, President of the Board of Trade, opening it to passenger traffic on 15 March 1899, the Metropolitan

having granted running powers from Quainton Road to Harrow-on-the-Hill. Public traffic on the GCR commenced on 15 March 1899 and on 2 April 1906 the Metropolitan leased its line from Harrow-on-the-Hill to Verney Junction to the Metropolitan & Great Central Joint Committee.

In the 1930s bus competition severely affected passenger traffic at stations between Verney Junction and Quainton Road as these were sited rather distant from the villages they served, as indeed the 'Road' suffix suggested. On 4 July 1936 the Quainton Road to Verney Junction passenger service was withdrawn and Metropolitan trains ceased running north of Aylesbury. Following closure of the branch to passenger traffic, level-crossing gates were operated by the goods train staff. Through parcels and freight trains continued to run. Three goods trains used the line each way daily to and from the Northampton district via Bletchley. In 1939 the work began on singling the track from Verney Junction to Quainton Road and this was completed on 28 January 1940. Until 1935 Metropolitan engines had been responsible for goods trains over this link, but the LNER worked the milk train to and from Marylebone on Sundays and the local milk train on weekdays. As most LNER goods trains ran via High Wycombe, to cater for the Aylesbury line two LNER workings were made each way daily between Quainton Road and Woodford & Hinton until 6 September 1947 when all traffic was diverted via the Calvert spur. By 1951 the branch was used for storing rolling stock and the track was subsequently lifted.

A description of Aylesbury station appears on page 65. Until the early 1900s, an unusual feature of the goods yard there was that its Down end was controlled by a key obtained from the Joint signal-box, shunting having to take place between train workings. There are no features of engineering interest between Aylesbury and Verney Junction and only one cutting beyond Quainton Road. The stations, all modernized by the Metropolitan, had a substantial brick building and awning on one platform, with a modest timber-built shelter on the other. Waddesdon Road had its main building on the Down side, while the others had theirs on the Up side. The Metropolitan opened Waddesdon Road station on 1 January 1897 and renamed it Waddesdon Manor on 1 October 1922. It closed to passengers and goods on 6 July 1936 when the Metropolitan ceased running north of Aylesbury and the LNER withdrew its local service. The station had been used by Lord Rothschild, owner of the manor, the Metropolitan Railway building him a special saloon from two old compartment coaches.

Quainton Road station is described on page 55. Just to the north, at the point where the Verney Junction line diverged, was an unusual gradient post showing 'level' on both arms. This was provided before the line was run by the Joint Committee in order to avoid the staff of a foreign company having to trespass in order to ascertain the gradient. With the arrival of the GCR, the Metropolitan erected a signal-box at Quainton Junction, approximately one-third-of-a mile north of the station, at the point where the line to Rugby and the line to Verney Junction separated. The latter ran parallel with the main line for a quarter-of-a mile before bearing away and climbing the two-mile long Hogshaw Bank, the steepest stretch of which was a half mile rising at 1 in 111, followed by a one-and-a-half-mile descent on a ruling gradient of 1 in 121. Granborough Road closed to all traffic on 6 July 1936 and until 6 October 1920 had been called Grandborough Road. Winslow Road also closed to all traffic on 6 July 1936.

Verney Junction, latterly having no junction and just an ordinary station on the Oxford to Bletchley line, closed to goods traffic on 6 January 1964 and to passengers on 1 January 1968. It served no particular village and was principally an interchange to and from the Oxford to Cambridge line. The Metropolitan Railway paid for improvements to the station. Originally there was no shelter on the Down platform and tickets were issued from the station master's house. Florence Nightingale frequently used the station when making visits to Sir Harry Verney at Claydon House. In 1894 the station master's working hours were 7.40 a.m. – 8.45 p.m. daily, and for this he received an annual salary of £80. He was assisted by a junior porter paid 15 shillings a week. In May 1894 the Metropolitan Railway, which shared the station costs with the LNWR, agreed to the appointment of a

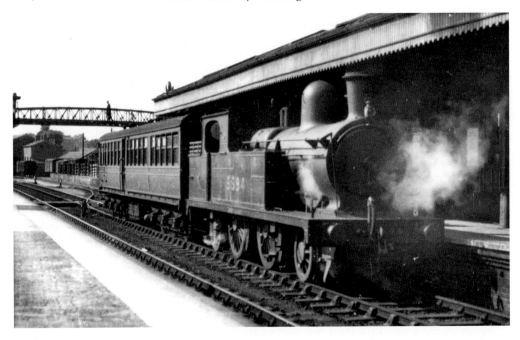

LNER F1/2 class 2-4-2T No. 5594 at the Up platform, Aylesbury, with the motor train to Verney Junction, *c.* 1935. The coach is of the same type as in the previous picture. Cattle pens are to the rear of the coach. The footbridge has unusually low sides. *Lens of Sutton*

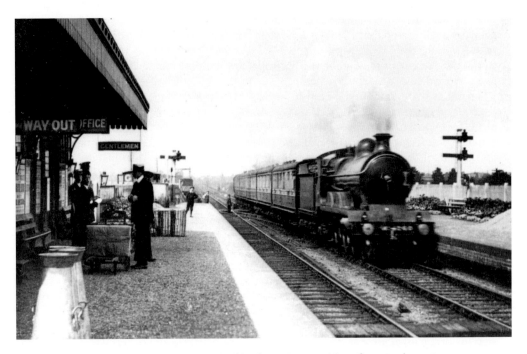

GCR 8B class 4-4-2 No. 260 passes Waddesdon Manor with a five coach express, *c.* 1910. A van stands in a siding to the left of the left hand signal. The signals are on low posts. *Author's collection*

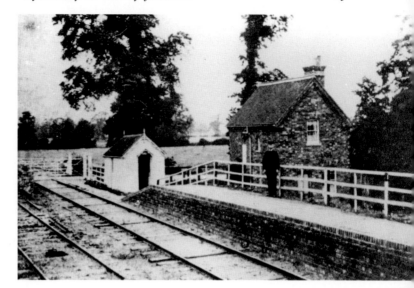

Winslow Road in single line days *c.* 1894. Notice the light track with rails spiked to the sleepers. *Author's collection*

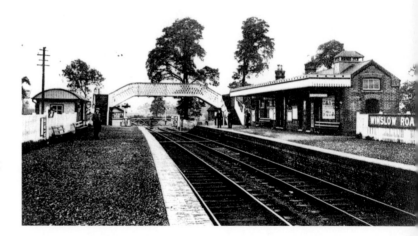

Winslow Road following track doubling, *c.* 1910. It closed to passengers 6 July 1936. *Author's collection*

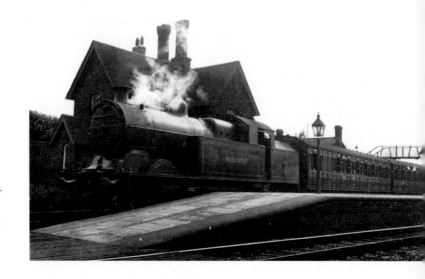

London Transport Passenger Board 0-6-4T No. 7 *Brill* at Verney Junction with a train to Baker Street, *c.* 1934. *Lens of Sutton*

senior porter at 17s 6d a week. To ease serious congestion, three exchange sidings were laid south-east of the station. This work was completed in January 1897 coinciding with the doubled and rebuilt line to Aylesbury.

During the period when the GWR worked the branch, trains were usually 'mixed'. The GWR supplied two new standard gauge 0-4-2STs of the '1040' class soon re-designated the '517' class when in July 1870 re-numbering took place. Designed by George Armstrong, these engines were built at Wolverhampton and had an open cab. The saddle tanks were later replaced with side tanks. On the cessation of GWR working, during the interim period the LNWR loaned two 38½-ton 2-4-2Ts No. 841 and No. 951. It charged £2 10s 0d for a day of ten hours, this sum including the driver's wages, but the Metropolitan supplied both the fireman and the coal. A trial trip was made on Saturday 31 March 1894 when the chief problem proved to be the newly laid Metropolitan sidings at Verney Junction which had such a severe curve that the LNWR engine was highly likely to become derailed. The LNWR locomotives began to work the line on 2 April 1894.

On 29 August 1894 the Metropolitan directors authorized the purchase of two 33-ton 2-4-0Ts from Sharp, Stewart & Co. at a cost of £1,575 each. No. 71 and No. 72 began work on 31 January 1895, the borrowed LNWR engines being returned the following day. On arrival at Verney Junction of the Metropolitan engine, it was not unusual for it to be sent to pick up cattle traffic from Winslow Road and Grandborough Road and return with it to Verney Junction for attachment to the return passenger train to Baker Street. On these occasions a special stop was made at Finchley Road for the cattle vans to be detached and sent to various parts of London. As there was no locomotive or carriage accommodation at Verney Junction, the Aylesbury to Verney Junction GCR railmotor and the Metropolitan train were kept overnight at Aylesbury. The GCR had built three railmotors between 1904 and 1905. The power bogies were very similar to those of the GWR and the coachwork had bowed ends and elliptical roofs. The main centre entrance was closed by a waist-high lattice gate. The rear bogie was unusual in that it was suspended by outside fixed links and a spring bolster in the manner of the engine bogie. A few months after each overhaul the railmotors developed an unpleasant motion. Not surprisingly, they had a relatively short life and were scrapped soon after the end of the First World War.

In 1906 three of Sacré's '12AT' class 2-4-0Ts No. 23, No. 24 and No. 448, originally designed for the Manchester South Junction & Altrincham Railway, were equipped for push-pull working and redesignated '12 AM' class. They worked a 60 ft long, six-wheeled bogie, electrically lit auto-coach with compartments for driver; luggage; sixteen first-class seats; and two third-class saloons each seating twenty-four passengers. Locomotive No. 24 and one of the coaches worked between Aylesbury and Verney Junction. The push-pull operation was a mechanical system using pulleys, rods and cables. For its last few years of working, the LNER used a two-coach push-pull set and an ex-GCR or GER, 2-4-2T, No. 8307, being employed.on the last day of passenger services.

The timetable for summer 1887 showed three trains each way running on weekdays only. Aylesbury to Verney Junction took about 35 minutes for the twelve-and-a-quarter miles. A first class single cost 1s 6d and a third class, 8d. In 1891 when the Metropolitan took over, four trains ran each way. Following the opening of the Metropolitan from Aylesbury to Baker Street on 1 September 1892, for some years a through service was run from Verney Junction to Baker Street in addition to the local service. The 1910 timetable showed a greatly improved service with nine each way daily and one Down and two Up on Sundays. Five ran through to Baker Street or Marylebone. In 1922 eight trains were offered daily, including one Pullman service with a car named *Mayflower* or *Galatea*. Six of the eight trains ran through to Baker Street or Liverpool Street. There was one train each way on Sundays.

Quainton Road to Brill

The Wotton Tramway was built to serve the Duke of Buckingham's estate. He paid its cost and gave his own land for the greater part of the line's length and leased the remainder from Winwood's Charity. As no land needed to be purchased, no Parliamentary powers were required. The tramway ran for six-and-a-half miles from Quainton Road station on the Aylesbury & Buckingham Railway, to Brill, while a one-and-a-half-mile-mile long branch served Moat Farm. Construction began on 8 September 1870 and, unusually, no contractor was employed except for a short period when the bridge rails were laid on longitudinal sleepers. The timber cross ties set at twelve-foot intervals were sunk and covered by ballast to prevent horses being tripped. The single track was standard gauge. Most of the earthworks were made in the winter when labour was available and cheap because during that season fewer were required for agricultural work. Ballast was expensive as it had to be brought by rail from Buckingham, but the cost of the line, including sidings and two goods sheds, was, exclusive of land, rather less than £1,400 a mile.

Quainton Road to Wotton opened on 1 April 1871 using horse traction. The greater portion of the remainder of the line opened for mineral and agricultural traffic in November 1871, while the final quarter-mile to Brill opened in March 1872. It was not intended to carry passengers other than estate workers and stockmen, but so many requests were made that a coach was borrowed and began service in January 1872. The line's principal traffic was general goods; ale; chalk for farms; coal; hay and manure. The tramway was used to bring Bath stone and other materials for the construction of Waddesdon Manor built 1877-83 by Baron Ferdinand de Rothschild.

The tramway was important as it had possibilities of being extended to Oxford, and to this end the Oxford, Aylesbury & Metropolitan Junction Railway was incorporated in 1883. On 7 August 1888 Royal Assent was given to the Oxford & Aylesbury Tramroad Act which authorized an eleven-mile extension from Brill to Oxford, the company to rent or purchase the Wotton Tramway. The Oxford scheme proved abortive and nothing was done except for securing extension of time Acts and envisaging electric traction. On 15 April 1894 the Oxford & Aylesbury Tramroad took over the Wotton Tramway and replaced the original track with 50 lb/yd flat-bottomed rail, spiked to transverse sleepers, but using Krupp's bullhead rail and chairs in places.

The original halts, mere earth banks, were replaced with low platforms. Stations were situated at the two termini and at Waddesdon, Westcott, Wotton and Wood Siding. Except for the termini and Wotton, all were request stops. Waddesdon Road was renamed Waddesdon in the mid-1890s but reverted to its original name on 1 October 1922 while Wescott became Westcott in the mid-1890s.

Following reconstruction, the line had to be inspected on behalf of the Board of Trade by Major-General C. S. Hutchinson. He found that the steepest gradient was 1 in 36 for a very short distance and that there were three other brief stretches of 1 in 39, 46 and 49. He reported that there were no cuttings or embankments of consequence and no over, or under, line bridges. The normal position of the gates at the four level crossings was across the railway and not the highway. An undertaking dated 22 November 1894 was given under the seal of the Oxford & Aylesbury Tramroad Company that speed would be restricted to 12 mph and 2 mph at level-crossings.

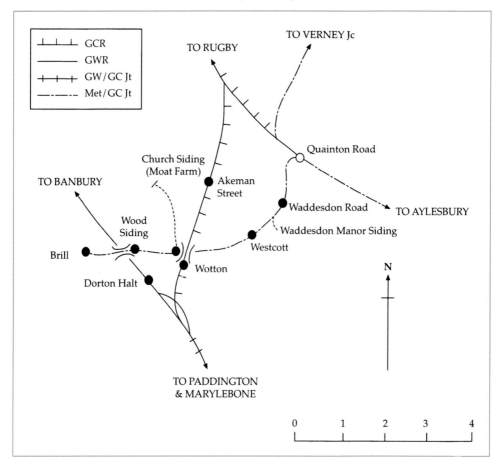

Form for announcing trucks forwarded.

WOTTON TRAMWAY.

His Grace the Duke of Buckingham and Chandos, Proprietor.

A TRAIN will leave BRILL STATION for QUAINTON at 6.55 a.m and 2.20 p.m. and will leave QUAINTON for BRILL about 9.10 a.m. and 6.5 p.m.

THE RUNNING WILL BE AS UNDER:—

	A.M.	P.M.
Leave Brill	6.55	2.20
„ Wood Siding	7.9	2.33
„ Church Siding	7.21	2.46
„ Wotton	7.31	2.55
„ Wescott	7.56	3.25
„ Waddesdon Road	8.20	3.40
Arrive at Quainton	8.33	3.55

	A.M.	P.M.
Leave Quainton	9.10	6.5
„ Waddesdon Road	9.33	6.26
„ Wescott	9.45	6.38
„ Wotton	10.10	7.0
„ Church Siding	10.16	7.6
„ Wood Siding	10.38	7.20
Arrive at Brill	10.55	7.40

These times will be adhered to as far as possible, but the running may be delayed, especially on the return journey, by late arrivals of the Trains at Quainton, or from other causes.

R. A. JONES,
Manager.

Brill, October 1st, 1887.

DE FRAINE, PRINTER, "BUCKS HERALD" OFFICE, AYLESBURY.

AYLESBURY & BUCKINGHAM RAILWAY,
AND
WOTTON TRAMWAY.

Arrangements have been made by which **GOODS** and **PARCELS** can be Booked through, between AYLESBURY and the undermentioned Places in WOTTON TRAMWAY District, on and after 1st December next, (including collection or delivery,) at the following Rates.

VIZ. —

Ale and Porter	6d.	per Cwt.
Groceries, in Mixed Packages	6d.	„
Hardware	6d.	„
Haberdashery and General Drapery	7½d.	„
Earthenware, in Casks and Crates	6d.	„
Leather	6d.	„
Iron and General Ironmongery	6d.	„
Wines and Spirits, in Casks and Cases	6d.	„
Ditto, in Hampers	7½d.	„
Ditto, in Jars or Bottles *(protected by basketwork)*	7½d.	„
Ditto *(protected by basketwork)* if in over 4-gall. size	9d.	„

	Above 14lbs. and Under 14lbs.	until more by weight
Single Parcels or Packages	6d. each.	8d. each.

DELIVERIES MADE AS FOLLOWS:

Brill and Wotton	*Daily.*
Boarstall, Oakley, & Little London	*Wednesdays & Saturdays.*
Ham Green, Kingswood, Grendon, and Edgcott	*Tuesdays, Wednesdays, Fridays, and Saturdays.*
Dorton, Ashendon, and Pollicott	*Wednesdays & Saturdays.*
Ludgershall and Piddington	*Mondays and Thursdays.*

☞ *Any further particulars can be obtained at the Offices of the Aylesbury and Buckingham Railway, Aylesbury; or any of the Offices on the Wotton Tramway.*

Aylesbury, 12th November, 1872.

DE FRAINE, PRINTER, "BUCKS HERALD" OFFICES, AYLESBURY.

Above left: Wotton Railway timetable, 1 October 1887. *Author's collection*

Above right: An early through-booking announcement.

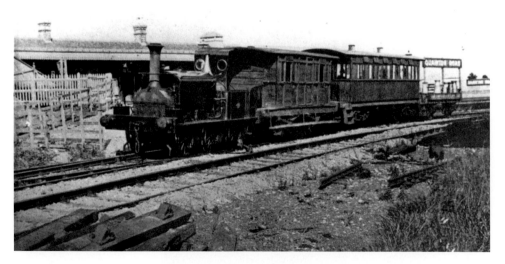

0-6-0ST *Huddersfield* at the Brill branch platform, Quainton Road, *c.* 1894. Milk churns are on the flat truck at the rear of the train. *Author's collection*

Waddesdon Road station, 1935. *Lens of Sutton*

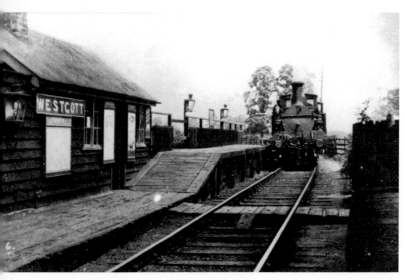

A Metropolitan Railway 4-4-0T arrives at Westcott, *c.* 1920. Its smoke box door is hinged laterally rather than vertically. Both platform and shelter are timber-built. *Lens of Sutton*

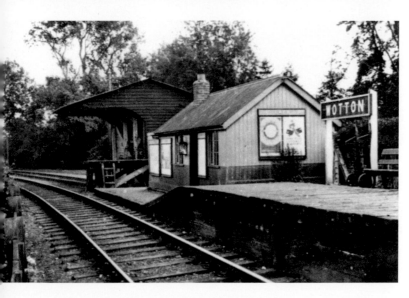

Wotton station, of similar construction to that at Westcott, *c.* 1935. Notice the goods shed beyond. *Lens of Sutton*

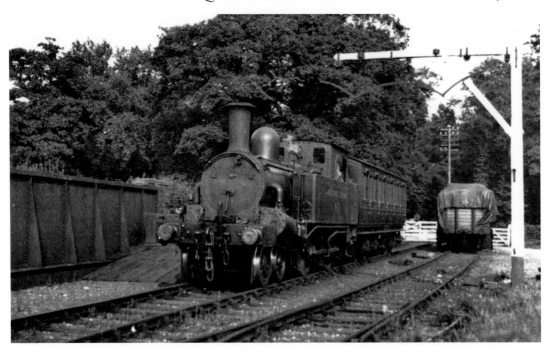

Metropolitan Railway 4-4-0T No. 41 with a Down train at Wood Siding, *c.* 1935. The girder of the bridge over the GWR (see centre picture, page 34) can be seen on the left. Notice the smartly painted loading gauge. *Lens of Sutton*

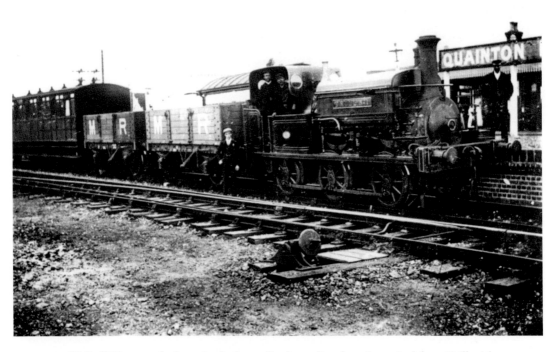

0-6-0ST *Brill* No. 1 at the branch platform, Quainton Road, on its arrival from Brill with two Midland Railway open wagons in front of the coach, *c.* 1900. The rope on the front buffer beam is used for shunting. *Author's collection*

Although still owned by the Oxford & Aylesbury, from 1 December 1899 the line was worked by the Metropolitan Railway and on 2 April 1906 the Metropolitan & Great Central Joint Committee took control of the line, but never purchased it. By 1908 track maintenance was carried out by the GCR which by 1910 had relaid the line with bullhead rails set in chairs, but the original bridge rails and later flat-bottomed rails could still be found in sheds at Brill. With the opening of the new GWR and GCR routes to the Midlands, the former's Brill & Ludgershall station opened in 1910 and the latter's Wotton in 1905, and these siphoned some traffic from the Brill line. The Moat Farm branch closed in 1910. With the formation of the London Passenger Transport Board in 1933, the LPTB took over the line's working, but then made the decision not to run trains beyond Aylesbury, so the branch closed from 1 December 1935. The last train, comprising one old coach and one newer one, carried so many passengers that more than half were required to stand. This was quite a contrast to an ordinary day as in its last years daily traffic averaged fifty-eight passengers and 34 tons of goods, the branch creating a loss of £4,000 a year. As the tramway's lease to the Metropolitan & Great Central Joint Committee expired at midnight on 30 November 1935, the Committee removed a rail at Quainton Road immediately after the arrival of the last train on 30 November. It was later replaced in order to facilitate the removal of the permanent way and other materials.

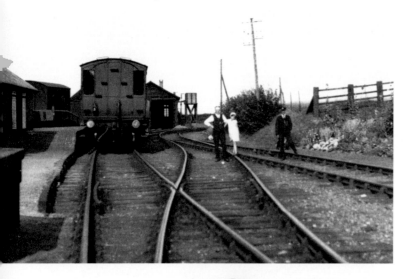

Brill: passenger station left; locomotive shed, centre, *c.* 1935. *Lens of Sutton*

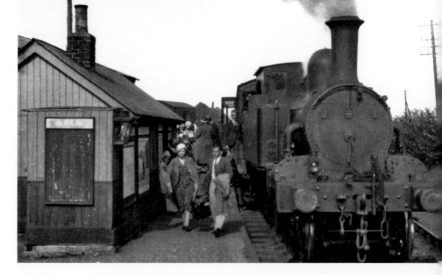

A well-patronised train arrives at Brill behind a 4-4-0T, *c.* 1935. Notice the safety chains each side of the central coupling. *Lens of Sutton*

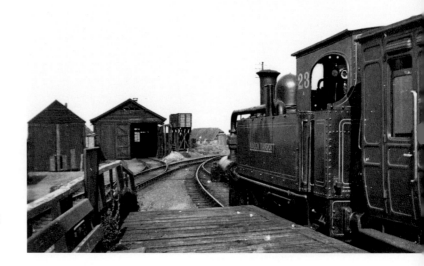

London Passenger Transport Board 4-4-0T No. 23 at Brill, *c.* 1935. The locomotive shed and water tower can be seen. *Lens of Sutton*

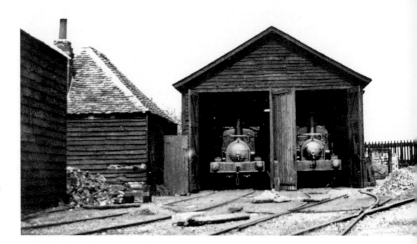

The two Manning, Wardle 0-6-0STs in the shed at Brill, *c.* 1905. *Lens of Sutton*

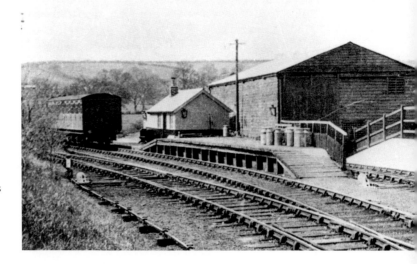

Brill: showing milk churns on the passenger platform and the large goods shed beyond, *c.* 1935. *Lens of Sutton*

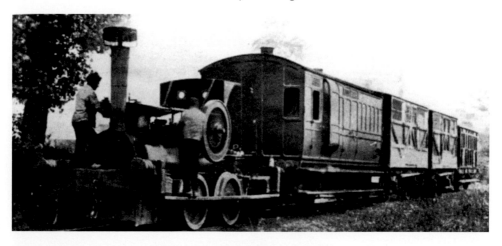

The Aveling & Porter 0-4-0WT, coach, two cattle trucks and a luggage/guard's van, *c.* 1890. Wood Siding is a likely location. *Author's collection*

From 1872 the line was worked by the firm of Chaplin & Home, the Duke of Buckingham being responsible for track maintenance. Chaplin & Horne ordered two 6 hp four-wheeled traction engine-like locomotives from Aveling & Porter at £400 apiece. Works No. 807 and No. 846 they were delivered in January and June 1872. Each weighed ten tons in working order and had a single cylinder seven-and-a-quarter inches by ten inches above the boiler. This imparted motion to a flywheel from where a chain connected with the wheels. A spark-arrester was fixed to the tall chimney. The boiler was fed by a pump worked from an eccentric on the crankshaft drawing water from tanks situated under each end. The crew was sheltered with a weatherboard rather than a cab. One engine was in steam at a time and was supplemented with a shunting horse. As the locomotive travelled at little more than four to eight mph, the journey of six-and-a-half miles took about 90 minutes. An engine made two double trips daily and a third if required. Chaplin & Home estimated the annual working expenses to be £650, including ten per cent interest on the two engines, while the income averaged £1,350 – £1,400. Both Avelings were sold to the Nether Heyford brickworks near Weedon, Northamptonshire. No. 807 was used as a shunting locomotive until 1940 when the brickyard closed. It then lay abandoned until 1950 when it was rescued by the Industrial Locomotive Society, and London Transport restored it as closely as possible to its original form. The line offered a locomotive quite hard work: although gently undulating from Quainton Road to Wotton, between Wotton and Brill was an almost continuous incline for two-and-three-quarter miles, varying from 1 in 100 to 1 in 51.

Two Manning Wardle 0-6-0STs replaced the Avelings: No. 1 *Huddersfield* and No. 2 *Brill,* the latter purchased in February 1894 from Messrs Perry, Cutbill & De Lungo, contractors for the Easton & Church Hope Railway on Portland. It arrived at Quainton Road, having travelled via Nine Elms. It was originally to be hired by the Wotton Tramway at £26 a month, but the line's chairman and benefactor purchased it for £450. In December 1899 when the Metropolitan took over the tramway, *Huddersfield* required extensive repairs and so was sold for £150. It was replaced with a similar new Manning Wardle, No. 3 *Wotton.* In Metropolitan days, although both engines were normally kept in the shed at Brill, one occasionally travelled to the Metropolitan's Aylesbury depot for heavier repairs. The two Manning Wardles were sold about 1914, Brill being used in 1924 on the Great West Road construction works. The Metropolitan Railway then used Sharp Stewart 2-4-0Ts and, later on, Beyer Peacock 4-4-0Ts, usually No. 23 and No. 45 built in 1866 for working the Inner Circle. On the Brill branch they worked alternate weeks and a fresh engine ran from Neasden shed every Monday. During the week the branch engine was

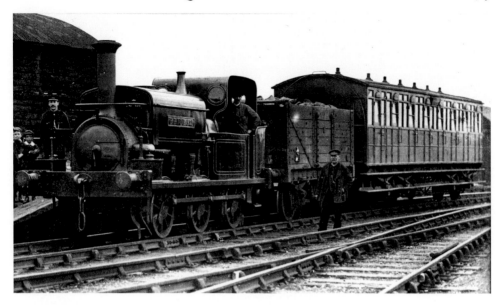

0-6-0ST No. 1 *Brill,* coal wagon and eight-wheel non-bogie coach at Brill, *c.* 1905. *Lens of Sutton*

stabled in the locomotive shed at Brill. In 1934 4-4-0T No. L45, while working from Brill to Neasden shed, was commandeered at Aylesbury to substitute for a failed LNER Pacific heading a Leicester to Marylebone express.

The coaches used on the Brill branch were interesting. Based on a GWR broad gauge design, the four axles were not on bogies, but the necessary flexibility was provided by the axleboxes being able to move laterally in the horn guides. They were built about 1862 by the Ashbury Carriage & Iron Company and rebodied in 1896.

The 1887 timetable showed two trains each way daily taking about 95 minutes for the six-and-a-half miles. There was only one class of passenger and rates were a penny a mile. It was probably the only line to use a farthing in its fare table: Quainton Road to Wood Siding fare 5¾d. No through booking could be made from other railways, though the tramroad was a party to the Railway Clearing House as far as goods and parcel traffic was concerned. By 1910 the service had improved to four each way on weekdays and two on Sundays, with a travelling time of about 37 minutes. In 1922 there were still four trains daily, but none on Sundays, journey time having been speeded to 32 minutes. Trains on the branch were usually 'mixed'.

The company's office was at Brill and the only signals on the line were at level-crossings to indicate the position of the gates. Except at Westcott and Wotton station where a permanent staff was employed, the level-crossing gates were operated by the train guard. Drivers carried a token which had a key to unlock the siding points. At Wotton in later years, the stationmaster of the adjacent LNER station was responsible also for the Brill branch station. Here the LNER passed over the tramroad, while immediately below Wood Siding was the GWR.

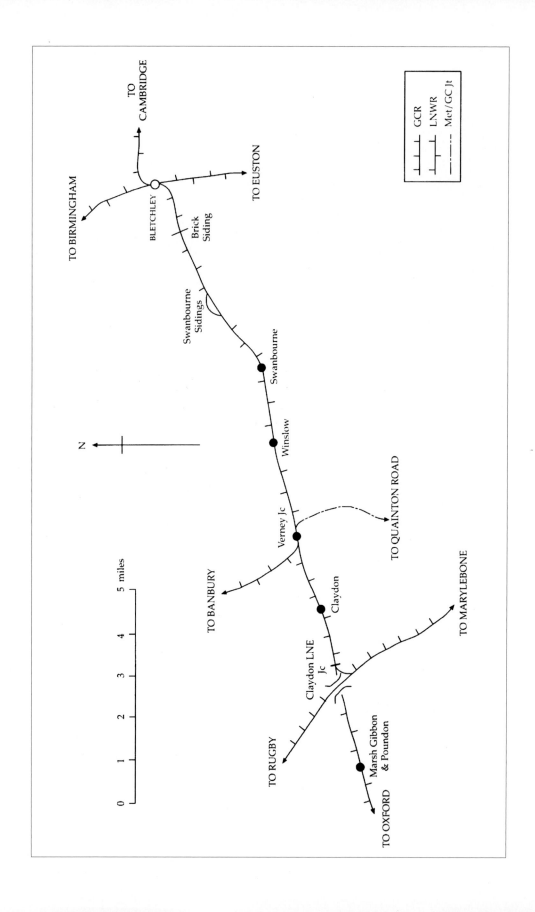

Bletchley to Marsh Gibbon & Poundon

The Oxford & Bletchley Junction Railway was authorized in 1846 to raise £500,095, with borrowing powers for a further £198,000, to construct a branch from the LNWR's London to Birmingham line at Bletchley. On 22 July 1847 the Oxford & Bletchley Junction amalgamated with the Buckingham & Brackley Junction Railway, also authorized in 1846, to form the Buckinghamshire Railway. Not all were in favour of the line; in fact a serious disturbance arose when a farmer confronted the railway's surveyors, and another clash occurred between surveyors and some villagers. Despite these problems, construction started in 1847 and pushed ahead to Banbury, rather than Oxford, and managed to open to Banbury five months before the GWR reached the town, and by June 1848 work on the Oxford line had been restarted.

On 1 May 1850 the Buckinghamshire Railway opened to passenger traffic from Bletchley via Verney Junction to Banbury. Verney Junction to Islip opened on 1 October 1850 and was celebrated somewhat unusually by an excursion from Westminster to Claydon of about 280 ragged-school children and their teachers, the LNWR charitably offering reduced fares. On arrival at Claydon, they were received by Sir Harry and Lady Verney and the flag-waving and cheering children of the Claydon schools. The youngsters dined on meat, plum pudding and apple pies. Beer was provided, but 'a greater number of them, being teetotallers, declined it and preferred water. After spending the afternoon playing games and wandering over the grounds of Claydon House, they all returned to the station and left at five o'clock on their return journey, highly pleased with their excursion.' The line was opened through to Oxford on 20 May 1851 and from 1 July 1851 the Buckinghamshire Railway was leased to the LNWR for a period of 999 years. The line was doubled in 1854.

The secretary of the Buckinghamshire Railway was Edward Watkin, a far-sighted man. In 1853 he was appointed general manager of the Manchester, Sheffield & Lincolnshire Railway, becoming its chairman in 1864. Not long afterwards he was also made chairman of the South Eastern Railway and the Metropolitan Railway. With a vision of running through trains from Manchester to the continent, he formed the Channel Tunnel Company in 1872 for which trial excavation work started in 1881. As was described on page 54, the Manchester, Sheffield & Lincolnshire Railway built an extension to London and became the Great Central Railway. However, by the time the extension was completed in 1899, the relationship with the southern companies had changed and his vast, imaginative scheme remained incomplete. Watkin was knighted in 1868 and created a baronet in 1880.

The Marsh Gibbon & Poundon to Bletchley line was part of the Oxford to Cambridge route and proved valuable in both World Wars, linking several other routes. During the Second World War traffic for the South Eastern Section of the SR, from the Great Northern and Great Eastern sections of the LNER, and also from the Midland and London & North Western sections of the LMSR, was routed via Bletchley and Oxford to gain the GWR and then on to the SR. By August 1942 a south curve had been laid at Bletchley to enable trains to run to or from the south without reversal. A yard was built at Swanbourne to hold 660 wagons to assist in coping with Bicester military traffic. On 29 September 1956 work started on a concrete-built flyover at Bletchley to carry Oxford to Cambridge tracks across the London to Birmingham main line. This work was carried out as a precursor to the 1966 main-line electrification with the hope it would facilitate east to west traffic.

The flyover opened on 15 January 1962 having cost £1.5m. It was planned to carry eight trains daily, but by 1981 the number using the flyover had shrunk to one four times a week and it has never been utilized by a scheduled passenger service.

The Oxford to Bletchley line was dieselized on 2 November 1959, but this failed to halt the declining passenger traffic, and the last passenger train ran on 30 December 1967, while Swanbourne marshalling yard had closed the previous March. Double track was no longer necessary for the reduced traffic, so work on singling the line east of Bicester was started on 24 June 1985; the track in best condition was retained, irrespective of whether it was the Up or Down road. While this work was being carried out, Bicester to Claydon was worked with the staff and ticket system, and special operating instructions had to be issued as by this date the system had fallen from general use on BR. Singling was completed on 28 September 1985 and from 30 September that year until the closure of Bicester London Road signal-box on 6 June 1986, electric token working was in operation; from 6 June 1986 the tokenless block system was adopted. East of Bicester the line today is normally only used by the Bristol 'Binliner' train en route to Claydon LNE Junction and the waste disposal site at Calvert.

The East West Rail Consortium consisting of a group of local authorities as been set up with the objective of securing rail access from East Anglia to Oxford via Milton Keynes. In 2005 the Office of the Deputy Prime Minister recognized the potential contribution a western section of this East West Rail could make to the Milton Keynes, South Midlands and Central Oxfordshire area where east to west road movement was difficult.

The Western Section Study Report of February 2007 put forward a scheme for an Oxford to Milton Keynes railway at a cost of £100m to £135m. It was anticipated that the private sector would contribute £100m. Claydon to Bletchley was cleared of vegetation to give engineers access to the track to carry out a survey. In the autumn of 2009 trial trenches were excavated along the route to determine the condition of the ground. At the time of writing, (2010), it is hoped to commence reconstruction early in 2014 and start operating new train services in late 2015. The proposed service is based on the use of Class 172 turbostar units, capable of 100 mph, replacements for Class 168 and Class 170. It is envisaged that from 06.00 to 22.00 two trains will run every hour calling at Bicester Town, Bletchley and occasionally Islip, with a journey time of about 35 minutes, or a local service operating hourly on weekdays calling at Bicester Town, Winslow, Bletchley and occasionally Islip, with a journey time of 47 minutes and an Oxford, Bletchley, Bedford local service with one train hourly calling at Bicester Town, Newton Longville, Bletchley, Woburn Sands and occasionally Islip, offering a journey time of 60 minutes. New connections would be made to the former sidings at Swanbourne for a railway engineer's depot. A new high-level station with an island platform would be provided at Bletchley on the embankment section of the fly-over. New two-platform stations would be built at Winslow and Newton Longville, all platforms capable of accommodating four 23-metre-long cars. The signals would be of LED type to minimize maintenance and power requirements. AWS and a Train Protection Warning System would be provided at signals.

In Project Evergreen 3, Chiltern Railways has proposed an Oxford to London route. A short connecting line would be constructed just south of Bicester where the Chiltern Railways Marylebone to Birmingham Snow Hill line crosses the proposed East West Rail Oxford to Milton Keynes. The East West Railway would be upgraded from Oxford to just east of Bicester Town including the restoration of much of the double track. Two trains would be run hourly taking 38 minutes Oxford to High Wycombe and 66 minutes Oxford to Marylebone.

Bletchley was a large and important station at the junction of the London to Birmingham and Oxford to Cambridge lines. The station building, in Jacobean style, was designed by J. W. Livock. There were fast and slow through lines and two through roads on either side, mostly used by Oxford and Cambridge trains respectively, giving a total of eight platforms. A low-height train shed covered about half the length of each platform. An hotel abuts the station frontage. Immediately south of the station the Oxford branch, which curves

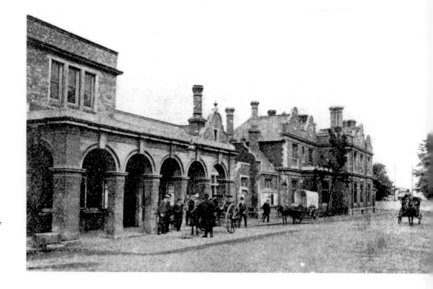

The exterior of the Down side of Bletchley station showing the hotel beyond, *c.* 1910. *Author's collection*

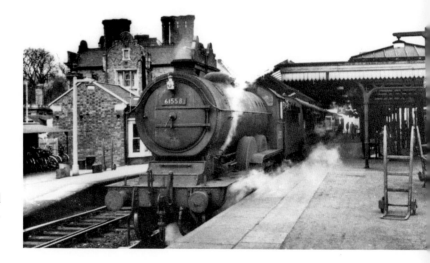

Ex-LNER B12 class 4-6-0 No. 61558 at Bletchley on an Oxford to Cambridge working. 14 March 1957. *P. Q. Treloar*

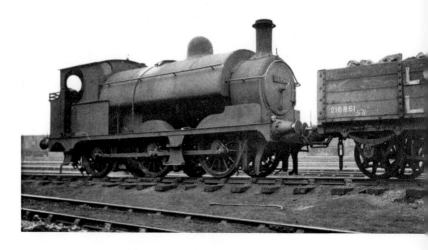

Ex-Lancashire & Yorkshire Railway 0-6-0ST No. 11307, on duty at Bletchley as coal stage pilot. 23 July 1938. *Colin Roberts' collection*

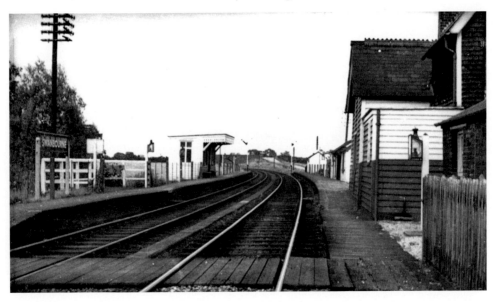

Swanbourne, view Up, *c.* 1960. The gabled main station building, right, had a doorway leading straight on to the track. It was screwed and barred shut since 1902 when a passenger left the waiting room and walked in front of a moving train. *Lens of Sutton*

to the south-west, had access from all the platforms. In 1854 the LNWR laid a curve to give a direct run from Oxford to Euston. Lifted in 1864, in 1934 it was relaid as a siding to Fletton's brick works and on 31 August 1942 relaid as a main line. West of this were Newton Longville sidings and signal-box opened to deal with the brick traffic. The sidings closed on 29 November 1964. Beyond is a rise at 1 in 142. Swanbourne Sidings opened as a Second World War relief for Bletchley. The summit of the line is reached about a mile east of Swanbourne station and descends at 1 in 214 to the station, now a private house. The mains supply of drinking water only arrived at the station house in 1953, and until that date it was brought in cans from Bletchley. The single goods siding closed on 1 June 1964, Just beyond, an 80-chain radius curve was forced on the railway company by an unsympathetic landowner.

The line continues to descend at 1 in 214 to Winslow, a brick-built affair and the principal station on the line in Buckinghamshire. Passengers enjoyed a most attractive road approach as the station and station master's house fronted a circular drive with a horse-chestnut tree in its centre. Rather less attractive were a gas works and brick works adjacent to the goods yard. The station closed to freight on 22 May 1967. Until Verney Junction opened on 3 September 1868, Winslow was the station for changing trains between the Oxford and Banbury lines. The water column at the end of each platform was fed from a 70,000-gallon tank sited a quarter of a mile east of the station. The water tower housed both the steam pump and its attendant. On one occasion, returning to the site he found the building alight, but the usual horses were unavailable to draw the local fire engine and time had to be spent finding alternative motive power, thus delaying its arrival. It was eventually assisted by the Bletchley brigade who were brought by special train. The water in the tank became so hot that it was almost boiling. However, the combined efforts of the brigades doused the flames, and the boiler engine and pump remained in working condition. The heat distorted the tank and it leaked 'rather badly'. Unfortunately the pump attendant's property was destroyed. Today the platforms at Winslow can still be seen together with the former station master's house. From Winslow the line falls at 1 in 149 for one-and-a-half miles and becomes level before Verney Junction, which had an island platform on the Down side, Metropolitan trains using its outer face, and a single

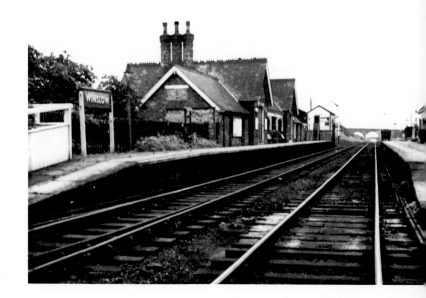

Winslow, view Down,
c. 1960. *Lens of Sutton*

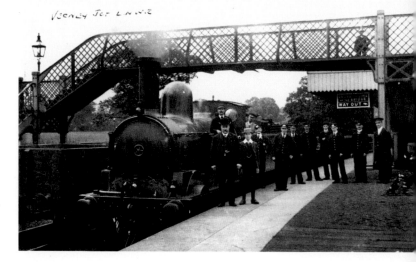

A Down London &
North Western Railway
goods train headed by
a Cauliflower 0-6-0 at
Verney Junction, *c.* 1910.
The station staff stand
on the right. *Author's
collection*

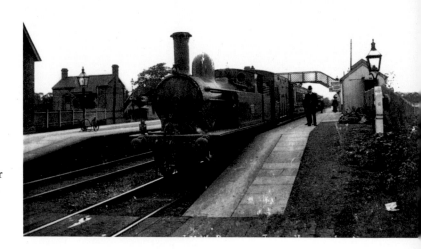

An Up LNWR passenger
train at Verney Junction
headed by a 2-4-2T,
c. 1910. *Author's
collection*

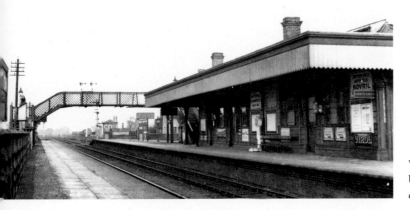

Verney Junction, view Up, *c.* 1910. *Author's collection*

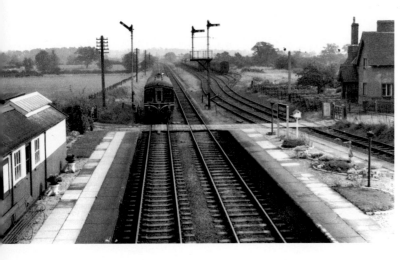

An Oxford to Bletchley train leaves Verney Junction. On the right, sidings are used for coaching stock storage. The nesting box on the platform is an unusual feature. The station master's house can be seen on the right. 27 September 1958. *E. Wilmshurst*

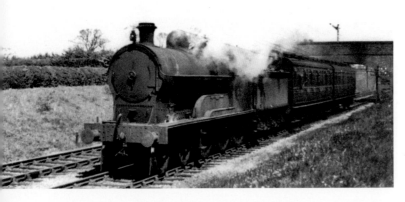

Prince of Wales class 4-6-0 No. 2568 *Falaba* near Claydon. 13 May 1939. *P. Q. Treloar collection*

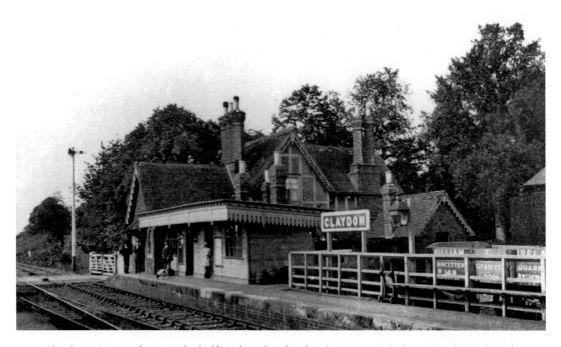

Claydon, view up showing the half-timbered style of architecture with decorative barge boards, *c.* 1921. The lettering on the quarry wagon in the siding reads: 'William J. Ireland, Lancetter Granite Quarries, Athenstone'. These were situated on the Nuneaton to Lichfield line. *Author's collection*

Attractive ironwork on an overbridge west of Marsh Gibbon & Poundon station. 5 May 1999. *Author*

platform on the Up line. It was an interchange station, rather than one used by the locality. It closed to goods traffic on 6 January 1964. The two platforms are still *in situ,* though rather overgrown, and have had their edging slabs removed.

In addition to serving local villages, Claydon station served Claydon House, home of the Verneys. The station building of brick and timber stood on the Down platform, while a wooden waiting shelter was sited on the narrow, timber-built Up platform. The stationmaster's house was half-timbered and had decorative barge boards similar to those on the Bletchley to Bedford line. Access to the goods sidings was controlled by Annett's key. The station closed to goods on 6 January 1964. The former railwaymen's cottages adjoining the goods yard are now in private hands. The platforms are still *in situ* and the level crossing has no barriers – just flashing lights. A further one-and-a-half miles west is Claydon L&NE Junction, laid in the Second World War to link with the ex-GCR line, and it allows through running to the south. The Midland, all-timber signal-box looks rather out of place on this ex-LNWR line. The junction, originally double, now single, was made near the site of a contractor's temporary siding laid in the late 1890s to convey materials for constructing the GCR. The spur was used for carrying bricks from Calvert Brick Works via Bletchley, Dunstable and Luton to King's Cross depot. West of Claydon L&NE Junction the LNWR passed below the GCR line and, just beyond, a siding opened in 1903 from Itter's brick works, trailed into the LNWR Down line.

Marsh Gibbon & Poundon station was on 'made' ground so its buildings were of timber for lightness, as was the Up platform. The station was not opened until 2 August 1880 and its signal-box was an integral part of the Down station building. It closed to goods on 2 November 1964. The platforms can still be seen. West of the station the line passes into Oxfordshire on crossing a tributary of the River Ray. Just in Oxfordshire, a bridge over the Marsh Gibbon to Stratton Audley lane has most attractive balustraded cast-iron sides.

Early in the twentieth century, 'Lady of the Lake' class 2-2-2s, 5 ft 6 in 2-4-2Ts and Webb 0-6-2Ts worked the line, the latter lasting till the 1940s. At one time, two of the 2-2-2s in use on passenger and milk trains were *Daphne* and *Prince Alfred.* 'Precursor' class 4-4-0s appeared before 1914. By 1930 a variety of engines was seen: 2-4-0 'Precedents', 4-4-0 'Precursors' and 'George the Fifths', 4-6-0 'Experiments' and the '8800' mixed traffic class. No. 5031 *Hardwicke* of the 1895 Race to Aberdeen fame was frequently seen. A '6700' class 2-4-2T usually worked the tightest train schedule of the day – the 10.45 a.m. Down – because with a light load, this type was considered by drivers to be the fastest engine. The LMS imposed a low limit for these engines, just two non-corridor coaches per train, together with any empties or horsebox traffic, to a maximum total of 220 tons. The longest surviving member of the 'Prince of Wales' class, 4-6-0 No. 25845, worked regularly over the branch until it was withdrawn in November 1947.

Goods trains were worked by 'Super D' 0-8-0s, 'Cauliflower' 0-6-0s and 0-6-2T 'Coal Tanks', while LYR and LMS Class 4F 0-6-0s made an occasional appearance. Early in 1948 class 4F 2-6-0s began to replace 'Cauliflower' and ex-LYR 0-6-0s on branch trains.

In 1934 Deeley Compound No. 1102 appeared on a Colne to Oxford excursion. Johnson Class 3P 4-4-0s appeared, as did Class 3F 0-6-0Ts, while during the Second World War United States-built Class S160 2-8-0s worked over the branch. Streamlined Pacific No. 6220 *Coronation* travelled over the line when it visited Oxford for publicity purposes in 1937. Stanier Class 4P 2-6-4T No. 42667 worked the last passenger train from Oxford, Rewley Road, the 4.45 p.m. to Bletchley, on 1 October 1951. From that date, passenger trains used the former GWR station at Oxford. In the 1950s and 1960s, engines often seen included ex-LNWR 'G1' and 'G2' class 0-8-0s, ex-LMS Class 5 2-6-0s and 4-6-0s, and Class 8F 2-8-0s. BR Standard Class 4 4-6-0s and 9F 2-10-0s, ex-Great Eastern 'D16' 4-4-0s, LNER 'B1'class 4-6-0s, 'K3'2-6-0s and GER 'B12' class 4-6-0s worked Oxford to Cambridge trains in the 1950s, while occasionally 0-6-0s of the 'J19' and 'J37' classes made an appearance. Steam ceased in 1965 with the closure of Oxford and Bletchley depots.

The branch saw two interesting internal-combustion-engined vehicles in the 1930s. Early in 1932 a Micheline unit tested between Bletchley and Oxford was the first rail vehicle

in Britain to use pneumatic tyres. A serious disadvantage was that it ran over, but did not explode, warning detonators. The saloon only accommodated twenty-four passengers, but was heated by passing air over the exhaust. With a full load it could accelerate from a standstill to 60 mph in two minutes. Driven by a 27 hp engine it ran almost silently and consumed petrol at twelve miles per gallon.

In 1938 the LMS ran trials of its three-car articulated diesel train, cars Nos 80000, 80001 and 80002, between Oxford and Cambridge. Driven by six 125 bhp diesel engines, its maximum speed was 75 mph. In mid-1961 ex-LMS diesel-electric No. 10000 appeared on crew-training trips between Bletchley and Oxford.

The original timber and galvanized iron engine shed at Bletchley, blown down in 1876, was replaced with a standard six-road LNWR brick shed with hipped roof. Hydraulic sheer legs and a hydraulic wheel drop were installed in 1906. In 1917 a 60-ft diameter turntable replaced one with 50-ft dimension. Seventy-five locomotives were allocated to Bletchley in the Second World War. The shed closed on 5 July 1965. Bletchley had seven sub-sheds: Aylesbury, Banbury, Bedford, Cambridge, Leighton Buzzard, Newport Pagnell and Oxford.

In 1887 seven passenger trains ran each way daily and one on Sundays. An express service of three through trains Oxford to Cambridge was inaugurated on 1 March 1905, the fastest taking 2 hours 25 minutes for the 77 miles – a vast improvement on the change and wait at Bletchley when a journey could take five to six hours, most passengers finding it faster to travel via London. By 1910 the frequency of branch trains had increased to eight Down and nine Up with one each way on Sundays. The 1941 timetable showed seven Down and five Up trains daily and two on Sundays. In 1967 ten trains ran daily between Oxford and Cambridge, the fastest taking just over 2 hours.

Around 1900 two Oxford goods drivers worked week and week about the day and night pick-up goods service to Bletchley and back, their duty demanding a 12-hour turn and often more. Two milk trains were run, and seven or eight trains of coal from South Wales day and night spaced at approximately three-hour intervals. An LMS train of glass-lined milk tanks from Carlisle was routed via Bletchley, Verney Junction and the Metropolitan/LNER line to the bottling plant at Marylebone. In 1959, as well as two local goods trains, there were through goods trains from Wellingborough to Yarnton; Ipswich to Cardiff; Cambridge to Cardiff; Irthingborough to Yarnton, and Corby Sidings to Hinksey. Today the line from Marsh Gibbon & Poundon to Claydon LNE Junction is used by the Bristol 'Binliner' on its way to Calvert.

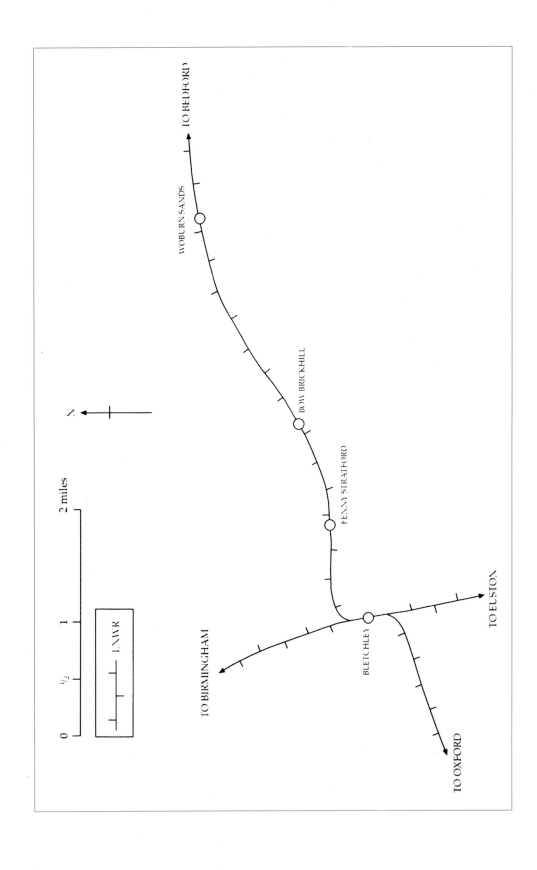

Bletchley to Woburn Sands

The Bedford Railway Company planned to build a sixteen-and-a-half-mile-long line from Bletchley to Bedford, and in 1845 was authorized to raise a capital of £125,000 and loans of £41,650. The company's engineers were no less than George and Robert Stephenson.

On 13 December 1845 the Duchess of Bedford cut the first turf at Bedford and the contractors Grissel, Peto & Jackson set to work, anticipating finishing the line by 31 July 1846, but delays were caused by slips in the Brogborough Hill area. Major-General Pasley carried out the Board of Trade inspection in October and passed the line for opening. An embankment slip near Fenny Stratford station delayed opening of the double track until 17 November 1846 when a train of thirty-three coaches, containing a total of 600 passengers and drawn by two Bury 2-2-0 locomotives, travelled from Bedford to Bletchley. Speed was not of the essence and it took one-and-a-half hours to cover the sixteen-and-a-half miles. Unfortunately, three coaches became derailed on the 20 ch radius curve approaching Bletchley. The rerailed train returned to Bedford where a champagne reception was given by the Duchess of Bedford, followed by a banquet at Bedford Assembly Rooms in the evening. For workmen's celebrations the railway company supplied beef or game, and plum pudding. 'Sixty three men sat down, not one was intoxicated, though ample opportunity was afforded.'

The line was worked by the LNWR and benefited all in the locality as coal prices fell by almost half, from 1s 9d a hundredweight, to 11d a hundredweight. Opening the line dealt a death blow to stage-coach proprietors and the Ouse Navigation. The line was eventually extended through to Cambridge on 4 July 1862. It was busy during both World Wars, but subsequently much traffic changed to the road. Brick works and their employees provided a considerable volume of traffic until the 1960s; the last brick wagons, which by then were Freightliner flats carrying containers, left Stewartby early in 1985. The year of 1964 saw the branch threatened with closure as its 1963 earnings of £102,200 failed to balance running costs of £199,700. Under instructions from Bedfordshire County Council, Buckinghamshire County Council and local councils, Cecil J. Allen, a leading authority on railways, drew up a case for retention.

As an economy measure, at the end of 1967 the Bletchley to Oxford passenger service was withdrawn together with that from Bedford to Cambridge. Unlike those two sections, Bletchley to Bedford could not be adequately served by a replacement bus, so trains continued. Every station became an unstaffed halt from 15 July 1968 and 'Pay Trains' were introduced. All intermediate goods yards closed 17 July 1967 and Bedford St John's yard closed 10 August 1970. In 1973 the line was almost closed, but reprieved when the United Counties Bus Company, which was to provide replacement services, experienced difficulties and an injunction prevented rail closure. The Transport Act of 1974 introduced Public Service Obligation grants and this included the Bletchley to Bedford line. In 1980 the Bedford to Bletchley Rail Users' Association was set up to promote the line and members delivered timetables and leaflets to every home within a mile of each of the stations on the branch. On receipt, some residents commented: 'We thought the line had closed'. By 1999 the Association had over 500 members and the number of passenger journeys made on the branch daily numbered about 800. In 2004 the line was re-signalled and level crossing gates replaced by half-barriers.

The branch curves away north-east of Bletchley station and falls at 1 in 275 to Fenny Stratford. Here is a Grade II listed typical Bedford Railway building in half-timbered

S.D.—49

LONDON & NORTH WESTERN RAILWAY

CHURCH OF ENGLAND
TEMPERANCE FETE
AT
ST. IVES.

On Thursday, July 10th,

A SPECIAL TRAIN
WILL BE RUN TO

ST. IVES

AS UNDER:—

FROM			Starting at a.m.	Fares for the Double Journey.	
				Third Class.	First Class.
BLETCHLEY	9 0	6/4	12/8
WOBURN SANDS	9 10	6/11	11/10
MILLBROOK (for Ampthill)	...		9 24	6/4	10/8
BEDFORD	9 40	4/7	9/2
BLUNHAM	9 50	4/0	8/0
SANDY	10 0	3/9	7/8
POTTON	10 7	3 8	6/10
OLD NORTH ROAD	...		10 17	2/8	6/4
LORD'S BRIDGE	10 27	2/1	4/2

Available for Return by Train leaving St. Ives at 8.55 p.m.

Tickets not Transferable, and available on day of issue only.

CHILDREN UNDER TWELVE YEARS OF AGE, HALF-FARE.

For all information as to Excursions on the London and North Western Railway, apply to
Mr. E. M. G. EDDY, District Superintendent, Euston Station, London.

Euston Station, London, July, 1884. **G. FINDLAY**, General Manager.

McCorquodale & Co., Limited, Cardington Street, London, N.W.

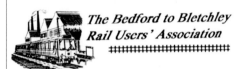

The Bedford to Bletchley Rail Users' Association

Join us on a

Railway Ramble

Saturday 1st August

Travel from local stations on the 13.46hrs train from BEDFORD - meeting at BOW BRICKHILL at 14.21 (2.21pm).

Enjoy good company on a leisurely walk through parks, countryside and along part of the towpath of the Grand Union Canal

Light refreshments (optional) at local pub

There is no charge for the ramble and no need to book in advance - just turn up and enjoy a relaxing family afternoon

The BEDFORD TO BLETCHLEY RAIL USERS' ASSOCIATION is a voluntary group dedicated to promoting and improving the Marston Vale line rail service. Members receive regular newsletters with up to date information about rail service developments.

If you are a regular user of this rail service, or in sympathy with the aims of the association we invite you to send for a free copy of the latest newsletter and details of the association. Send an S.A.E. to: Richard Crane, 23 Hatfield Crescent, Bedford MK41 9RA

Tired of traffic jams and parking problems ?

Rediscover YOUR Local Railway

BEDFORD MIDLAND Only a few minutes walk to the bus station and town centre. There is an open market on Wednesdays and Saturdays.
Visit the Bunyan Museum and enjoy walks alongside the beautiful River Ouse.
Main line rail connections north to Leicester and the East Midlands and South to Luton, London, Gatwick Airport and Brighton.

Bedford St.Johns Close to County Hall and South Wing Hospital. A few minutes walk to small retail park and to riverside. 15 minutes walk to Aspects Leisure Centre. 10 minutes walk to town centre

Kempston Hardwick Nearest station to the village of Wootton. A few minutes walk to the Chimney Corner Pub

Stewartby A good starting point for rambles around Stewartby lake. A centre for water sports

Millbrook Admire the beautifully restored station. 10 minutes walk to the village of Marston Moretaine

Lidlington An attractive village with Post Office, shops and two Pubs. Pleasant walks up to the Greensand Ridge

Ridgmont Signposted footpaths to Aspley Heath

Aspley Guise An attractive village- a good place to begin rambles

Woburn Sands A few minutes walk to the a variety of shops, pubs and a large Garden Centre

Bow Brickhill Pleasant walks to the Church and woods

Fenny Stratford Towpath walks along the Great Union Canal

BLETCHLEY Main line rail connections south to Watford and London. Frequent trains north to Milton Keynes for InterCity connections

MILTON KEYNES Regular bus links to City Centre shopping

Support the association that supports YOUR Local Railway -
For a FREE copy of the latest Newsletter and for details of the BEDFORD to BLETCHLEY RAIL USERS' ASSOCIATION send an SAE to: Richard Crane, 23 Hatfield Crescent, Bedford MK41 9RA

Above right: Poster advertising the Bedford to Bletchley Rail Users' Association ramble, 1 August 1998. 2 August 1998. *Author*

Left: The Bedford to Bletchley Rail Users' Association poster promoting the line. 5 May 1999. *Author*

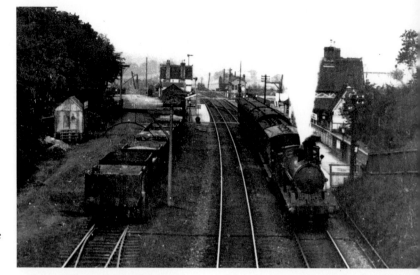

A LNWR 0-6-0 leaves Fenny Stratford with an Up stopping train, *c.* 1910. Notice the staggered platforms. Wagons stand beneath the loading gauge. *Author's collection*

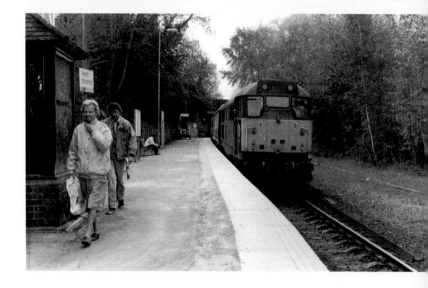

Class 31/4 No. 31468 at the rear of the 13.46 Bedford to Bletchley leaving Fenny Stratford. No. 31452 of the same class was at the front. 5 May 1999. *Author*

Rear view of DMU No. 117704 working the 13.50 Bletchley to Bedford as it leaves Fenny Stratford. The signals protect the level crossing east of the station. 5 May 1999. *Author*

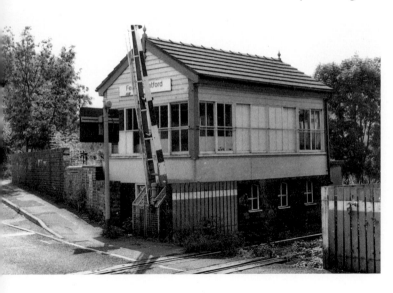

Ex-LNWR signal box at Fenny Stratford beside the level crossing east of the station. 5 May 1999. *Author*

Gothic style, unusually ornate with a mixture of herringbone, lattice and other geometrical designs. It has fretted barge boards and ornate tiles. The small dormer window has a brow of fancy barge boards. Lean-to porches flank the main building to offer shelter for waiting passengers. The platform is still in railway use, but the house is now private. The platforms were staggered until 1948, when a new Down platform was built opposite the Up. In due course it became disused and was transferred to Bedford St John's to replace the old station, and opened there on 12 May 1984. In addition to the railway company's goods sidings at Fenny Stratford, a siding ran to Rowlands Brothers, timber merchants. About 1979 the line was singled through Fenny Stratford to reduce costs of the new viaduct required to straddle the A5 by-pass east of the station. Before reaching this new bridge, an ex-LNWR signal-box stands by Simpson Road level-crossing and a short distance further on the line become double. For about half a mile the line continues to fall at 1 in 275, but rises at 1 in 330 before Bow Brickell Halt.

On 1 December 1905 the LNWR introduced a steam railcar service between Bletchley and Bedford, and opened seven halts, Bow Brickell being the only one in Buckinghamshire. They were simply and cheaply built at a cost of about £40 each, merely a rail-level platform about 50 ft in length of old sleepers, name board and oil lamps. The platforms at Bow Brickell were staggered either side of the level crossing, which had the advantage that road traffic was not held up while passengers boarded, because the gates could be opened immediately the rail motor had passed. Today the level-crossing lifting barriers are operated by the signalman at Fenny Stratford using the assistance of CCTV.

The rail motors were equipped with folding steps and, to ensure that they did not foul the loading gauge, the vacuum brake could not be released until the conductor folded back the steps flush with the coach side. Two rail motors were in use and in 1911 they earned 10¼*d* per mile against an operating expense of only 6¾*d*. Although to a certain extent efficient, they had the drawback of lacking the power to haul a trailer if required and the cab could become unbearably hot. First World War conditions caused the service to be withdrawn in 1917, but it was reinstated on 5 May 1919. By the early 1920s it had become a locomotive-worked push-pull train, this method lasting until dieselization on 2 November 1959. The Derby 'Lightweight' DMUs required the halts to be rebuilt to conventional height and to a length of about 300 ft.

The climb at 1 in 330 continues to Woburn Sands, another Grade II listed building in the company's half-timbered style. The station is really situated at the charmingly named Hogsty End. Special sidings served a timber depot, Eastwood's brick works and Woburn Sands & Apsley Guise Gas Company's works. An ex-LNWR signal-box still guards the

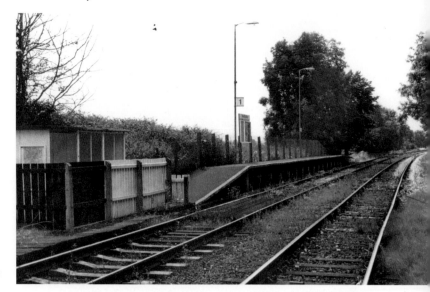

Platform 1, Bow Brickill, for Up trains. The Down platform is staggered on the far side of the level crossing behind the photographer. 2 August 1998. *Author*

Auto-fitted ex-LNWR 0-6-2T Coal Tank No. 7769 leaves Woburn Sands, *c.* 1938. *Author's collection*

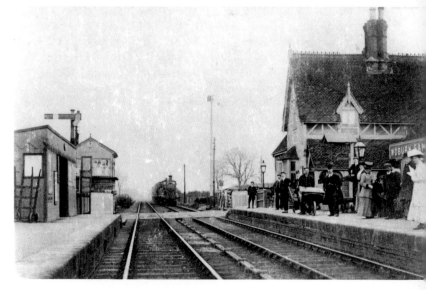

An Up passenger train headed by a Jumbo 2-4-0 approaches Woburn Sands, *c.* 1910. The station building, right, is ornate. *Author's collection*

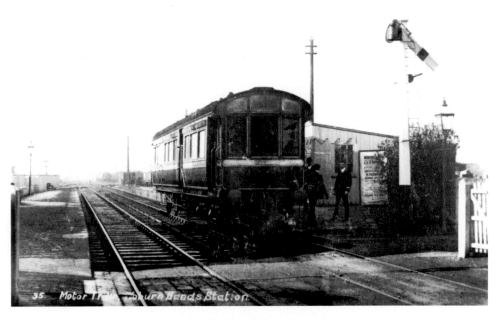

A Down steam rail motor on an Oxford to Bedford working, at Woburn Sands. A self-contained unit, the boiler is at the far end of the vehicle. *Author's collection*

level-crossing. A bell outside the signal-box door was rung to warn of imminent closure of the gates. The station building, concrete rendered, is now a shop.

A footpath crossed the line 200 yards east of the station. The Working Time Table Appendix warned guards of Up freight trains that if their train stopped and blocked the path, the train had to be divided and the front portion drawn ahead. About 200 yards beyond Woburn Sands station the line enters Bedfordshire.

In the latter part of the nineteenth century Webb 'Jumbo' 2-4-0s headed most passenger trains and 'Cauliflower' 0-6-0s the goods. The twentieth century saw, among other classes, 'Precursor' 4-4-0s and 'Prince of Wales' 4-6-0s on passenger trains, while freight was handled by 'Super D' class 0-8-0s. Bedford to Bletchley stopping trains were worked by Webb 2-4-2Ts. In due course Stanier 'Black Fives' replaced LNWR passenger engines and Johnson 0-4-4Ts, the Webb 2-4-2Ts. Later, Class 8F 2-8-0s superseded the 'Super Ds' and Ivatt Class 2 2-6-2Ts the Johnson tanks. Early in 1948 Class 4F 2-6-0s began to replace 'Cauliflower' and L&Y 0-6-0s. In the BR era ex-LNER 'D16' class 4-4-0s and 'B1' and 'B12' class 4-6-0s appeared. One of the last steam locomotives working push-pull trains over the line was Class 2 2-6-2T No. 41272 which bore a plaque on its side, stating that it was the 7000th engine to be built at Crewe. In the line's latter years principal classes were BR Standard and LMS 2-6-4Ts and BR Standard Class 4 and Class 5 4-6-0s.

English Electric diesel-electric railcar, *Bluebird*, works No. 859, ran trials between Bletchley and Bedford in 1933. Its English Electric 200 hp six-cylinder engine suffered from big end bearing failures and heavy cam shaft wear. It had a maximum speed of 60 mph and an average fuel consumption was 6.26 mpg, including shunting. In working order the railcar weighed 37½ tons. It seated fifty-three, but could be adapted to seat sixty-one. The saloon was heated by a low-pressure boiler, fired by fuel oil, the steam heating radiators below the seats. As only one man was needed in the cab, a dead man's handle was provided for safety. The railcar could haul a 27-ton coach as a trailer. The vehicle was not purchased by the LMSR and was returned to the makers in 1934.

A few years later an LMS three-car diesel unit appeared: Nos 80000-80002. From 5 September 1938 it worked 462 miles every day over the Bletchley-Cambridge-Oxford line. Withdrawn at the outbreak of the Second World War, the train was stored until 1949 when it was converted into a two-car maintenance train for the Manchester South Junction & Altrincham electric line.

Derby 'Lightweight' DMUs, brought in with dieselization of the branch on 2 November 1959, were replaced by Craven's Class 105 units, which in their turn were succeeded by Class 104 Birmingham RCW sets in late 1981. A Class 121 non-gangwayed single car with a cab at each end carried over 200 passengers on more than one occasion, though normally a Class 117 strengthened the Class 121 at busy times. A shortage of Class 117 units in 1998 demanded bus replacements on occasions. For just a week from 10 October 1998 a Fragonset Railways-owned Class 31 locomotive was used to 'top and tail' two Forward Rail coaches to replace one of the DMUs. The experiment proved such a success that from 29 March 1999 a Fragonset Class 31 was at each end of a pair of Riviera Trains Mk 1 or Mk 2 coaches. On 22 March 1999 one of the Class 31s, 31601, was named *Bletchley Park Station X* after the Second World War code-breaking station of that name.

With the opening of the line in November 1846, five trains ran each way between Bletchley and Woburn Sands and two on Sundays. The first timetable carried a warning that to ensure being booked, passengers should arrive at stations ten minutes before a train's scheduled arrival and that 'The doors of the Booking Office will be closed punctually at the hours fixed for the Departure of Trains, after which no person can be admitted'. It therefore almost went without saying that 'Passengers cannot be rebooked at the Roadside Stations by the Train in which they are travelling. Carriages intended to receive Passengers who are expected by the Trains at the terminal Stations, should be on the Arrival Side of such Stations, five minutes at least before the time specified in the Tables.'

By 1864 the train service had become six each way on weekdays and only one on Sundays. Trains took rwelve minutes from Woburn Sands to Bletchley, though one, not calling at Fenny Stratford, was timed to cover the distance of four-and-a-quarter miles in nine minutes. The 1910 timetable showed a vast improvement with thirteen trains each way and on Sundays one Down and two Up. Five of the weekday services were motor trains. In 1939 seventeen trains ran each way during the week, and five on Sundays. Most were through trains, but three were the Woburn Sands to Bletchley shuttle service. The journey time was about eleven minutes. In 2010 an hourly interval service was offered, with sixteen each way on weekdays only and a journey time of ten minutes from Bletchley to Woburn Sands.

The theologian Professor C. S. Lewis used the line when travelling from Cambridge to Oxford. Before departure he rang the station refreshment room at Bletchley and asked them to place an omelette on low gas when they saw his train from Cambridge approaching. By the time he arrived, it was done to a turn and he had ample time to consume it before making his way back to the Oxford train.

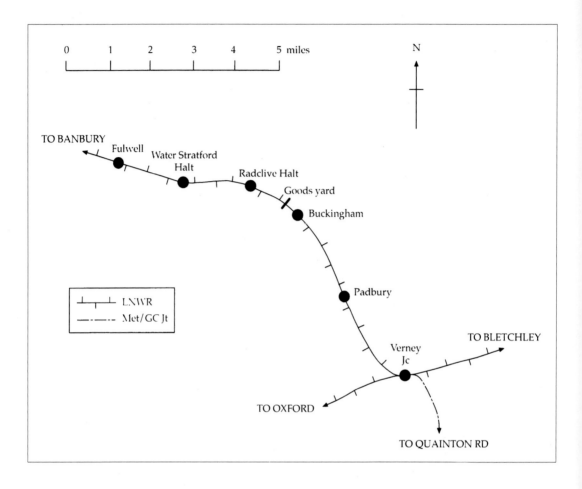

Verney Junction to Fulwell & Westbury

As mentioned on page 95, the Buckingham & Brackley Junction Railway was incorporated in 1846 to build a line from Brackley Junction (later re-named Verney Junction), on the Bletchley to Oxford line, to Brackley and Banbury. The authorized capital of the Buckingham & Brackley Junction was £200,000 in shares and borrowing powers of £66,666. On 22 July 1847 the Buckingham & Brackley Junction amalgamated with the Bletchley and Oxford to form the Buckinghamshire Railway. The first sod was ceremonially turned at Landborough Road, on 20 April 1847. Usually a mayor or titled person undertook this task, but most unusually it was carried out by Dr Field, physician to the firm of Thomas Brassey, who had won the contract for making the line.

As so often happened, the relatively well-paid navvies tended to drink too much alcohol and Buckingham police had to be out in full force on Saturdays and Sundays. The railway company appointed a full-time chaplain and several scripture readers to attempt to persuade the navvies to have more spiritual thoughts. As finances were in a low state, Padbury and Fulwell & Westbury stations were not built until 1878 and 1879 respectively. Robert B. Dockray was the engineer in charge of the line. An interesting fact regarding the line's construction was that at least one of Brassey's engines, *Trio*, was brought by road to Buckingham from Wolverton to assist with the building work.

On 26 March 1850 the directors, contractor and his assistants inspected the completed line and on returning dined in Winslow goods shed. On 19 April 1850 Captain Wynne, the Board of Trade Inspector, went over the line in a two-coach train headed by two tender engines, two engines being required to provide sufficient weight to test the bridges. Wynne declined to give a certificate as the sidings were incomplete. Captain Laffan made a further inspection on 29 April 1850 and passed the line, public opening to passenger traffic being on 1 May 1850. Goods and minerals were carried from 15 May 1850 when about 100 coal wagons arrived. The following year, between 5 May and 3 August 1851, 7,072 passengers were carried along the branch in excursion trains to the Great Exhibition.

In more recent years traffic on the branch was light and, had the line not been selected on 13 August 1956 for experiments with Derby 'Lightweight' single railcars between Banbury and Buckingham where they connected with the steam push-pull to Bletchley, the line would have closed at an earlier date. For the first eighteen months passengers and parcels had the inconvenience of changing trains at Buckingham, but then a through service was introduced from Banbury to Bletchley. Two new halts with sleeper-built platforms opened between Buckingham and Fulwell & Westbury – Radclive and Water Stratford. It was intended that each railcar should work on alternate days, but they were so popular that on Thursdays (market day) and Saturdays the pair had to run as a twin unit. This caused a problem, at the two new halts which were only just longer than a single coach;. it meant that a twin car train was required to pull up twice. The halts had normal height platforms, but the other stations had very low platforms which required the use of portable steps.Although the diesel units increased traffic by over 500-600 per cent and gave a third reduction in running costs, the line failed to pay its way and made an annual deficit of £4,700 – a reduction of about £10,000 from the cost of steam working. The passenger service was withdrawn between Banbury, Merton Street and Buckingham on 2 January 1961 and to goods traffic on 2 December 1963. Following this complete closure, a length north of Buckingham was used for storing condemned coal wagons. Later, after

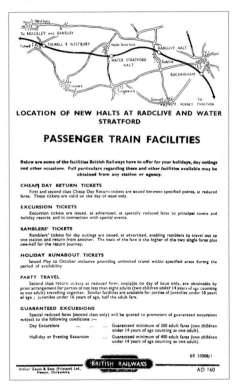

The Buckinghamshire & Brackley Junction
Railway Company's seal. *Author's collection*

these had been removed, they were replaced by two miles of coaches. Verney Junction
to Buckingham remained open to passengers until 7 September 1964. The line was
uneconomic as in 1963 it had carried only 6,600 passengers, bringing receipts of £4,000.
This figure included 1,000 passengers on Stowe School specials. Passenger trains, apart
from these specials, only averaged two passengers a train, with receipts of £1. Travelling
from Windsor, the Royal train arrived on the branch at 1.00 a.m. on 4 April 1966, to spend
a night at Padbury. At 10.00 a.m. it continued to Buckingham where a red carpet ran from
the platform. The line closed to goods traffic on 5 December 1966.

Verney Junction is described on page 81. Padbury had a small, low platform, with
portable steps provided for the less athletic passengers. Accommodation was provided in
a brick building. The station opened on 1 March 1878 and was conveniently close to the
village. One goods siding received four to five wagons of coal each week. Milk churns were
despatched by passenger train to the United Dairies' creamery at Buckingham. From 1942
until its closure on 7 September 1964, Padbury station was in charge of Porter Mrs Allen.
It closed to goods on 6 January 1964.

Buckingham station had double track. Originally it had a timber building, but
J. W. Livock designed one in brick and this was erected in 1861. Around the turn of the
century W. H. Smith opened a bookstall at the station and this was later run by Wyman's.
About 1900 a dairy was erected opposite the station, and milk and milk products were
dispatched by rail. From 1923 when Stowe School was founded, a ten-coach train ran at
the start and end of each term. The station closed to passengers on 7 September 1964 and
the goods yard, nearly half-a-mile to the north, on 5 December 1966.

Radclive Halt, one-and-a-quarter miles north of Buckingham, had a single platform and,
although installed by British Railways, had LNWR oil-lamp illumination. Water Stratford
Halt was a similar construction on the Buckinghamshire/Oxfordshire border. After
travelling for over a mile through Oxfordshire, the line returned briefly to Buckinghamshire
to enter Fulwell & Westbury, a single platform with a small timber building housing the
offices. Beyond the station the line crosses the River Ouse and enters Oxfordshire.

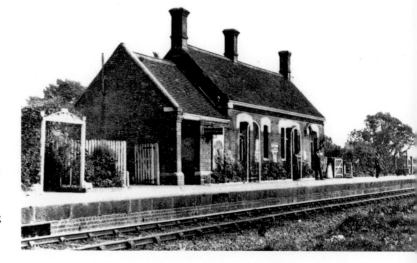

A solitary milk churn stands on the platform at Padbury station, *c.* 1910. The loops in front of the doorways are for training rambler roses. *Author's collection*

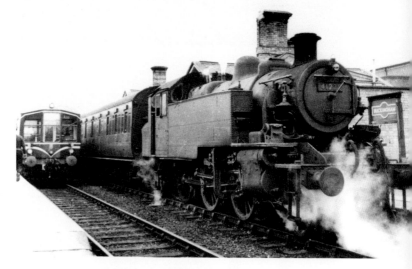

An auto-fitted Class 2 MT 2-6-2T No. 41222 (1E, Bletchley) at Buckingham with a train from Bletchley. Left, a Derby 'Lightweight' single car DMU waits to convey passengers onwards to Banbury. 14 March 1957. *P. Q. Treloar*

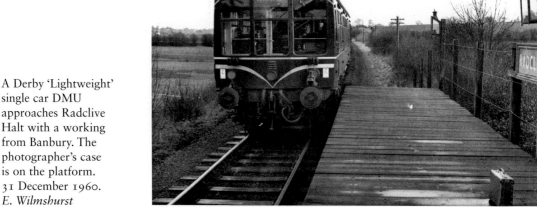

A Derby 'Lightweight' single car DMU approaches Radclive Halt with a working from Banbury. The photographer's case is on the platform. 31 December 1960. *E. Wilmshurst*

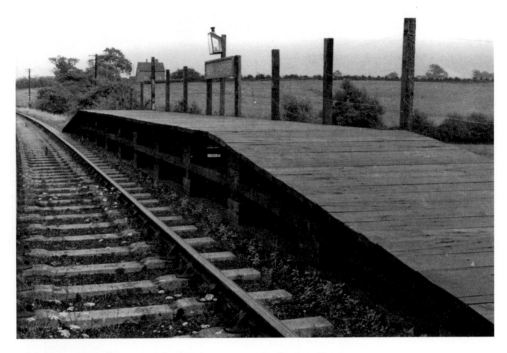

The sleeper-built Water Stratford Halt, *c.* 1960. *Author's collection*

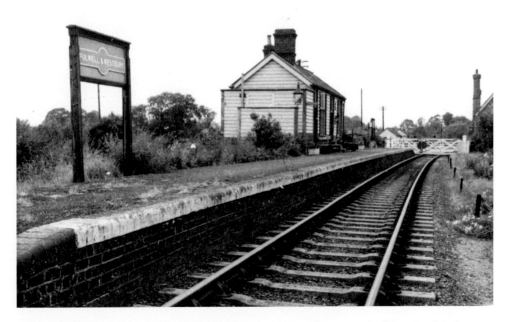

Fulwell & Westbury, view towards Buckingham, *c.* 1960. The station building is of timber.
Lens of Sutton

Engines working the branch during the LNWR era included 2-2-2s of the 'Small Bloomer', 'Problem' and 'Lady of the Lake' classes, 0-6-0s of the 'DX' type, 'Coal Engines' and 'Cauliflowers', the latter working passenger as well as goods trains; 0-8-0s of 'G1', 'G2' and 'Super D' classes, 2-4-2Ts, 0-6-Ts and No. 1967, a Webb Compound 2-2-2-2T The latter imparted a fore-and-aft motion to its coaches, and passengers rocked in the manner of a rowing eight. In LMSR days L&Y 0-6-0s appeared in addition to MR/LMS 0-6-0s. Stanier and BR Standard Class 4 2-6-4Ts and auto-fitted Class 2 2-6-2Ts worked passenger trains until the diesel era. When the line north of Buckingham was used for stabling condemned wagons, Class 9F 2-10-0s were used to move them.

The Derby 'Lightweight' cars used on the branch – No. M79900 and No. M79901 – were single units, unlike the rest of the class. The intention was that each railcar would work on alternate days, but it was found that on Thursdays (market day) and Saturdays, a single car became so crowded that both had to be run. The luggage compartment was cramped due to the need for a second driving cab. No. M79900 had a small luggage compartment and seats for sixty-one passengers. No. M79901 had a larger luggage compartment and seats for fifty-two passengers. In operation, the luggage accommodation of No. M79900 was found to be too small, and an extra nine seats had to be taken out and the partition moved.

The first train service in 1850 offered four trains each way daily and by 1887 had improved to seven Down and five Up daily, with two Up and one Down on Sundays. In 1910 Buckingham was served by six through trains from Bletchley, four proceeding on to Banbury, including a through coach from Euston slipped at Bletchley. In 1922 seven Down and nine Up trains ran on weekdays and two each way on Sundays. By 1941 the service had declined to three each way daily, with one Down and two Up on Sundays. In 1958, the diesel era, the branch enjoyed its best weekday service ever – nine each way, with a reduction in the final year, 1964, to eight each way.

In April 1909 a comedy of errors occurred at Padbury. The crew of the pick-up goods engine shunting there were extremely taciturn. The driver jumped off to pick violets while his fireman stepped down to answer a somewhat different call of nature. During the period that both were absent from the footplate, their engine and its train of about a dozen wagons started up of its own accord. Fortunately, 45-year-old Guard Jim Bates had his wits about him and realized that if it was not stopped before Fulwell & Westbury it would collide there head-on with a passenger train.

Bates applied the brake hard in his van, but was aware that this would be insufficient to halt the train. At great risk to life and limb, he climbed to the wagon in front of his van and dropped the wagon's handbrake. He gradually made his way from truck to truck, his task made more difficult by the fact that they were filled with either coal or granite.

Officials at Buckingham station were horrified to see the crewless engine dash through the station, and observed the brave guard going from wagon to wagon dropping the brakes. He tried to climb on the engine, but unfortunately the space between it and the first wagon was too great for him to cover.

His efforts finally brought forth dividends. The dropped brakes succeeded in halting the train just before it would have collided with the passenger train standing at Fulwell & Westbury. But for Bates's quick thinking and risk-taking, there would have been passenger fatalities.

The goods train was reversed to Buckingham where the driver and fireman were waiting, having pursued it two-and-a-quarter miles from Padbury. What was the outcome of this event? Jim Bates was promoted to the rank of station master, while the errant driver and fireman were dismissed from the company's service.

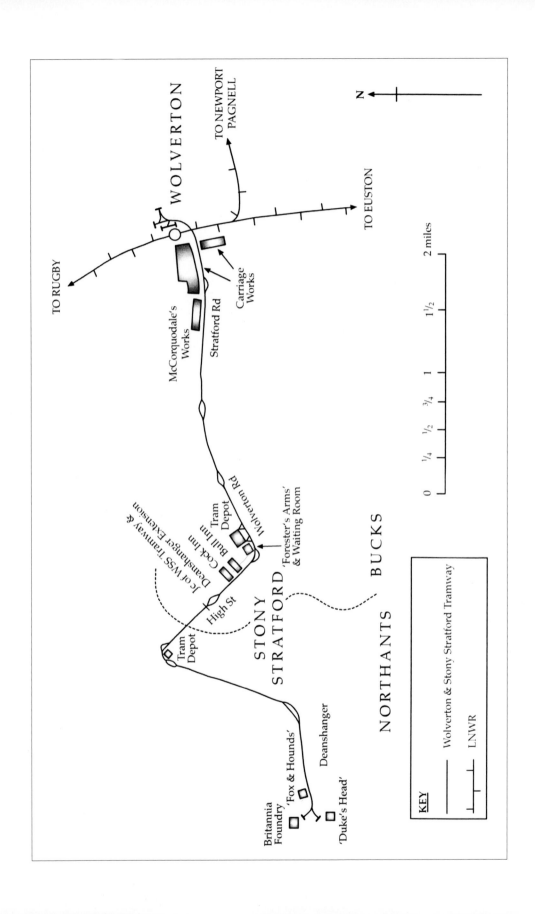

Wolverton & Stony Stratford Tramway

The growth of the LNWR's carriage works at Wolverton, combined with the setting up of McCorquodale's printing works in 1875, led to a proposal to build a line to link Wolverton with the old market town of Stony Stratford. An 1882 promotion proved abortive, but a civil engineer and contractor, Frederick Charles Winby, on 16 July 1883 received a Tramways Order authorizing a two-and-three-quarter-mile long single four-foot gauge line. The Wolverton & Stony Stratford & District Tramways Company Limited was incorporated on 6 September 1883 to acquire Winby's rights. By 1886 only £34 of the authorized share capital of £20,000 had been raised.

On 18 August 1886 Charles Herbert Wilkinson of Wilkinson & Co., a firm of contractors which was also trying to build a line from the LNWR station at Newport Pagnell to the MR station at Olney, entered into a contract to build the Stony Stratford tramway for £13,325. On 5 October 1886 the company's name was changed to the Wolverton & Stony Stratford District Light Railways Co. Ltd. The shares were quickly taken up by the locality and no time was lost laying the line, at three-foot-six-inches gauge, rather than the four-foot authorized. Stephen P. W. D'Alte Sellon was appointed the company's engineer.

On 27 May 1887 public passenger traffic began between the Barley Mow Inn, Stony Stratford and Wolverton station. Economically the tramway was good for the district: the ordinary fare was 2d, while the horse-bus had previously charged 6d. Back in the mid-nineteenth century two horse-buses were run and, in addition to transport, passengers were offered entertainment on their journey. One bus was owned by the Cock Inn and the other by the Bull Inn, and both landlords enjoyed relating tall stories – hence the phrase 'A Cock and Bull story'. Average horse-bus receipts had been £2 to £3 weekly, but the tramway took £45. Weekly tickets for a shilling were available to workmen and entitled them to four trips a day – this being an era when most wives or mothers cooked a midday meal for their menfolk.

The tramway company's managing director was Louis Clovis and it was not until his death a few years later that it was revealed that he was in fact Prince Louis Lucien Clovis Bonaparte, descendant of Napoleon Bonaparte's brother.

From March 1888 the tramway carried LNWR's goods to Stony Stratford and saved the railway company about £10 weekly. To further develop goods traffic, an Order of 19 July 1887 sanctioned a two-mile-long extension to Deanshanger to serve the Britannia Ironworks where agricultural implements were made. This extension, owned by Charles Wilkinson and leased to the tramway company, was opened to passengers and goods on 24 May 1888. The through fare was 4d.

On 26 July 1889 the company's legal title changed to the Wolverton, Stony Stratford & District Tramroads Co. Ltd. It became insolvent, went into voluntary liquidation on 4 September 1889, and on 17 December 1889 the line closed and placed in the hands of the official receiver. In 1891 the Wolverton to Stony Stratford portion was taken over by a syndicate headed by Herbert Samuel Leon MP, assisted by Alfred L. Field. Field was appointed managing director and secretary and held these offices until his death in 1913. The company traded as the Wolverton & Stony Stratford & District Tramways Co. Ltd, and the line from the Barley Mow, Stony Stratford to Wolverton station reopened on 20 November 1891. On 15 September 1893 yet another new company was incorporated, the Wolverton & Stony Stratford & District New Tramway Co. Ltd, and gradually the shares were acquired by Leon until he held the controlling interest.

The year 1914 saw bus competition when the London General Omnibus Company, which had just acquired the Bedford depot of the New Central Omnibus Co., extended the Bedford to Newport Pagnell route through to Stony Stratford. Because of the number of passengers in the Wolverton area, it ran local trips from Stony Stratford to Wolverton and Stantonbury. With the outbreak of the First World War, the War Office commandeered these buses for troop carrying and the Bedford depot closed on 22 November 1914 to the benefit of the tramway. On 28 October 1916 the tramway purchased a new Selden bus, registration BD 3451, to maintain the tramway service which at times suffered from derailments and breakdowns due to poor wartime maintenance. It also had the advantage of reducing costs when loadings were light. The foot of the tramway timetable now bore the sentence: 'The Motor Bus now takes the place of the Tram as occasion demands'.

Following the armistice, the tramway's condition was extremely poor and the company's financial position forced it into liquidation on 17 July 1919. The secretary and manager, George Henry Margrave, was appointed liquidator. Although Sir Leon (he was knighted in 1911) offered the tramway free to the Wolverton Urban District Council, the local authority refused to take over the line and closure seemed inevitable, threatening hardship to 600 workmen using the line daily. Of these, 550 were weekly ticket holders, still only paying a shilling weekly – a quite uneconomic fare. In view of the fact that alternative transport was unavailable, following representations to the LNWR directors by A. R. Trevithick, the LNWR works manager, the LNWR purchased the company on 13 February 1920. It is curious that the LNWR did not think of replacing the tramway with buses which the railway company had been running in various places since 1905. In the spring of 1920 the tramway experienced bus competition once more when a half-hourly interval service was opened between Stony Stratford and Stantonbury.

The LNWR completely relaid the track placing concrete below the rails. Tramways staff in the LNWR period consisted of three drivers, three conductors, one fitter, a bricklayer and two labourers.

By 1926 twelve motor buses ran between Wolverton and Stony Stratford and offered a faster service than the trams which were restricted to eight mph. The General Strike caused the service to be suspended on 4 May 1926 and the LMSR (as successor to the LNWR) never restored operations, the official abandonment being 19 May 1926. Latterly the tramway had run about fourteen trips daily, taking fifteen minutes for the two-and-three-quarter miles. Weekly takings averaged about £30 and the LMSR lost about £2,000 annually on the operation. In 1927 Buckinghamshire County Council took over the track, lifted it and reconstructed the road to incorporate the tramway's site.

The tramway commenced at the cattle sidings on the east side of Wolverton station. Immediately south of the tramway terminus was a reversing triangle so that the locomotive could always be at the leading end of the train. A little further south a siding led to a main-line exchange siding in the goods yard. Leaving the terminus, the tramway crossed the LNWR main line by a bridge and ran down the road through the centre of the town. Then, for about a mile, it ran on its own reservation on the south side of the road to a point half a mile before the Wolverton Road joins High Street. Here it crossed to a reservation on the north side. At Stony Stratford the tramway regained the middle of Wolverton Road and at the junction turned right into High Street, where its one-time terminus was the Barley Mow. At Old Stratford, before reaching the Grand Junction Canal, it turned left to Deanshanger and ran on a reservation on the south-east side of the road. For many years the Stony Stratford terminus was at the Cock Hotel in High Street, but in 1910 it was cut back to terminate at the Forester's Arms on the corner of High Street and Wolverton Road.

The original two tramway engines were supplied by Krauss & Co. of Munich and were to their standard tramway locomotive design, with a skirt enclosing the motion and wheels. The steam brake was automatically applied if the speed exceeded ten mph. As these machines lacked sufficient power to haul two heavy passenger cars, in 1887 Thomas Green & Son, Leeds, supplied two replacement engines capable of hauling two

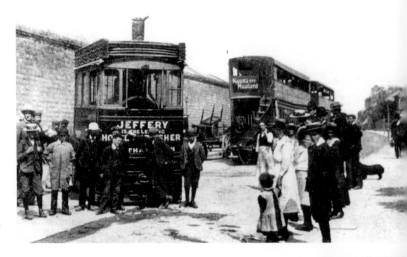

Derailment of a steam tram engine in Stratford Road, Wolverton, *c.* 1910. *Author's collection*

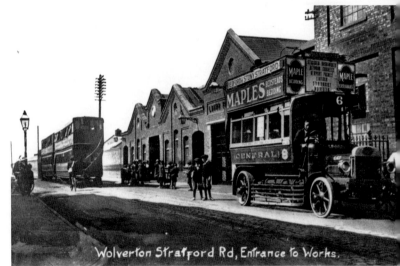

Entrance to Wolverton carriage works, *c.* 1913: left, steam tram and two 100-seat trailers; right, a former Central (after being taken over by General) Leyland bus. LF 980 has General-type route stencil, bonnet number L63, destination boards and lifeguards. *Author's collection*

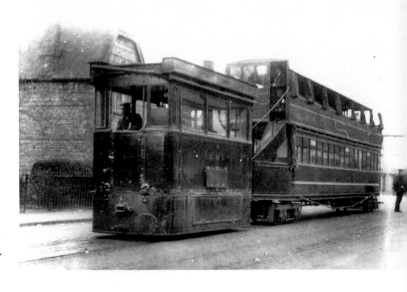

No. 2 in LMS livery outside the Forester's Arms, *c.* 1924. *P. Q. Treloar collection*

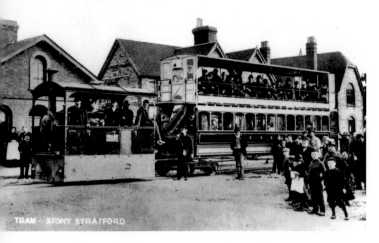

A Krauss tram engine at the Forester's Arms, *c.* 1888. The 44 foot 6 inches long car has knifeboard seating on the upper deck and no decency boards or curtains. The cream rocker panel is unusual. *Author's collection*

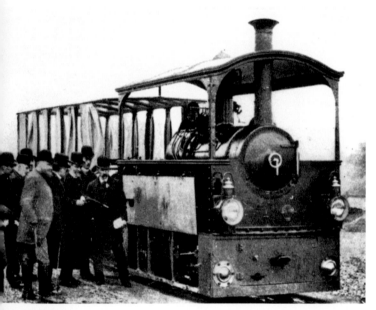

A Krauss engine and 20-seat open-sided car with curtains, forms the inspection train. The locomotive's skirt is raised to expose the motion for oiling. Notice the elaborate headlamps. A rope or flexible pipe is stowed on the firebox. May 1888. *Author's collection*

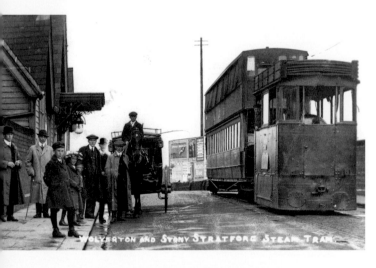

A Thomas Green & Co. tram engine and trailer outside Wolverton station, *c.* 1914. *Author's collection*

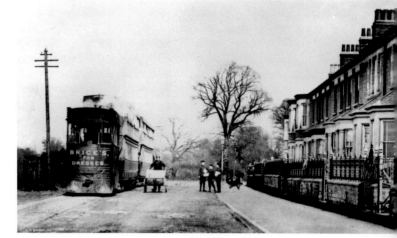

A Green engine hauls two cars
along Wolverton Road,
c. 1910. *Author's collection*

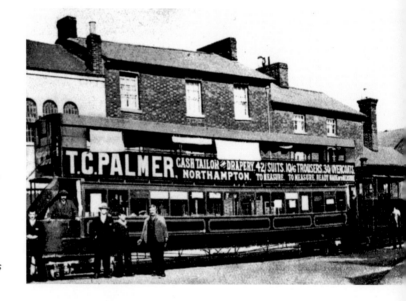

A 100-seat trailer outside
the Forester's Arms, Stony
Stratford, *c.* 1910. This view
shows well the length of the
car and its sag. Notice the
curtains to give shade from
the sun or offer shelter in
inclement weather. Hauling
it is a Green engine. *Author's
collection*

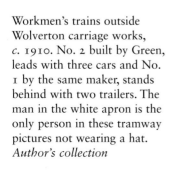

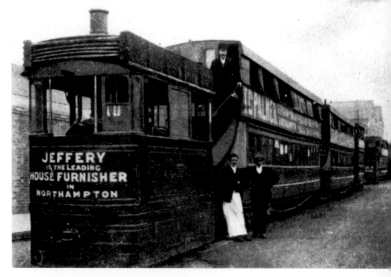

Workmen's trains outside
Wolverton carriage works,
c. 1910. No. 2 built by Green,
leads with three cars and No.
1 by the same maker, stands
behind with two trailers. The
man in the white apron is the
only person in these tramway
pictures not wearing a hat.
Author's collection

fully loaded double-deck cars while a condenser fitted on the locomotive's roof reduced the amount of steam emitted. In 1888 a third Krauss engine was purchased to haul the twenty-seater car used on the Deanshanger extension. In 1900 the Brush Electrical Engineering Co., Loughborough, supplied an engine which, although generally similar to the Green engines, had six, instead of three, side windows. It often broke its suspension springs and the firebox soon bulged, requiring additional stays. The LNWR purchased a 0-4-0ST from Messrs Bagnall, Stafford. Except for the motion and wheels being boxed in, it was a conventional railway locomotive. As its standard height chimney failed to carry smoke above the top-deck passengers, a stove-pipe extension was fitted. It was in chocolate-coloured livery relieved by yellow and white lining, with the LNWR coat of arms and initials proudly displayed.

Passengers were carried on large, double-decked, covered-top, tramway-type cars mounted on bogies situated at the extreme ends of the vehicles to ensure that the couplings and draw gear remained centrally over the track when negotiating corners. Like all the company's rolling stock, they were built by the Midland Carriage & Wagon Co., Shrewsbury. These cars lasted the company's lifetime. Three measured 44 ft in length and five feet nine inches in width, accommodating 100 workmen on hard seats. All passengers sat longitudinally, those in the lower saloon facing inwards, while those on the upper deck were on knife-board seats facing outwards. The lower saloons had no fewer than sixteen windows on each side. Except for the ends, the upper half of the top deck was open, but could be screened from wind, rain or sun by dropping canvas curtains.

One car, 38 ft in length and six feet wide, seated eighty passengers. Charles E. Lee, writing in the *Railway Magazine* in 1952, claimed that this car was the only one with upholstered seats. A fifth car, 24 ft 6 in by 5 ft 9 in, seated fifty passengers. F. D. Simpson, in *The Wolverton & Stony Stratford Steam Trams*, believes this car to have been the only one with upholstered seats. Its top deck had transverse 'garden seats' arranged two on one side of the gangway and one on the other. In 1887 a four-wheeled single-deck open-sided roofed toastrack car, seating twenty passengers, was purchased for working the Deanshanger extension. Although appearing on the stock list until 1911, it was probably not used after the extension closed in 1889.

The brakes of all cars could be applied either by a capstan wheel on the end platform or from the engine by means of pull rods and chains. The cars were originally illuminated by an oil lamp set in each bulkhead shining a yellow light inside the car and a ruby red outside, but in due course acetylene lighting was fitted. Following purchase by the LNWR, the Pinsch oil-gas system used on its main-line coaches was adopted, reservoirs being placed below the cars. To be re-gassed from a railway gas tank wagon, the cars were placed on the transfer siding at Wolverton. Until 1920 the passenger cars were in a tawny-brown livery. When new, the rocker and waist panels were lined, but omitted from subsequent repaints. In the LNWR era, the cars were painted in passenger coach livery of chocolate and white.

The Midland Carriage & Wagon Co. also supplied eight 10-ton, 24-ft long coal and coke trucks, and two parcel vans. Two of the wagons had flanges made in sections and arranged so that they could be withdrawn inside the tread surface and thus enable them to operate on an ordinary road. When the train reached the Cock Hotel, horses hauled the wagons off the rails and along the road to the consignee. Two horses were shown in the company's stock return for 1888 and 1889. Goods traffic was probably not reintroduced when the line reopened in 1891, though LNWR parcels and GPO mails were carried. A small parcels office/waiting room was opened at Stony Stratford on the corner of High Street and Wolverton Road, next door to the Forester's Arms. Edwin Braggins, in charge of this office. always wore top hat and frock coat.

42 lb/yd tramway grooved rail was used on the street section, while roadside lengths had bull-head rail held in chairs spiked to sleepers. They were on an embankment 10-15 in above the adjoining highway surface. Gradients were easy apart from a sharp rise of 1 in 20 from the Wolverton terminus to the railway bridge, and a fall of 1 in 32 for about

500 ft about midway between Wolverton and Stony Stratford. The Deanshanger extension was practically level.

The tram depot was at Stony Stratford and situated on the north side of Wolverton Road behind a terrace of houses. It had two entrances/exits: that at the west end of faced Wolverton, while its eastern counterpart had a triangular junction. The depot had three sheds: the largest held the cars on two roads; the smaller, the tram engines on two roads, and the smallest shed was the single road repair shop. The latter had tools powered by a small gas engine. Outside the car shed a siding served the coke stage and water supply. Coke was used, as tram engines were required to use a smokeless fuel. The LNWR widened the car shed to four roads. From 1887 to 1889, a small depot near the Old Stratford crossroads accommodated the Deanshanger section Krauss engine and twenty-seater car.

The tramway was free from serious accidents to people, though one schoolboy fell from a tram and was injured when it passed over him. On another occasion a Sunday school outing was returning from Wolverton station when a donkey which had escaped from a field, on seeing the tram approach, tried to return through the hedge, failed and was fatally injured between the engine and leading car. Occasionally the River Ouse would flood and wash debris into the rail groove, thus causing derailments and forcing the crew to paddle around in the water trying to get the vehicle rerailed.

Table 3.
Wolverton and Stony Stratford tramway locomotive stock

Builder	Locomotive Number	Building date	Works number	Cylinders	Wheel diameter	Working pressure lb/sq in	Date withdrawn	Notes
Krauss	1	1887	1861	8 x 12	2ft 6in	175	1887	see footnote*
Krauss	2	1887	1862	8 x 12	2ft 6in	175	1887	see footnote*
Krauss	3	1888(?)	1863	8 x 12	2ft 6in	175	c. 1920	
Green	1	1887	43	9 x 14	2ft 6in	175	1926	Condensing
Green	2	1887	51	9 x 14	2ft 6 in	175	1926	Condensing
Brush	4	1900	308	7½ x 12	2ft 6in	175	1926	Condensing
Bagnall	5	1920	2153	10 x 15	2ft 9Xin	150	1926	

*Probably part-exchanged for the Green engines.

Wolverton to Newport Pagnell

Following several abortive schemes to place Newport Pagnell on the railway map, on 29 June 1863 the Newport Pagnell Railway was authorized to construct a four-mile long line from the LNWR at Wolverton, purchase the Newport Pagnell Canal and make a working arrangement with the LNWR. The company was empowered to raise a capital of £45,000 and £15,000 by loans.

Messrs Bray & Wilson won the contract for building the line and were at work by August 1864. Earthworks were considerable as much of the line was either on an embankment or in a cutting. Beyond Linford station the railway followed the course of the erstwhile Newport Pagnell Canal. The major work was the lattice girder bridge over the Grand Junction Canal at Linford. The span of 82 ft was constructed in Wales by Lennard Brothers, sent to the site in sections where it was riveted together before being rolled across the canal on top of two narrow boats.

On 30 September 1865 a train of seventeen ballast wagons, crowded with navvies, ran the length of the line. However, the railway, although virtually complete, could not be opened to the public as the company quibbled with the LNWR's charge of £500 a year for the use of its Wolverton station.

On 8 May 1866 Captain Rich inspected the line on behalf of the Board of Trade, and was generally satisfied with the works except for the junction at Wolverton. On 24 July 1866, in order to get goods traffic started, the NPR arranged for use of the LNWR station at a rental of only one third of £500 and £80 annually for use of the junction. In due course the junction at Wolverton was made suitable and safe for passenger traffic and the line was fully opened on 2 September 1867. The Wolverton Brass Band travelled in the first train from Newport Pagnell to Wolverton and back, then marched through decorated streets to the Swan Hotel. Later in the day the usual rustic sports were held, celebrations continuing until the early hours of the following morning. On that second day, tea and tobacco were donated to all persons in the town over sixty years of age. More sports were held in the afternoon.

Employees of Wolverton Carriage Works welcomed the opening, as quite a number of them lived at Newport Pagnell and the line's inauguration meant that they could avoid the long trudge to and fro. Nearly 400 men and over 100 boys used the workmen's train, paying for a weekly ticket: 1s 6d men and 1s boys.

Meanwhile, on 2 June 1865, the NPR obtained an Act to extend its line to Olney and on 10 August 1866 received an Act to push the line to a junction with the Northampton & Peterborough branch of the LNWR and to form a junction at Olney with the MR's Bedford & Northampton line.

Almost immediately after Bray & Wilson finished the Wolverton to Newport Pagnell contract on 12 October 1865, they commenced work on the extension to Olney. In 1866 a substantial bridge was constructed at Newport Pagnell across the Wolverton Road, but work on the extension was then suspended and the work never restarted. The bridge was demolished in the 1870s.

Undismayed by the failure of this extension, in 1887 Charles Herbert Williamson, the contractor who had just finished laying the Wolverton & Stony Stratford tramway, commenced building a 3 ft 6 in gauge steam tramway, just over 6 miles in length, to link the NPR station at Newport Pagnell with the MR station at Olney. Most of the line was to

be constructed on its own right of way beside the road or across fields, but the ends had a street section. About five miles of track had been laid, and an iron bridge across the River Ouse near Sherington, when the project was halted because the Board of Trade refused to allow a tramway to run along the main street through the village of Emberton and the company was unable to purchase land for a reserved track. In 1893 Buckinghamshire County Council obtained an Act of Parliament authorizing it to lift the rails.

Returning to the story of the Newport Pagnell Railway, the company was in a poor financial position as its income was insufficient to cover working costs and interest on loans. The only solution was to sell the line to the LNWR and the transaction was completed on 29 June 1875, the LNWR paying NPR shareholders £50,000 less the £2,724 owing to the LNWR; the LNWR also defrayed costs of winding up the company, paying outstanding mortgage debts and removing the bridge at Newport Pagnell on the Olney extension.

The branch gave a useful service to the local communities but, with the development of road transport, the passenger service was withdrawn on 7 September 1964 and freight on 22 May 1967. The track was lifted early in 1968 and the route is now available for walkers, cyclists and equestrians.

Newport Pagnell trains started at Wolverton from the picturesque timber chalet-style station, sadly demolished in 1991. Newport Pagnell trains used the Up bay platform with its own run-round loop. This was actually the second Wolverton station and built on a deviation line, the first station having been closed on 1 August 1881 when the expanded railway works took in the site of the original station.

The Newport Pagnell branch curved round to Bradwell. Around 1902 a third side was added, making a triangular junction which gave through running from Newport Pagnell to the south and also allowed trains, such as the LNWR Royal train normally kept at Wolverton, to be turned. Bradwell station was opened soon after the line had its passenger service. Here Mr Wylie had a private siding and, curving sharply, it trailed in just before the passenger platform. The pony trucks of Ivatt Class 2 2-6-2Ts tended to become derailed on this siding, but crews were skilled at rerailing them quickly. The siding was shared with various coal merchants. In the early years five to ten coal wagons arrived each week, and three wagons of lime. The railway brought grain and coal to two mills near the station and, in the 1920s, the Anglo-American Oil Co. had a depot served by the siding. Latterly, Messrs Goodman dispatched wagons of scrap metal. Bradwell closed to goods traffic on 22 May 1967. Dominating the station building was a water tank, the only one on the branch and supplied from a stream near the main line at Wolverton. The adjacent water column, dated 1847, was of London & Birmingham Railway design and made by Curtis & Kennedy.

Half a mile before Great Linford the line crossed the Grand Junction Canal, the bridge marking the summit of the line which then fell on a ruling gradient of 1 in 80 to Great Linford, known merely as Linford until March 1884. The station was situated in a cutting, with no goods siding, just a single passenger platform.

In view of the projected extension to Olney, Newport Pagnell was built as a through, rather than terminal, station. Rather unusually, the platform and entrance canopies were suspended from the chimney stacks by cable, instead of having support columns. The goods yard east of the station had a siding serving a corn, cattle cake, coal and lime merchant, who also was a brick maker. South of the passenger platform was a siding to a flour mill, previously served by the canal. To the rear of the passenger station, Aston Martin cars, whose works were nearby, were loaded at the carriage dock. The station closed to goods 22 May 1967.

On the approach to the station was the single road, timber-built locomotive shed which had been transferred to Newport Pagnell from Leighton Buzzard in 1889. On 1 January 1916 Newport Pagnell engine shed went up in flames, badly damaging 2-4-2T No. 889 within. The shed's corrugated iron replacement remained until closure on 13 June 1955. The line's first engines included a 0-4-2WT and 2-2-2ST. For much of the branch's life it

was worked by LNWR 2-4-2T 'Motor Tanks' and 0-6-2T 'Coal Tanks'. In 1949 they were replaced by Ivatt Class 2 2-6-2Ts. Stanier and Fairburn 2-6-4Ts sometimes appeared in the 1950s, though not being auto-fitted, were supposed to run round the train at Newport Pagnell but, if the Wolverton signalman was accommodating, illegally pushed the 2-coach set from Newport Pagnell to Wolverton. Later on, BR Standard Class 3 2-6-2Ts and Class 4 2-6-4Ts appeared. Normally the daily freight train was worked by the tank engine, tender engines appearing infrequently on this duty. In 1904 *Engineering* announced that the branch was to be electrified. Either this was based on rumour, or plans were changed. Branch passenger trains were steam-worked until their withdrawal on 7 September 1964, but from 1966 when Bletchley closed to steam, Derby Sulzer Type 2 (later termed Class 24) diesel-electrics worked the daily freight, which was mostly coal and scrap metal.

The first timetable showed six trains each way daily and two on Sundays, but the December service offered eight daily. By 1887 ten Down and eleven Up trains were worked daily, most taking thirteen minutes to cover the four miles. No trains were shown on Sundays. Fares were 1s 0d first class; 8d second class and 4d Government trains. The 1939 timetable offered fifteen Down and fourteen Up trains, taking eleven minutes, though in 1941 this had shrunk to nine each way. In 1961 there were six Down and seven Up trains. Push-and-pull trains had been introduced in 1920.

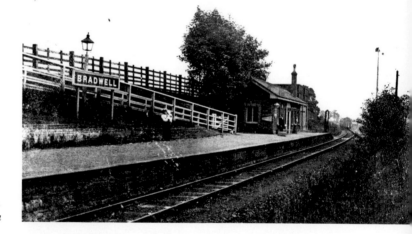

Bradwell, view towards Newport Pagnell, *c.* 1910. The water tank beyond the station building is unusually large for a small station. *Author's collection*

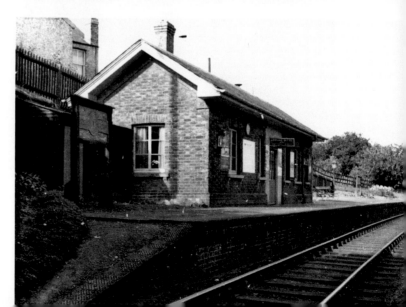

Great Linford, view Down, *c.* 1960. *Author's collection*

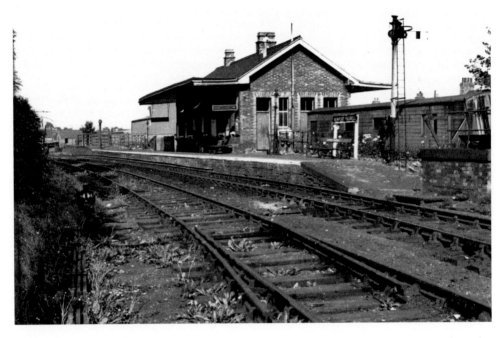

Newport Pagnell, view east, *c.* 1960. A grounded North London Railway body is on the right and a ground frame on the far right. *Lens of Sutton*

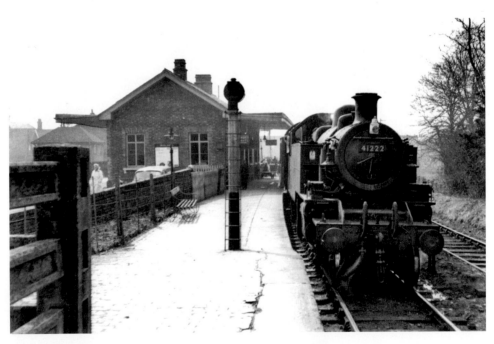

Ivatt class 2MT 2-6-2T No. 41222 at Newport Pagnell having worked the 2.45 p.m. from Wolverton. The cattle dock is on the left. 6 April 1963. *E. Wilmshurst*

Leighton Buzzard to Stanbridgeford

On 30 June 1845 the Dunstable & London & Birmingham Railway Act was passed, sanctioning a line from Leighton Buzzard on the London & Birmingham Railway. Authorized capital was £50,000, and the London & Birmingham was empowered to purchase land, construct the line and, on completion, absorb the company. Thomas Jackson won the building contract and no significant engineering works were required. The seven-mile-long line opened on 1 June 1848. Following decreasing passenger receipts, the line closed to this traffic on 2 July 1962.

The first station at Leighton Buzzard closed on 14 February 1859, when it was replaced 176 yards to the south by a new six-road station with timber buildings on the platform. Leaving the station, branch trains curved sharply eastwards away from the main line, past the engine shed, and descended before crossing the Grand Union Canal and then the River Ouzel into Bedfordshire. Only half a mile of the branch was in Buckinghamshire. On the far side of the River Ouzel were sited Grovebury transfer sidings with a two-foot gauge railway, opened on 20 November 1919, conveying silver sand from neighbouring quarries. Exchange traffic, which amounted to over 100,000 tons annually in the 1930s and 1950s, ceased in 1968 and this last stub of the Dunstable branch then closed completely. It was not the only mineral traffic, for until the 1950s ex-LNWR 0-8-0s and 0-6-2Ts handled extensive lime and sand traffic. It was not unusual for heavy trains of chalk from Totternhoe Quarries to stall on the gradient up to Leighton Buzzard station and, in order not to delay road traffic unnecessarily, it was the custom not to open Wing Road level-crossing gates until a train had actually cleared the summit. Push-and-pull passenger trains were worked by ex-LNWR 2-4-2Ts until 1951, when Ivatt Class 2 2-6-2Ts took over their duties. One or two coaches were propelled from Leighton Buzzard to Dunstable. Class 4P 2-6-4T No. 42659 was seen on the branch and Class 3P 2-6-2T No. 40206 worked for a week. The occasional football specials to Luton were headed by Class 4MT 2-6-0s or Class 5MT 4-6-0s. Leighton Buzzard engine shed, opened around 1859, was a two-road brick building with a pitched roof. It closed on 5 November 1962.

In 1860 the passenger service consisted of nine Down and ten Up trains on weekdays only, and no Sunday services were run, this being a condition imposed in the original agreement with the owner when he sold his land to the railway. Train services decreased through the lifetime of the branch. By 1890 there were only eight trains each way; seven in 1910; six Down and seven Up in 1938; five in 1941; four in 1958 and three in 1961.

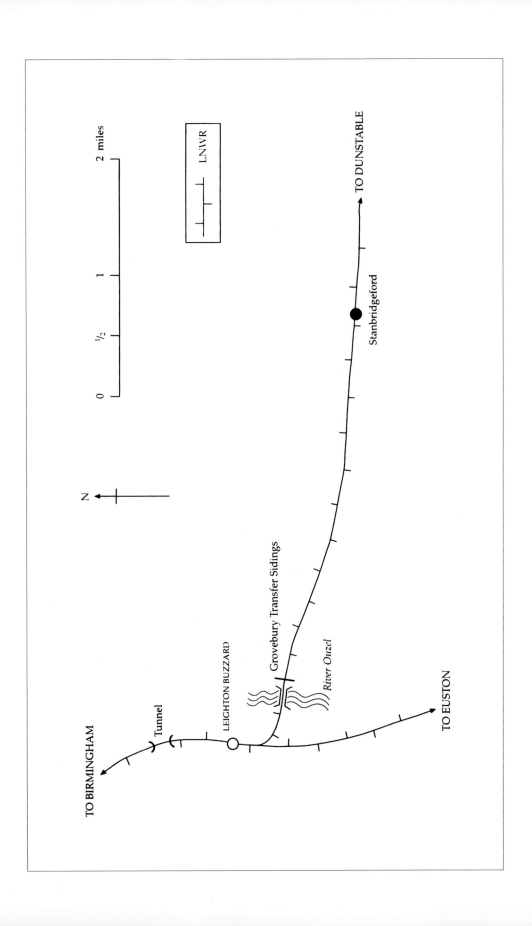

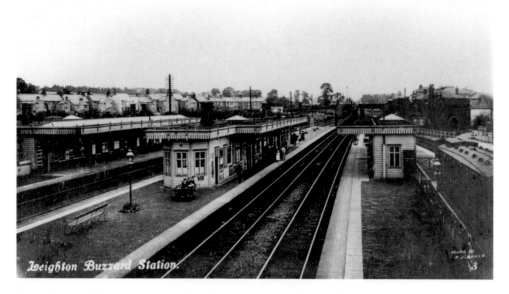

General view of Leighton Buzzard station, *c.* 1912. *Author's collection*

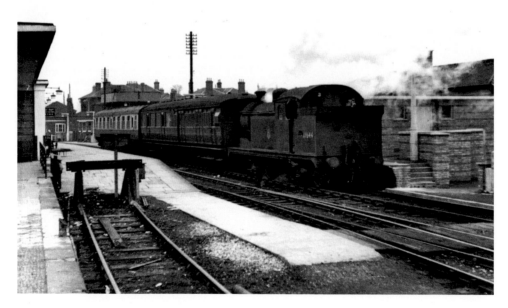

Ex-LNER N7 class 0-6-2T No. 69644 at Leighton Buzzard with the 1.34 p.m. to Luton, Bute Street. 9 April 1958. *D. Holmes*

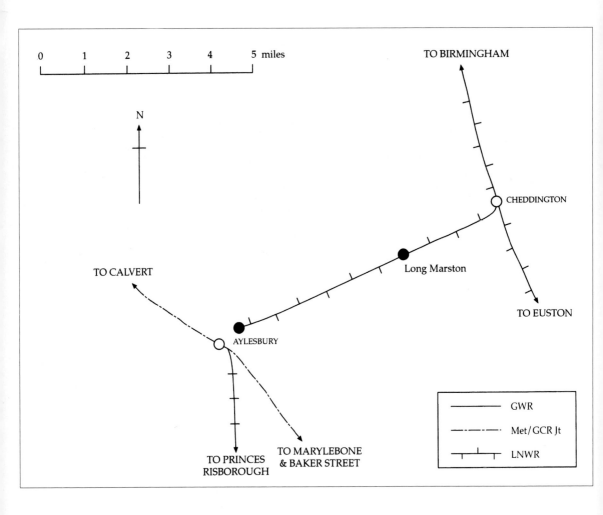

Cheddington to Aylesbury

Construction of the London & Birmingham Railway began in 1834, and on 10 November 1835 a meeting was held at the White Hart Inn, Aylesbury, to consider building a branch line from Cheddington. Among those present were Sir Harry Verney and Robert Stephenson, the latter being appointed the company's engineer. In due course the Act was passed on 19 May 1836. The branch illustrates well the 1830s concept of a railway which was as far as possible a straight line between the centres it served, largely ignoring intermediate places, even if they could generate traffic.

The start on constructing the Aylesbury Railway was delayed due to the London & Birmingham hoping to build a Cheltenham, Oxford & London & Birmingham Union Railway and, had this plan come to fruition, the Aylesbury Railway would have been rendered redundant. A further reason for delay was the collapse of Medley's Bank in Aylesbury, Medley being one of the Aylesbury Railway's promoters. The bank's failure also affected the finances of other promoters. but it eventually paid 2s 6d in the pound. On 14 December 1837 the London & Birmingham agreed to lease the Aylesbury Railway at £2,500 annually. All the necessary land was purchased by May 1838 and the first turf was cut on the twelfth of that month. The contractor J. R. Chapman ambitiously anticipated a November opening, as so few earthworks were needed and there were no road or river bridges and not even an intermediate station. The seven-mile-long line cost £59,000.

On 27 May 1839 Chapman ran an inaugural train of a dozen coaches containing the company's directors and friends. The celebratory opening was set for 10 June, when shops would be closed, as it had been declared a public holiday. Thousands gathered to watch as the first train, consisting of five first-class and third-class coaches left Aylesbury at 7.00 a.m. It covered the seven miles to Cheddington in fourteen minutes. Crowds watched as each train, giving a free trip, departed to the strains of the Long Crendon village band. At a banquet held at the White Hart Inn in Aylesbury to celebrate the opening, Dr Lee, of Hartwell House near Aylesbury, prophesied: 'I should not be surprised if the day should come when in addition to our Aylesbury branch, we should see another branch to Thame, another to Princes Risborough, another to Waddesdon, and another to Wendover, and perhaps some of us may live to see this.' His prophecy, later largely fulfilled, was greeted with laughter. Medals struck in honour of the opening displayed the profile of George Corrington of Missenden, the company's chairman. The line opened to the public on 11 June 1839 and was of great benefit to the town; travelling by road from London took fourteen hours, but the railway reduced the 43-mile journey to two hours ten minutes. Two local coach proprietors running services to London, Oxford and Banbury tried to compete with the railway and reduced their fares to a ruinous level before being forced to retire. In its first half-year the line carried 19,565 passengers, bringing a total of £5,735 in receipts. Goods traffic began in November 1839.

On 15 January 1840 the Aylesbury Railway was leased to the London & Birmingham Railway for five years. On 16 July 1846 the London & Birmingham became part of the LNWR which purchased the Aylesbury company for £60,000. In due course Aylesbury was served by the Wycombe Railway, the Metropolitan Railway and the Great Central Railway, which all offered a direct service to London to the detriment of the branch from Cheddington. With the post-Second World War development of road transport, passenger trains were withdrawn between Cheddington and Aylesbury on 2 February 1953, goods lasting almost a further eleven years until 2 December 1963.

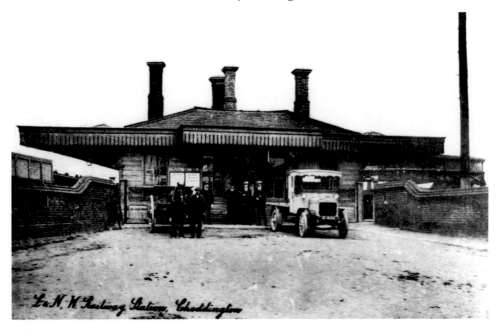

Road approach to the timber-built Cheddington station, *c.* 1913. *Author's collection*

The original station at Cheddington had its main buildings on the Down platform, Aylesbury branch trains using its outer face, and the junction allowed through running to coal trains from the Midlands. When the main line was quadrupled in the 1870s the station was rebuilt using standard LNWR timber buildings. In 1869 a small gas works had been installed at the station to provide for station and signal lighting. The gas was produced from sulphurated hydrogen. By the 1880s the signals had reverted to oil lamps. In season, the area around Cheddington produced plums and damsons, ten to fifteen tons being dispatched by train in baskets daily. Wagonloads of textile waste arrived by rail and was delivered to Twyford Seeds to help retain moisture in the soil. Groups of LNWR horses from Euston were brought to Cheddington for a month's rest in the fields.

After negotiating the sharp curve leading from Cheddington, at night the lights of Aylesbury could be seen dead ahead as the line was ruler-straight. Marston Gate station, approximately midway between Long Marston and Wingrave, was opened in 1857. It seems that at first no proper passenger facilities were provided and that the level-crossing keeper issued tickets, because in 1864 a booking office and station master's house were built at a cost of £283. The station was built to allow for track doubling. Goods traffic was mainly farm-based – cattle and milk – the latter being catered for at a special platform (opposite the passenger platform) which dealt with up to fifty churns daily. Horse manure arrived from London and cattle feed was brought in, so the station was provided with a cattle dock. Coal was also handled. Signals and points were operated by a six-lever frame sited in the open, opposite the passenger platform, its block instrument mounted on a signal post. Following closure to passengers, the level-crossing gates were operated by gatemen who travelled on a train restricted to 15 mph. just west of Marston Gate a gradient post indicated a fall towards Aylesbury of 1 in 5007.

The first station at Aylesbury was in Station Street: the arrival platform was sited on the north side and the departure on the south. In 1863 a rival line, the Wycombe Railway (see page 45), entered Aylesbury. In the 1880s the threat of the Metropolitan Railway's extension to Aylesbury led to demands for action, as the LNWR's goods facilities were cramped. Since no land was available in the immediate vicinity, the solution was to give the whole of the station site to the goods department and build a new line from the station

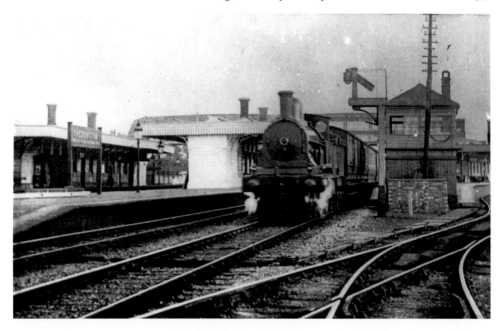

LNWR Jubilee class 4-4-0 leaves Cheddington with a Down express, *c.* 1900. The Aylesbury branch is on the far right. *Author's collection*

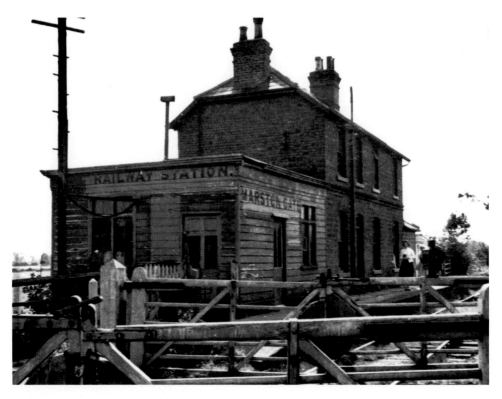

Marston Gate station: the removal of later signs has revealed early lettering, *c.* 1960. *Lens of Sutton*

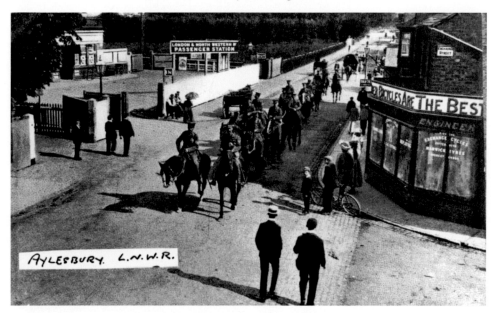

AYLESBURY. L.N.W.R.

Lancers pass the LNWR station in High Street, Aylesbury, 1912. *Lens of Sutton*

throat, curving round to a new red-orange Ellistone brick-built passenger station in High Street. This new station opened on Sunday 16 June 1889, exactly a month short of fifty years after the opening of the first station. Set back from the road, it was approached by a semi-circular drive beautified with flower beds and rockeries. A train shed covered the single 400-ft long platform and track. No run-round loop was provided at the station itself, so after passengers had left an incoming train it reversed to the trailing siding. The engine would be uncoupled, then reversed into this siding. The guard then released the brakes and let the train roll down the 1 in 160 back into the platform. The engine would then emerge from the siding and couple to the train.

Incoming traffic included: coal and goods for shops, barley and hops for beer, vats of Guinness to be bottled; while dispatched goods included: books and magazines (printed by Hazell, Watson & Viney), tins of condensed milk, cheese, butter and cattle. Between the passenger station and Park Street were osier beds, and 1880 the LNWR opened a basket factory employing twenty men. Osiers brought from other LNWR lines included Oxford to Cambridge and those in Warwickshire and Staffordshire. From 1893 until the mid-1920s production averaged 2,000 baskets and hampers a year. They varied from a capacity of 22 cu. ft to small baskets for correspondence and waste paper. In the late 1930s the local beds fell into disuse and all osiers were brought in by rail until 31 December 1947 when the factory closed.

'High Street' was added to the name of the goods depot on 1 July 1950 and to the passenger station from 25 September the same year. Following closure of the latter on 2 February 1953 the station buildings were utilized as a wine and spirit store. In the 1950s New Holland dispatched forty wagons of agricultural machinery daily; Hazell, Watson & Viney used the railway heavily, and cattle trains were still in demand. Latterly shunting the yard was difficult as it was necessary to run over the busy Park Street level-crossing, and the signalman was frequently opening or closing the gates. The gas works, sandwiched between the goods yard and passenger station, in later years received forty wagons of coal, and another twenty wagons were delivered to coal merchants.

The first engines used on the line were two Bury 2-2-0s, *Aylesbury No. 1* and *Aylesbury No. 2*. In due course these were followed by LNWR types including McConnell 0-4-2WTs. Later in the century, Webb 2-4-2Ts and 0-6-2Ts worked the branch and continued to do

so until the BR era. Ivatt Class 2 2-6-2Ts appeared in the late 1940s. Push-pull working introduced in 1950 obviated use of a guard, but required a passed fireman to be on the footplate as, for half the time, he was alone on the footplate and therefore had to be qualified to work the engine without supervision when the driver was in the control vestibule. For the very last passenger train over the branch 2-4-2T No. 46601 was used. Goods trains in the final years were worked by 'Super D' 0-8-0s, Class 4F 0-6-0s, Ivatt, Stanier and Hughes-Fowler 2-6-0s, 'Black Five' 4-6-0s and even 'Patriots' and 'Jubilees'. Branch engines were kept in a single road, brick-built locomotive shed at Aylesbury. Erected in 1856, it replaced an earlier structure whose site was required for a coal yard. The new shed was 150 ft in length, suggesting that originally it housed the whole passenger train. It closed on 30 September 1950. Staff based there consisted of two drivers and three firemen – one of the latter coaled and watered the engine at night. Tank engines were preferred because they were easier to coal: a wagon could be placed next to the bunker and the coal simply shovelled over the end of the wagon, this operation being carried out in the sheltered confines of the shed. Coaling a tender engine meant taking it out of the shed and alongside a wagon, which could be highly unpleasant in a biting wind or drenching rain.

At least from the opening of the new station at Aylesbury in 1889, two sets of three six-wheeled coaches were allocated to the branch. Normally one set was used and the other retained as spare. A composite carriage was kept at Cheddington for strengthening trains on market days. From the early 1930s two bogie coaches were used, one of which was nearly always ex-LNWR.

At the opening of the line in June 1839 three trains ran each way daily and two on Sundays. The proposed extension of the Wycombe Railway to break the LNWR's monopoly of Aylesbury caused the train service to be improved in 1860 to six trains each way daily. In 1887 eleven ran each way daily and three on Sundays, covering the seven miles in seventeen minutes, and by 1909 this had been reduced to fifteen minutes. Sunday trains were omitted as a First World War economy measure and never reinstated. In 1939 nine trains ran daily, taking fourteen minutes. By 1941 the service had been reduced to six Down and seven Up. An improvement showed in 1950, with eight each way, taking fifteen minutes, but in the winter of 1952-3 only four trains ran each way, plus one on Wednesdays and two on Saturdays. Except on Wednesdays and Saturdays the last train for Cheddington left Aylesbury at the early hour of 1.25 p.m. and made no London connection, for the branch had long ceased to be a useful route from Aylesbury to London. As soon as the Metropolitan Railway opened to Aylesbury in 1892 it proved very competitive as its route was five miles shorter than the LNWR's and no change of train was required. Then the opening of the GCR in 1899 siphoned off some of the traffic from Aylesbury to the north, and traffic on the LNWR's branch dwindled still further.

Mercifully, the line escaped any severe disaster. On 3 July 1849 serious consequences could have arisen when, due to the locomotive's regulator being insufficiently closed and the tender brakes not applied, an unmanned goods train left Aylesbury pursued by a manned locomotive, crashed through Broughton Road level-crossing gates, gained the main line at Cheddington and proceeded along it to Leighton Buzzard, where it stopped when steam pressure became low.

Turvey to Ravenstone Wood Junction

The Bedford & Northampton Railway was built under an Act of 1865, only about seven miles being in Buckinghamshire. The route adopted was almost the same as that surveyed by Charles Liddell between Bedford and Northampton in 1864, except that the MR station at Bedford was used instead of an independent one. This modification saved the company £20,000. The line, worked by the MR, opened to passenger and goods traffic on 10 June 1872 and from the start was operated by the block telegraph. The MR possessed running powers over the Stratford-upon-Avon & Midland Junction Railway between Ravenstone Wood Junction and Broom Junction, and also between Cockley Brake Junction and Blisworth, while the SMJR possessed running powers over the Bedford & Northampton Railway from Ravenstone Wood Junction to Olney. The Bedford & Northampton Railway amalgamated with the MR from 1 January 1886. Due to a fall in traffic, by 1952 all trains to Turvey used the Up line, the Down track being used for stabling wagons and coaches. The line closed to passengers on 5 March 1962.

On entering Buckinghamshire three miles west of Turvey station, the line undulated, crossing the River Ouse just before reaching Olney, principal station on the Oakley Junction to Northampton line. It was an attractive two-storey domestic design carried out in stone. Exchange sidings with the SMJR were provided. Olney closed to goods traffic on 6 January 1964. From the station the line rose at 1 in 70 for one-and-a-quarter miles where the gradient eased to 1 in 75 for the next two miles, reaching a summit just before Ravenstone Wood Junction. Except in fog or falling snow, when banking was prohibited, goods trains of any length required rear assistance up this gradient. From the summit the line fell to Ravenstone Wood Junction where the lonely signal-box was set in extensive woodland. Beyond it the line left Buckinghamshire.

Trains were worked by the various classes of MR and SMJR locomotives, and latterly Bedford to Northampton passenger services were in the hands of Park Royal railbuses. An engine shed opened at Olney in the early 1890s to house the MR engine working the short-lived passenger service to Towcester. Adjacent was a 50-ft diameter turntable. SMJR engines used the shed facilities but none of that company's locomotives were stabled there. Officially the shed closed in 1928, but engines were serviced on the site until the mid-1950s.

In 1872 the opening timetable showed five trains each way on weekdays only, but by 1910 the service had improved to eight Down and seven Up. In the 1920s and 1930s six ran each way, with an additional train on Saturdays. By 1958 only five trains ran. Between 1923 and 1939 on Towcester racedays the LMSR ran excursion trains from Bedford. In 1956 goods services included: Stratford-upon-Avon to Bedford; Stratford to Olney; two from Clifford Sidings, just east of Stratford, to Olney; an empty wagon train Stratford to Turvey and a 'runs as required' from Olney to Towcester.

Olney station looking towards Northampton. 10 December 1960. *E. Wilmshurst*

Bibliography

Baker, S. K., *Rail Atlas of Great Britain & Ireland*, Yeovil, OPC, 1996

Bett, W. H. and Gillham, J. C., *The Tramways of the South Midlands*, Broxbourne, LRTA, 1991

Biddle, G. and Nock, O. S., *The Railway Heritage of Britain*, London, Michael Joseph, 1983

Bradshaw's Railway Manual, Shareholders' Guide & Directory (various years)

Bradshaw's Railway Guide (various years)

Clark, R. H. & Potts, C. R., *An Historical Survey of Selected Great Western Stations, Vols 1-4*, Oxford, OPC, 1976-85

Clinker, C. R., *Register of Closed Passenger Stations & Goods Depots*, Weston-super-Mare, Avon-Anglia, 1988

Cockman, F. G., *The Railway Age in Bedfordshire*, Dunstable, The Book Castle, 1994

Cooke, R. A., *Atlas of the Great Western Railway*, Didcot, Wild Swan, 1997

Cooke, R. A., *Track Layout Diagrams of the GWR & BR WR*, Harwell, Author, Section 24, 1975; Section 26, 1992; Section 27, 1987

Cummings, J., *Railway Motor Buses & Bus Services in the British Isles 1902-1933*, Oxford, OPC, 1980

Dow, G., *Great Central, Vols 1-3*, London, LPC, 1959-65

Gough, J., *The Midland Railway, A Chronology.* Mold, RCHS, 1989

Hawkins, C. and Reeve, G., *An Illustrated History of Great Western Railway Engine Sheds, London Division*, Didcot, Wild Swan, 1987

Hawkins, C. and Reeve, G., *LMS Engine Sheds, Vols 1 and 2*, Didcot, Wild Swan, 1981

Lyons, E., *An Historical Survey of Great Western Engine Sheds, 1947*, Oxford, OPC, 1974

Lyons, E. and Mountford, E., *An Historical Survey of Great Western Engine Sheds 1837-1947*, Oxford, OPC, 1979

McCormack, K., *Western Region Steam Around London*, London, Ian Allan, 1998

McDermot, E. T., Clinker, C. R. and Nock, O. S., *History of the Great Western Railway*, London, Ian Allan, 1964 and 1967

Richards, E. V., *LMS Diesel Locomotives & Railcars*, Long Stratton, RCTS, 1996

Robertson, K., *Great Western Railway Halts, Vol.1*, Pinner, Irwell, 1990

Simpson, B., *The Oxford to Cambridge Railway, Vols 1 and 2*, Oxford, OPC, 1981/83
 The Aylesbury Railway, Yeovil, OPC, 1989
 The Banbury to Verney Junction Branch, Witney, Lamplight, 1994
 The Wolverton to Newport Pagnell Branch, Witney, Lamplight, 1995

Simpson, F. D., *The Wolverton & Stony Stratford Steam Tramway*, Bromley Common, Omnibus Society, 1982

Turner, K., *Directory of British Tramways*, Yeovil, Patrick Stephens, 1996

Anon., *Chinnor & Princes Risborough Railway Visitors' Guide*, Chinnor, CPRR, 1995

Anon., *Buckinghamshire Railway Centre Stock Book*, Quainton Road, BRC, 1990

Anon., *British Rail Main Line Gradient Profiles*, Shepperton, Ian Allan, no date

Anon., *British Railways Pre-Grouping Atlas & Gazetteer*, Shepperton, Ian Allan, no date